In Search of
VAN GOGH

Gloria Fossi

In Search of
VAN
GOGH

CAPTURING THE LIFE OF THE ARTIST

THROUGH PHOTOGRAPHS AND PAINTINGS

Original Photography by
Danilo De Marco
Mario Dondero

HARPER
DESIGN
An Imprint of HarperCollinsPublishers

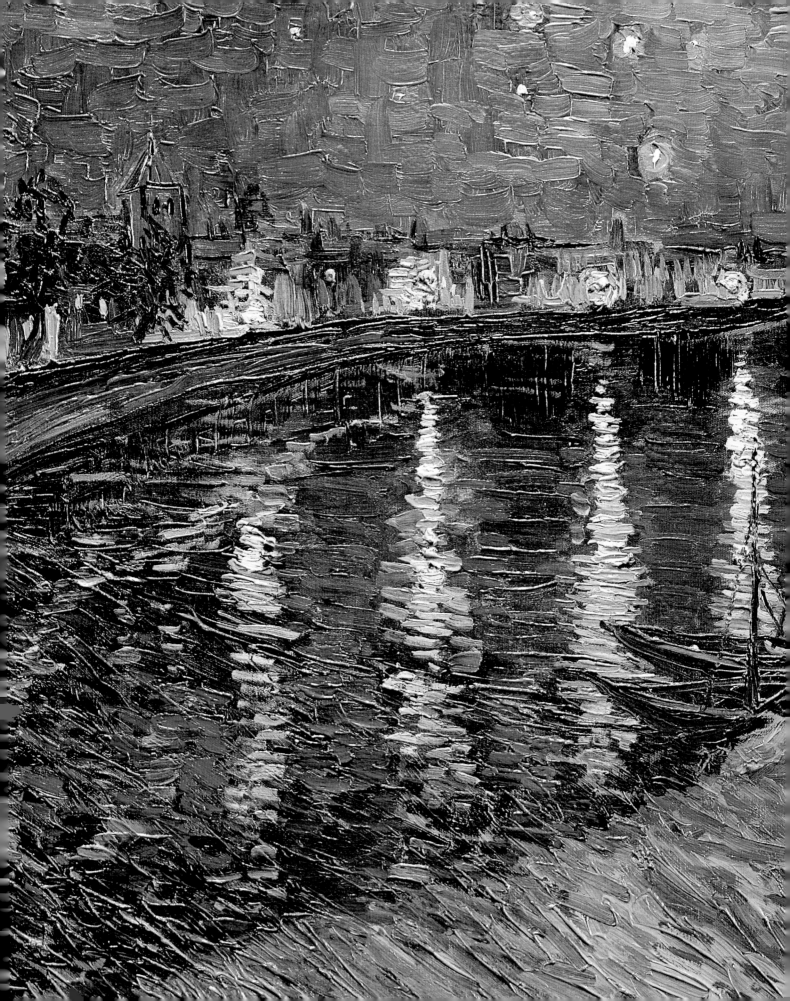

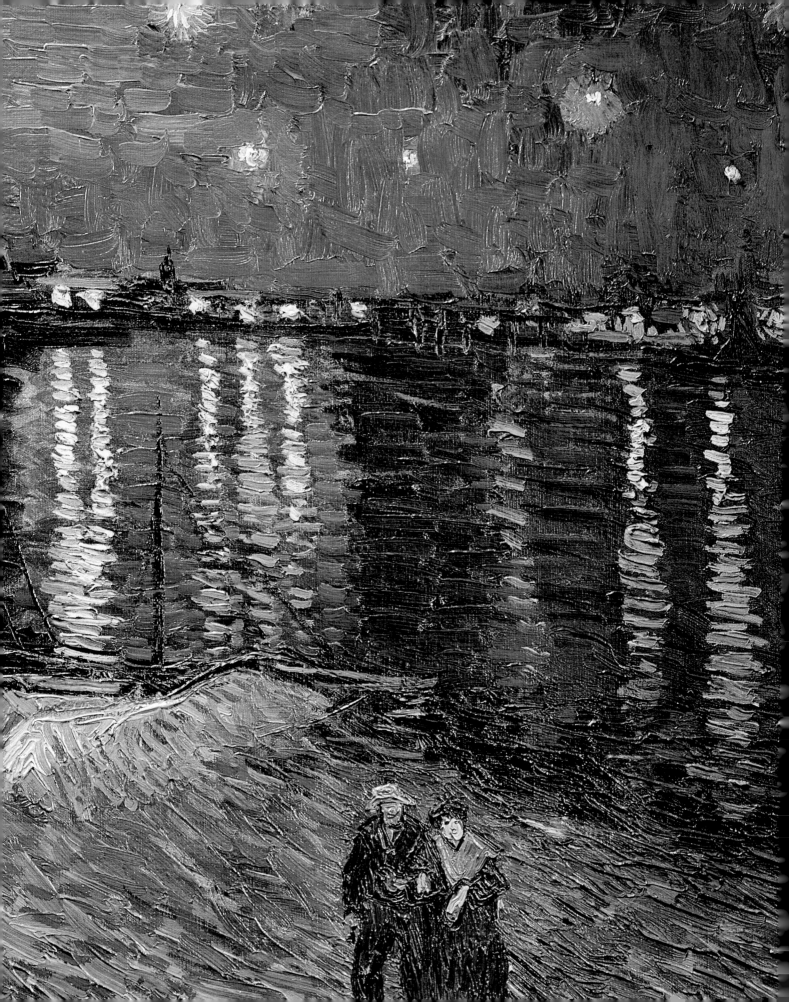

Contents

In Search of Van Gogh

To search for Van Gogh means to retrace his actual, physical path to the mental states that inspired his art. It means to take our understanding of art and geography and apply it to what we know of Vincent's feelings and musings on life, art, books, and authors—all found in a vast collection of letters he wrote between 1872 and 1890: 820 in all, 658 of which were addressed to his brother Theo. These letters contain a treasure trove of surprises, and since 2009 we've been lucky enough to have access to them through a wonderful six-volume edition published online.[1]

Research for *In Search of Van Gogh* started in 1990, when two talented photographers, Danilo De Marco and Mario Dondero, called me from Paris to make a book on Van Gogh. It's not unusual for art historians to reach out to photographers. This time, it was the photographers—two extremely well-read lovers of Van Gogh—who reached out to me. The publishing house for which I worked, and for which I still write, happily accepted the challenge and supported me as I developed and amplified the project with ever more Van Gogh paintings, previously unpublished investigations, and critical analyses. The final product was made all the more beautiful by Danilo and Mario's poetic snapshots.

For months, Danilo and Mario retraced Van Gogh's path on foot or by train, traveling just as Van Gogh had. They followed him from Holland to England and on to Belgium and France—they were with him every step of the way. They wanted to use the magic of photography to re-create what Vincent had imagined onto canvas: a tall order that could easily have turned into a banal location-to-painting comparison. We needn't have worried: Danilo and Mario's photographs became even more captivating when set against Van Gogh's paintings. It was a promising start.

I was thrilled to reread Van Gogh's letters after studying him for so long. In 1990, few of them had been translated into Italian, and now I could also use Danilo and Mario's photographic talents to contextualize them. I followed them into the field during the last phase of their project and worked with them to choose the "right" snapshots for the book. The black-and-white proofs on the chapter openers illustrate our selection process: the markings indicate which photos we wanted to include in the chapter introductions.

The more scrupulous scholars of Van Gogh have long known that the man cannot be reduced to "all genius and madness." Retracing his steps thus allows us to reaffirm a self-evident truth—that the myth of Van Gogh's "cursed" existence may be hard to kill but is ultimately unfounded (Jaspers 1951). Van Gogh was a learned artist and an avid reader. He knew how the art market worked. Some of his paintings were exhibited in Paris while he was still alive, and a talented young critic, George–Albert Aurier, who knew Vincent personally, wrote an impassioned article about him. No small thing, for those times (Aurier 1890). But no one had ever

Auvers-sur-Oise (Val d'Oise, Île-de-France) Field of grain.

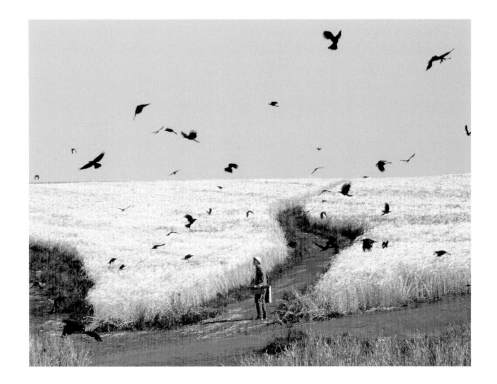

A frame from "Crows," a vignette from the 1990 film *Yume (Dreams)*, by Akira Kurosawa.

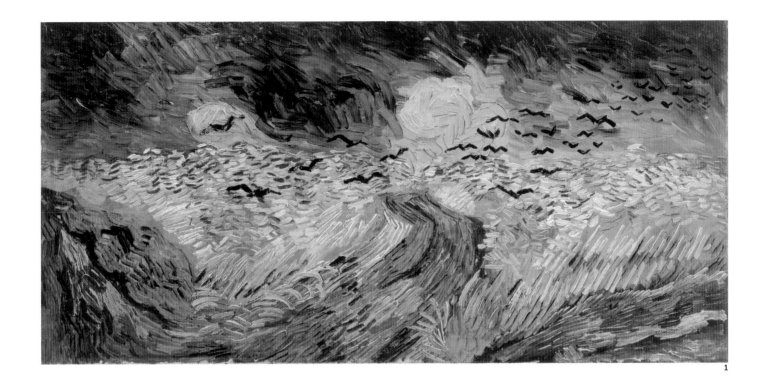

1

Wheatfield with Crows
(Auvers-sur-Oise,
July 1890). Oil on canvas,
51x103cm. Amsterdam,
Van Gogh Museum
(Vincent van Gogh
Foundation). F779/JH2117.

retraced his steps—with such analytical focus and artistic devotion—quite like we did.

Today, it would no longer be possible to photograph these places as Mario and Danilo did. (Mario passed away in 2015, and this book is dedicated to him. Danilo is still working; he does not use digital equipment, and he develops his black-and-white photos himself.)

Online itineraries make it easier than ever to visit Van Gogh landmarks, curtailing the charm of discovery. However, the internet and new renovations also offer new opportunities. Although some locations or buildings are no longer open to the public, others have become available for the first time. In Zundert, the house where Vincent was born now hosts an exhibition space and artists in residence. The Saint-Paul de Mausole monastery and former psychiatric hospital allows visitors to enter through the hall depicted in a famous painting and visit the room where Vincent stayed in 1889. Dr. Gachet's garden in Auvers-sur-Oise is once again full of trees, plants, and flowers, including the notorious purple foxglove—the subject of a new analysis in this book. His house, which Van Gogh described as full of "dark, dark, dark" paintings, brightened by a few Cézannes and Pissarros, is now a museum. When we got there in 1990, we were met with hostility—we weren't even allowed in. But Danilo wasn't deterred. He climbed onto the roof of our car while I tried to distract the custodian, who was suspicious of us and wouldn't leave the window. (This is why I wanted to keep the picture taken from the car, from outside the boundary wall, even though we could have gotten a much better shot today.) Meanwhile, the

Café de la Paix in Auvers has lost its mystique. When we went there for a drink, we spotted a portrait of Kirk Douglas, looking exactly like Van Gogh, hanging among the pictures of former patrons.

Other places have remained intact: in the Auvers cemetery, ivy still covers Vincent's and Theo's adjoining tombs, while the Auberge Ravoux is a house-museum. Visitors can climb the stairs to Vincent's narrow room, where he spent his last hours wounded and in pain. Old windmills still dot the moors of the Brabant. The port of Antwerp is still bursting with life, just as Van Gogh described it in 1886—though with the addition in 2016 of a futuristic building designed by star architect Zaha Hadid shortly before her untimely death. In Paris, where Montmartre is always Montmartre, my beloved Les Fusains—an enchanting and quiet artists' retreat—is off-limits to the public.

Each of Van Gogh's former residences has become a tribute to the artist. The prestigious Van Gogh Museum in Amsterdam—now the Vincent van Gogh Foundation—has expanded and modernized its spaces. When in Auvers, it still feels natural to imagine yourself inside a Van Gogh painting as you walk in silence through a field of grain. Akira Kurosawa did just that, thirty years ago—only a few weeks before we did, though we didn't know it at the time. He literally went inside a Van Gogh painting and reconstructed it in a studio to create a beautiful, pioneering short film (full-immersion 3D renderings are common in moviemaking today).

As I write these words now, I see Van Gogh, his work, and the places he inhabited in a new light compared to thirty years ago. Retracing his steps pushed me to explore new directions. For example, I now believe—as do a number of American astrophysicists—that the Whirlpool Galaxy, or M51, discovered in 1773, was the real inspiration behind his iconic *The Starry Night* (1889). Vincent was painting the stars or "a group of lively friends," as he liked to call them—real stars. This is why I know that—aside from his illness, which I won't address—"there are no ghosts in Van Gogh's paintings, nor are there hallucinations," as Antonin Artaud put it (Artaud 1947).

Vincent's artistic journey was both mental and physical: ruthless and painful introspection drove his love of nature and people, sometimes to the point of self-destruction. The more we understand his world, the richer and more complex it becomes. This book follows Vincent's guidance: "Do go on doing a lot of walking and keep up your love of nature [. . .]. Painters understand nature and love her and *teach us to see*." (London, January 1874. To Theo.)

1 The full collection of Van Gogh's letters, including critical annotations and illustrations, is the result of fifteen years of research by the Van Gogh Museum in Amsterdam in collaboration with the Huygens Institute for the History of the Netherlands in The Hague (Jansen, Luijten, Bakker 2009). The collection is online at www .vangoghletters.org.

Auvers-sur-Oise (Val d'Oise, Île-de-France) The Café de la Paix before renovations, when it still had a mural inspired by the 1956 movie *Lust for Life*, directed by Vincente Minnelli and starring Kirk Douglas in the role of Van Gogh.

Traveling, Van Gogh—Style

(1990)

It's hard to shake Van Gogh's overwhelming presence, especially after seeing the places he visited during his brief and dramatic life. His bitter, sometimes excruciating existence was marked by deep suffering but enriched by a formidable imagination, whose wild and restless wandering energized impressionism and propelled him to the forefront of Western art.

One hundred years have passed since the funeral procession carrying the man "suicided by society" (as Antonin Artaud put it) turned onto the cemetery road in Auvers-sur-Oise. One hundred years for the memory of Van Gogh to loom ever larger in the public consciousness. In a cruel twist of fate, his work ended up fetching astronomical prices, with some pieces landing in private collections. Nevertheless, his art is now displayed in many museums, and even the most modest pieces are available in hundreds of different formats. His art reached into people's hearts, just as he'd intended. Vincent believed, without a hint of arrogance and even in moments of dark desperation, that one day the world would see him. "Painters—to take them only—speak to the next generation or to several succeeding generations through their work." (Arles, July 1888. To Theo.)

In a way, Vincent was not unlike Don Quixote. He was a wanderer. As was our team: art historian Gloria Fossi, and Danilo De Marco and myself as photographers, retraced his steps, often literally walking the same rustic paths in old Holland or trudging through the olive groves of Provence, as the old painters had.

Either out of necessity or for the pleasure of merging with nature, Van Gogh traveled long stretches on foot. We did likewise, often stopping at the same country taverns he stayed in, when he wasn't sleeping under the stars. We walked across rural Holland, where Vincent spent his youth and difficult homecomings. We saw his native Brabant and the Drenthe of his luminous skies. We experienced the dark Borinage and the rough-and-tumble art world of Montmartre. We journeyed from the Provence of sadness and of immortal artworks all the way to Auvers, in the Île-de-France, the scene of his last act. Many of these places, especially the urban ones, have changed quite a bit. Some are completely gone. But in many cases, the past century hasn't completely destroyed the old charm: at Scheveningen, the famous beach near The Hague, it's still possible to get lost in the dunes where Vincent set up his easel and conversed with Anton Mauve. In the Borinage, there are almost no "miners in the snow at dawn": the scourges of firedamp and silicosis have moved on. The mountains of debris, the black *terrils*, are now gentle hills smiling in the sun.

Arles is always beautiful in the sun. The view from Montmajour looks onto landscapes like marvelous Van Goghs. The Saint-Paul de Mausole asylum still embodies its stark past. Not much has changed in Antwerp, either, including the Academy of Fine Arts and the ZNA Stuivenberg Hospital, which still takes in the Siens, the "little sisters," who bring comfort to the desperate from behind the windows of the red-light district. In Drenthe, peat is no longer the main currency (it can be seen only at Veenpark, in Barger-Compascuum), but the atmosphere of times gone by lingers on.

One rainy night, on a half-empty bus from Zweeloo to Hoogeveen, we thought we'd met Van Gogh himself in the form of a bony, blond young man with feverish eyes. He kept us entertained with a long monologue. At the next stop, he disappeared into the night.

Mario Dondero

2

The Painter on the Road to Tarascon (Arles, July 1888). Oil on canvas, 48x44cm. Magdeburg, Kaiser-Friedrich Museum, destroyed during World War II. F448/JH1491. The painting was destroyed in 1944 in Magdeburg, Germany.

It's easy to take a trip these days, especially an organized one. It's not so easy to travel off the beaten path.

But that was Van Gogh. He abandoned the conventional routes that might have led him to an ordinary life—he could have been a more orthodox clergyman, a family patriarch, or even a painter but a more sensible one, maybe with some eccentric traits but nothing out of the ordinary. He might have been respectful and respected in his day.

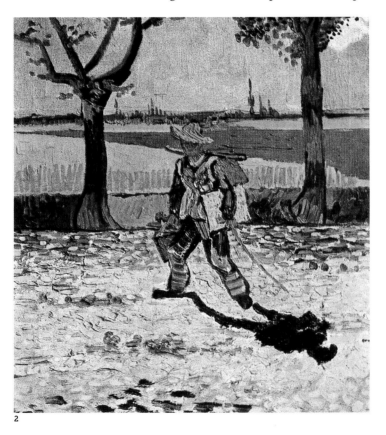

2

None of this came to pass. He made himself the poorest of the poor, rescued a pregnant prostitute and her daughter from the street and built a home with them, if only briefly. He visited brothels, where he probably received the only tenderness he ever knew.

In this spirit we set out toward such places, often on regional trains or half-empty buses, avoiding the well-worn paths and seeking in ourselves the same courage "beyond time" and "beyond measure" that characterized Van Gogh's life.

We weren't looking for a neat little package. We wanted our photography to express and interpret an existential sense of flux, the conditions that tie places to people and people to one another. We pursued every event that piqued our interest, trying to see it from every possible angle. We stayed in constant motion. We discovered cities, countries, landscapes, and human insights and behavior. We were driven by a childlike curiosity that defied complacency and rigidity.

Van Gogh led a heroic existence. He used his last blinding blaze of light to find catharsis and redemption. But that same blaze ultimately warned of the dying of the light. The geography of the mind was Van Gogh's battleground: he painted himself and others almost maniacally, until his suffering began to slip through the bounds of his mind and into his soul. His subjects are bewildered men looking out on a world they don't recognize and can't reach. Harsh reality overwhelms them, overpowering even their closest bonds. We wanted to remain faithful to this message.

We dove headlong into our search. We wanted to find the key to how one man can produce such an infinite, heartbreaking, and universal melody. We wanted to respect the places, the silences of spaces, the passing of time, and the internal drives of the men and women Vincent chose to capture, in all their simplicity. This was the only way to undertake a meaningful journey—the only way to tell our story.

Danilo De Marco

Vincent's Roots

1853–1876

From Zundert to The Hague

1853–1873

A baby boy was born on March 30, 1852, in Zundert, a village of about one hundred souls in North Brabant, a melancholy stretch of moorlands on the border with Belgium, less than thirty miles from Antwerp. They named the baby Vincent, but he was stillborn and was buried in the small reformed-church cemetery in Zundert. His father, the Protestant minister Theodorus van Gogh—born in Breda in 1822 and assigned to the parish in 1849—officiated. One year later to the day, on March 30, 1853, Theodorus's wife, Anna, gave birth to another baby, this one healthy. Again he was named Vincent: the future painter would forever be tied to the memory of his dead brother. The Van Gogh

family was tight knit, and it grew to six children. There were three girls and three boys: Anna (1855), Theo (1857), Lies (Elizabeth, 1859), Wil (Wilhelmina, 1862), and Cor (Cornelius, 1867). All of them, along with their mother, outlived Vincent, who died in Auvers-sur-Oise in France on July 29, 1890. (His father died in 1885.) Theo, who was especially close to Vincent, died the following year, at the age of thirty-four.

The Van Gogh family wasn't originally from Zundert. They were from The Hague, where family members had excelled in goldsmithing, theology, and art dealing since the eighteenth century. By tradition, there was always a Vincent in the family, at least starting with the son of David van Gogh, a gold wire–drawer. That Vincent was born in The Hague in 1729 and worked as a sculptor, in Paris and elsewhere. The artist's paternal uncle (born in 1820) was also named Vincent, though his family called him Cent. He ran an art gallery in The Hague, where his namesake nephew would later work as an apprentice. Cent and his brother Theodorus were quite different from each other but very close. They shared a strong thirst for knowledge, and both even married women from the same family in The Hague: the Carbentus sisters, daughters of a bookbinder to the Dutch court. Cent was a talented entrepreneur, and Theodorus often went to him for career advice for his elder boys, Vincent and Theo.

In short, the Van Goghs were close, traditional, and devout. Vincent stayed in touch with family throughout his life, even though his father's rigid way of thinking led to a widening rift between them. But he remained close to his mother and siblings until the end, despite occasional squabbles and time apart. They all knew that he was the fragile one, the one who needed the most care and attention.

The six young Van Goghs grew up in the Brabant (as an adult, Vincent liked to call himself a child of the Brabant). The moors, the dark earthen paths, the fields of heather, and the "smoky, foggy" atmosphere were his world. He loved the thatched-roof farmhouses and the black, sandy roads battered by the wind. He went back to them again and again, even while complaining that modern life had managed to reach even there, changing the landscape beyond his liking. We know from his letters, and from the memoir his sister Elizabeth published in 1910, that Vincent was a solitary boy who liked to take long walks through the moors. He came to know the migratory patterns of birds, and if two skylarks alighted in a field of rye, he was happy to watch them in perfect silence, "without even breaking a blade of grain." He studied beetles with their "glossy backs" in their natural habitat, then gathered them for cataloging. Insects with impossible names: "he knew them all."

Later, as a twenty-nine-year-old in The Hague, he would say that drawing "is the foundation of all the rest." It's a natural statement, given his knowledge of history and art (and very likely drawn from Florentine Mannerist thinkers of the sixteenth century, like Pontormo). According to Lies, when Vincent was a child, he fashioned an elephant out of clay. When he was eight, he showed his mother "the sketch of a cat climbing the apple tree in the garden with a wild leap." His grades were not great, though, and after attending school in Zundert in 1861, he was given a private tutor. In 1864 he enrolled in the reformed college in Zevenbergen, twenty miles from his village. In 1866 he moved on to the technical institute in Tilburg.

It's no surprise that this sensitive child suffered from being apart from his parents. "I stood on the steps at Mr. Provily's, looking after your carriage on the wet road; and then of that evening when my father came to visit me for the first time. And of that first homecoming at Christmas!" In two different instances, he was back in the family fold: In 1873 he followed them to Helvoirt, and in 1876 he joined them in Etten. However, by 1869, a sixteen-year-old Vincent had already moved to The Hague to work for his uncle and remained there until 1873. He worked at the Goupil & Cie Gallery, which his uncle Cent had passed on to Hermanus Gijsbertus Tersteeg, who is mentioned in several letters. Theo stayed with Vincent between August and September 1872. The brothers began their lifelong correspondence shortly after that.

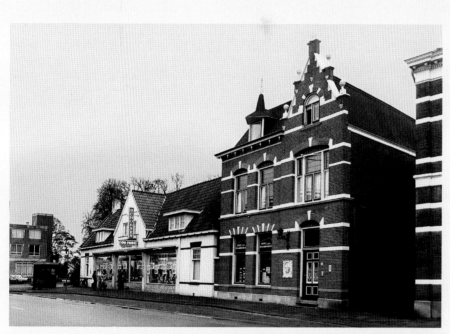

Zundert, Markt 26–27
The building was constructed in 1903, after Vincent's place of birth was demolished. Seen here in 1990, before renovations.

Zundert (1853–1864)

In Vincent's day, the steam-powered train had caused Zundert to lose its status as an important postal station. Today, its population of about twenty thousand keeps Vincent's memory alive. Once a year, on the first Sunday of September, the town comes to life with a colorful flower parade, the largest in Holland and among the most famous worldwide.

Zundert (North Brabant, the Netherlands) A parade in the Zundert central square: behind the carriage, in the background, stands the Protestant church rectory where Vincent and his siblings were born. This photo was taken in 1901.

Zundert, Markt 26–27 Today, the building that replaced Vincent's birth home in 1903 now hosts the Van Gogh Huis as well as a permanent exhibition on Vincent's childhood in Zundert and its surroundings—a testament to his family and its relationship with the town. The house also provides accommodation for young artists in residence and an exhibition space for contemporary art that relates in some way to Van Gogh's work.

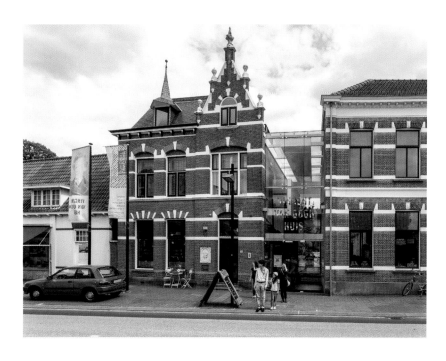

We think Vincent first experienced his love of nature in the family garden, a lush plot located behind the rectory (where tables are now available to visitors). In her childhood memoir, Lies described the garden, the vegetable patch, and the fields that extended into the countryside beyond the hedge: "Expanses of marigolds, roses and deep red geraniums shone beneath the setting sun. Everything was in full bloom, thirsting in that hot, late August afternoon. The sheets, white as snow, were drying on the lawn behind the flowerbeds [. . .]; then came rows upon rows of fragrant berry bushes. The whole garden was surrounded by a line of beech trees that delineated the fields of rye and grain stretching as far as the eye could see." (Du-Quesne Van Gogh 1910, p. 10)

Beyond the House, between the Church and the Fields

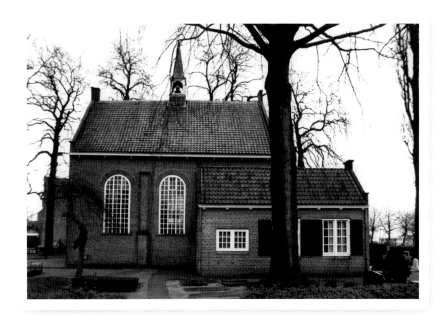

Zundert (North Brabant, the Netherlands) The Protestant church where Vincent's father, Theodorus van Gogh, was employed. Vincent was baptized here.

As an adult, Vincent sometimes used the small church cemetery to meditate. In the spring of 1877, he took the train from Dordrecht and then walked more than seven miles through the night to get there:

Saturday night I took the last train from Dordrecht to Oudenbosch, and walked from there to Zundert. It was so beautiful on the heath; though it was dark, one could distinguish the heath and the pine woods and moors extending far and wide [. . .]. The sky was overcast, but the evening star was shining through the clouds, and now and then more stars appeared. It was very early when I arrived at the churchyard in Zundert; everything was so quiet. I went over all the dear old spots, and the little paths, and waited for the sunrise there.

(ETTEN, APRIL 8, 1877. TO THEO.)

Zundert The grave of Vincent van Gogh, the artist's stillborn sibling, born on March 30, 1852.

Zundert Country road.

Vincent would take these paths to wander off. Much later, he told his friend the painter Anthon van Rappard that the mysterious charm of the Brabant was gone, forever lost to modernity:

I remember as a boy seeing that heath and the little farms, the looms and the spinning wheels in exactly the same way I see them now in Mauve's and ter Meulen's drawings. But since then that part of Brabant with which I was acquainted has changed enormously in consequence of agricultural developments and the establishment of industries. Speaking for myself, in certain spots I do not look without a little sadness on a new red-tiled tavern, remembering a loam cottage with a moss-covered thatched roof that used to be there. Since then there have come sugar-beet factories, railways, agricultural developments of the heath, etc., which are infinitely less picturesque. It can't be helped—but what is sure to remain is something of the stern poetry of the real heath.

(THE HAGUE, AUGUST 13, 1882.
TO ANTHON VAN RAPPARD.)

Zundert View of the village and town hall.

Portrait of the Artist's Mother

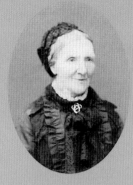

How is Mother these days? I often think of you both, and it is from the bottom of my heart that I give you my best wishes.
(Arles, July 31, 1888. To Wil.)

Anna Cornelia van Gogh-Carbentus (1819–1907) was a middle-class woman. She was simple, not pretty, but very bright, as we'd guess from the painting on the opposite page—the only finished portrait of a family member.

I can't look at the colorless photograph. Vincent painted this portrait based on a black-and-white photograph of his elderly mother. He'd asked his sister Wilhelmina (Wil) to give it to Theo in Paris, who then sent it to him (Arles, September 9–14, 1888). Vincent was glad to receive the photo "because you can see that she is well, and because she still has a very lively expression." (Arles, September 21, 1888. To Theo.) Nevertheless, the black-and-white tones made her expression look too "ashy." So he painted her, hoping to do the same for his father if he ever received a photo of him. On October 8, 1888, he told Theo, "I am doing a portrait of Mother for myself. I cannot stand the colorless photograph, and I am trying to do one in a harmony of color, as I see her in my memory." (Arles, October 8, 1888. To Theo.) His mother's face stands out from the green background of the canvas, just like Vincent's face in the self-portrait he'd made a few days before, in which he had imagined himself as an ascetic, like a "bonze." There is a marked physical resemblance between mother and son, which family members often pointed out.

A modest painter of flowers. Van Gogh later told his sister that he didn't love how the portrait had come out. Nevertheless, it successfully conveys Vincent's love and affection for his mother, who had always cared deeply about her son's well-being, even from afar. A modest painter of flowers herself, she was the first to spot Vincent's precocious talents. She was also the only one to take notice of his drawing of an angry cat, made when he was eight (Du-Quesne Van Gogh 1910, p. 13). Anna survived her son and died in 1907, at the age of eighty-eight.

Anna van Gogh-Carbentus, Vincent's mother, in a photo taken in The Hague around 1888. This vintage photograph is shown in a mirror image: we believe that Vincent held the photo to a mirror as he painted (a common tactic among artists), to give the image a greater likeness to its subject.

3

3
Self-Portrait (Dedicated to Paul Gauguin) (Arles, September 1888), detail. Oil on canvas, 61.5x50.3cm. (Full portrait fig. 73, p. 164.) Cambridge, Harvard Art Museums/Fogg Museum. F476/JH1581.

4
Portrait of the Artist's Mother (Arles, October 1888). Oil on canvas, 40.6x32.4cm. Pasadena, Norton Simon Museum of Art. F477/JH1600.

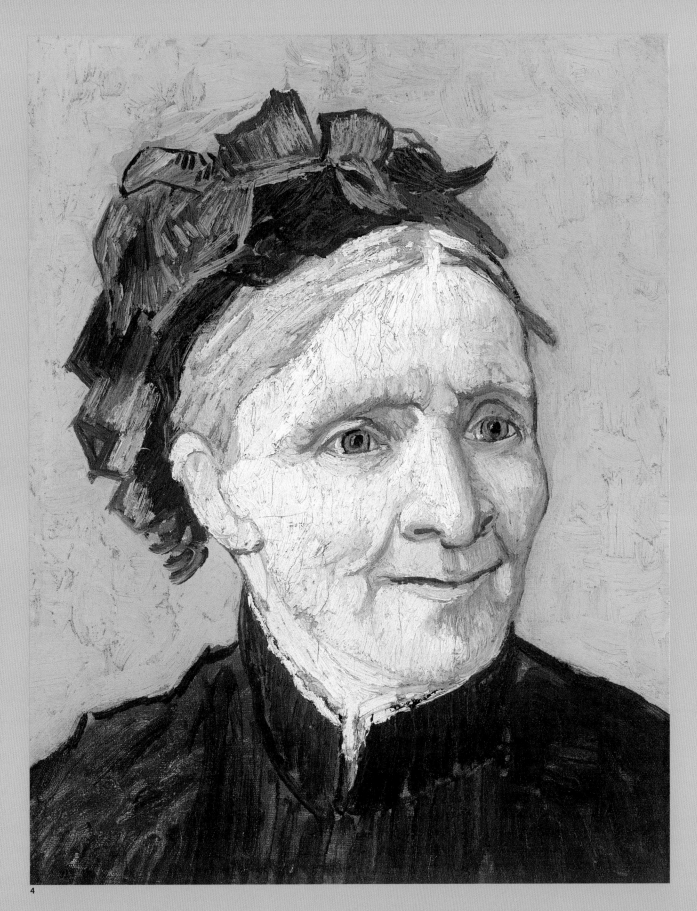

4

From Zevenbergen to Tilburg and Back to Zundert
October 1, 1864–March 19, 1868

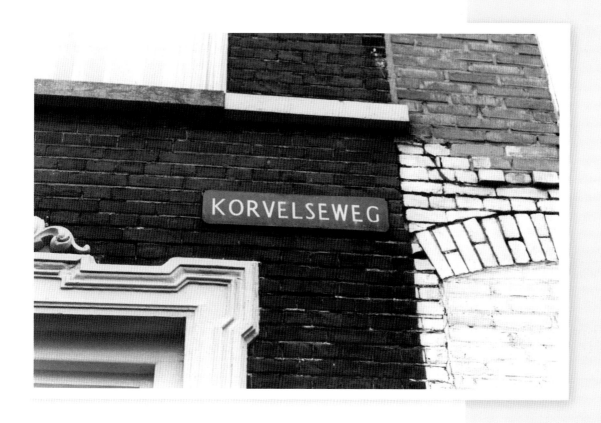

Tilburg (North Brabant, the Netherlands) The Korvelseweg street sign.

Tilburg A glimpse of the town center.

While recovering from the wound to his ear, Vincent remembered:

During my illness I saw again every room of the house at Zundert, every path, every plant in the garden, the views from the fields round about, the neighbors, the graveyard, the church, our kitchen garden behind—down to the magpie's nest in a tall acacia in the graveyard. It's because I still have earlier recollections of those first days than any of the rest of you. There is no one left who remembers all this but Mother and me.

(ARLES, JANUARY 22, 1889. TO THEO.)

A new discovery This photograph was found in 1957 and identified by Marc Edo Tralbaut as Vincent at thirteen. Scholars used this interpretation until 2018, when the Van Gogh Museum in Amsterdam officially declared that the photograph was taken around 1873 in Brussels, in the studio of Balduin Schwarz. This means the boy couldn't have been Vincent. It must have been Theo, who was younger but still the spitting image of Vincent.

After two years at the Jan Provily Protestant school in Zevenbergen (October 1864 to August 1866), Vincent went to study in Tilburg, twenty miles from Zundert. Between 1866 and 1868, he struggled through lessons at the Hogere Burgerschool technical institute at Korvelseweg 57. All he wanted to do was paint. During a financial rough patch, his father took the boy out of school on March 19, 1868, effectively ending his formal education.

Years after Vincent's death, his sister recalled the games she and the other younger siblings played in the garden behind the house, and how their older brother would arrive suddenly from the fields. He was an introverted and solitary child, as strange to his siblings as they were to him:

"The old house loomed behind them, with its long line of windows, deep green shutters [. . .]. The [elder] was in search of solitude, not the company of his family [. . .]. He was gangly and slightly hunched over, and had the bad habit of dangling his head. His straw hat concealed his short, reddish hair. His face was strange, not young, his forehead already wrinkled, his eyebrows already creased with thoughts. His small, deep set eyes would change from blue to green. But his clumsy manner belied a certain greatness, with clear hints of an intense interior life [. . .]. He knew where the rarest flowers grew." (Du-Quesne Van Gogh 1910, p. 10)

The Hague: Vincent's First Job
July 30, 1869–January 6, 1873

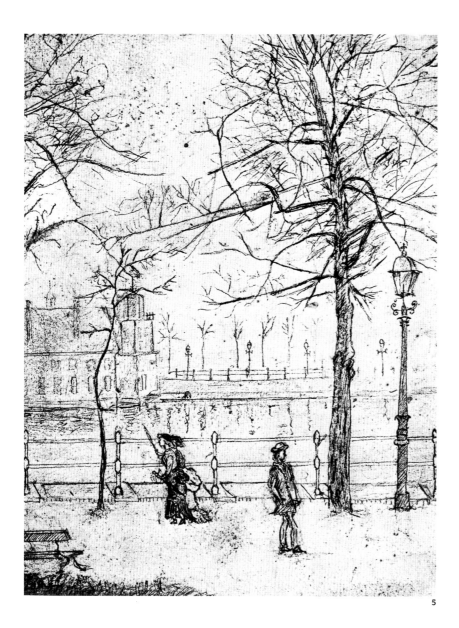

5

5

Sketch of Het Binnenhof (The Hague, spring of 1873). Pencil, pen, and ink on paper, 22.2x16.9cm. Amsterdam, Van Gogh Museum (Vincent van Gogh Foundation). FXIV/JHjuv.

During a rainy September in 1872, Vincent received a welcome visit from his brother Theo:

Many thanks for your letter, I was glad to hear you arrived home safely. I missed you the first few days and it felt strange not to find you there when I came home in the afternoons. We have had some enjoyable days together, and managed to take a few walks and see one or two sights between the spots of rain.

(THE HAGUE, SEPTEMBER 29, 1872. TO THEO.)

Uncle Cent gave Vincent his first job: as a clerk at the Dutch branch of the Goupil Gallery, a Parisian outfit that specialized in the sale of prints. Vincent started to draw his first sketches in The Hague, home of the royal court. He sketched a glimpse of Hofvjiver (the "court pond"), which is now accessible by bicycle.

My New Year began well; they have granted me an increase of ten guilders (I therefore earn fifty guilders per month) [. . .]. Isn't that splendid? I hope to be able to shift for myself now. [. . .] The beginning is perhaps more difficult than anything else, but keep heart, it will turn out all right.

(THE HAGUE, JANUARY 1873. TO THEO.)

The Hague (the Netherlands)
The Court Pond.

Memories of Etten
March 31–April 14, 1876

In 1875, Vincent's father was transferred to Etten, some twelve miles from Zundert. He and Anna lived there until 1882. Theo and Vincent were away working but met there during vacations. Meanwhile, Vincent had moved from London to Paris, but he was staying in Etten between March 31 and April 14, 1876. Theo joined him from The Hague:

Do you know that I will first go to Etten, save for something unforeseen? I think I will leave the 1st April, perhaps even the 31st March. Our parents have written me that you also intend to come to Etten. When do you leave? I hope to have the opportunity to send you the Longfellow before your departure; it is perhaps a good book for a journey. My hour approaches: just three more weeks. Now and then I have to remind myself, "Be patient and meek."

(Paris, March 15, 1876. To Theo.)

Vincent had not yet given himself to painting. He drew the church and the presbytery where his parents now lived. Then he returned to England and moved to Ramsgate. But he missed home:

These first hours after our parting—which you are spending in church, and I at the station and on the train—how we are longing for each other and how we think of the others.

(Ramsgate, April 17, 1876. To his parents.)

6

Parsonage and Church in Etten (Etten, April 1876). Pencil, pen, and ink on paper, 9.5x17.8cm. Amsterdam, Van Gogh Museum (Vincent van Gogh Foundation). FXXI/JHjuv06.

6

Etten-Leur (North Brabant, the Netherlands) This village in the Dutch Brabant is now home to more than forty thousand people. The Protestant church is in the background; the rectory did not survive.

7

Memories of the Garden in Etten
(Arles, November–December 1888).
Oil on canvas, 73x92cm.
Saint Petersburg, Hermitage.
F496/JH1630.

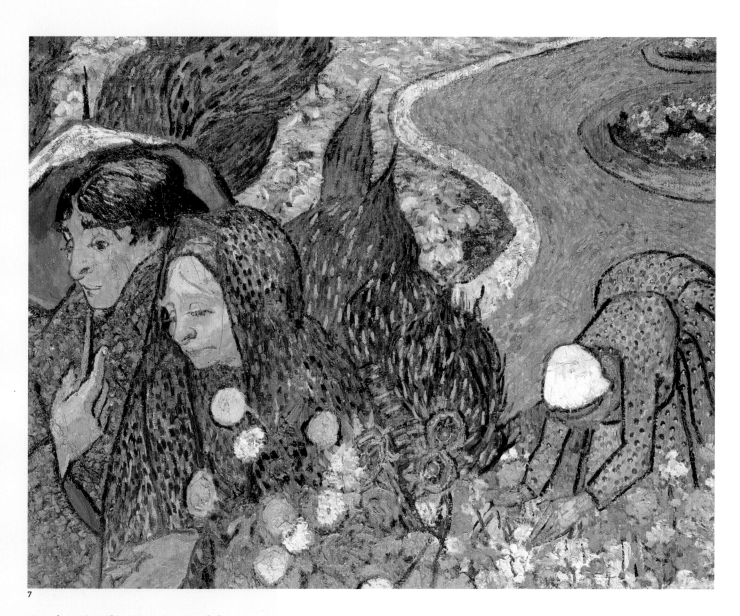

7

Years later, in Arles, Vincent painted the garden in Etten as if it were a dream. Two women are in the foreground.

[...] The bizarre lines, purposely selected and multiplied, meandering all through the picture, may fail to give the garden a vulgar resemblance, but may present it to our minds as seen in a dream.
(ARLES, NOVEMBER 12, 1888. TO WIL.)

Some believe that the brunette with the red-and-white umbrella is a romanticized image of Wil. If this is true, the older woman could be his mother. But the young woman also looks like Madame Ginoux, the "Arlésienne" (fig. 81–84, pp. 174–176). Around the same time,

that same face appeared in at least two of Paul Gauguin's paintings, *Night Café at Arles* (p. 176) and *Old Women of Arles*, now at the Art Institute of Chicago. The pointy hedge behind the two women seems to evoke a dream version of the Etten bell tower, as seen on the opposite page.

England, a Magnificent Country

May 19, 1873–December 19, 1876

On May 19, 1873, Vincent moved to London to work for the British branch of the Goupil Gallery at 17 Southampton Street. The gallery entrance opened onto a vital artery bursting with life: the market stalls of Covent Garden, the bookshops of the Strand, the Royal Opera House, and the National Gallery were all within striking distance.

London was a metropolis of more than three million people, the largest in the world at the time, and Vincent complained about the high cost of living (he paid eighteen shillings per week in rent alone). But he was earning good money—ninety pounds a year, a lot for a man his age. London factory workers made a quarter of that amount. Vincent's father also

8

The House on Hackford Road (London, 1873–1874). Pen on paper, 12.2x16.6cm. The sketch is a rare visual representation of Van Gogh's first London lodgings. It depicts the Victorian facade of the Loyer house, where Vincent lived on the fourth floor between 1873 and 1874. The sketch was discovered in 1972 among Loyer family documents and returned to Van Gogh's estate after a thirty-year loan to the Van Gogh Museum in Amsterdam.

earned less. We don't know the precise location of Vincent's first apartment in London. We do know that his two landladies bred parrots, and that Vincent liked living there. "There are also three German boarders who are very fond of music, they play the piano and sing, so we spend very pleasant evenings together." (London, June 13, 1873. To Theo.)

In his spare time, Vincent explored the countryside, which moved him to declare that England was a magnificent country, "quite different from Holland or Belgium." He loved the "parks with high trees and shrubs." He also took long walks in the city.

Initially he was in no hurry to visit museums and galleries. He wanted first to absorb English culture, perfect the language, and read its literary heavyweights—Shakespeare, Dickens, George Eliot. His visual understanding of art had so far been mainly informed by Rembrandt and the Dutch masters of the 1600s. He also loved the teachings of the Barbizon school, and he collected the art of French painters like Daubigny, Millet, and Corot, and of Dutch painters of the Hague school, like Jozef Israëls and Anton Mauve, whom he would later meet.

When he finally visited the Royal Academy in August, he saw the portraits of Gainsborough and the landscapes of John Constable and William Turner. Three years later,

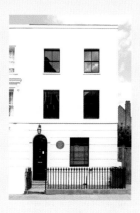

London, 87 Hackford Road
Mrs. Loyer's house was renovated and opened to the public in March 2019 as a residence for young artists and a venue for cultural events.

while working as a Protestant minister in Isleworth, he would deliver a sermon inspired by the painting of a lesser-known artist, George Henry Boughton.

Meanwhile, high prices led Vincent to change his lodging. At the end of August, he moved to 87 Hackford Road in Brixton, south London. His landlady, Ursula Loyer, was the widow of a Protestant pastor. She managed a small nursery school on the ground floor with her nineteen-year-old daughter Eugenie. Vincent was comfortable with the Loyer ladies. He was especially happy about his bedroom on the fourth floor: finally a room of his own, "without a sloping ceiling and without blue wallpaper with green fringes."

He soon made friends. He spent a "glorious" day boating on the Thames with two Englishmen. He admired the hawthorns and flowers in the gardens, and the "magnificent" chestnut trees. He wished that Theo would visit: "I'm finding it very pleasurable taking a look at London and the English way of life and the English people themselves," he wrote. "I also have nature and art and poetry, and if that isn't enough, what is?" He still loved the Brabant and The Hague dearly. He contemplated art and nature—and women, too. He told Theo that a man and a woman can become one, that is, "one whole and not two halves." He may have been influenced by his unrequited love for Eugenie Loyer. Nothing came of that: Eugenie got engaged to Samuel Plowman, another lodger, and Vincent's love turned to bitterness.

During this time, Vincent's sister Anna came to stay with him, but in August 1874, they suddenly left the Loyer house. The reason remains a mystery. It's possible that Vincent had one of his first nervous breakdowns. What we do know is that Vincent and Anna moved to Kensington Road (City of Westminster, Borough of Lambeth), close to the beating heart of London. Their new landlord was a man named John Parker. Anna, who was teaching in Welwyn, later went to live in the old Rose Cottage. In October, Vincent went to Paris before briefly returning to London.

In May 1875, Vincent was back in Paris, working at the Goupil Gallery, but he was fired a year later. These were turbulent times. He faced disappointment and uncertainty. After a whirlwind series of moves, Vincent returned to England to teach French in Ramsgate, a picturesque coastal village. Operated by William Port Stokes, a teacher and Protestant minister, the school numbered twenty-four children between the ages of ten and fourteen.

In his room, a few steps from the school, Vincent covered his walls with prints by his favorite artists. He was strongly drawn by the school's window and its view of the sea, which led him to reflect on childhood, family, and faith. He described the window to his brother Theo and depicted it in various paintings. The sea had an effect on him, but mainly he was struck by the color yellow, which was typical of buildings in Ramsgate. Afterward, yellow would take on a fundamental role in Vincent's readings, paintings, and life.

Ramsgate by the Sea
April–June 1876

Ramsgate (Kent, England)
The house at 11 Spencer Square, where Vincent lived from April 17 until the end of June 1876.

That same night I looked out of the window of my room at the roofs of the houses you can see from there, and at the tops of the elms, dark against the night sky. Above the roofs, a single star, but a beautiful, big, friendly one. And I thought of us all and I thought of my own years gone by and of our home, and these words and this sentiment sprang to my mind, "Keep me from being a son who brings shame."

(RAMSGATE, MAY 31, 1876. TO THEO.)

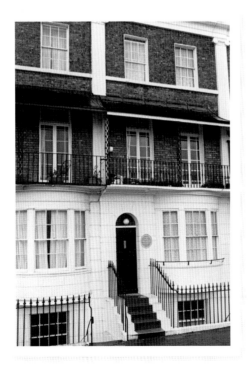

Ramsgate The school at 6 Royal Road, where Vincent taught French.

I arrived here safely yesterday, at about one in the afternoon [. . .]. It is a boarding school, and there are twenty-four boys from ten to fourteen years old.

(RAMSGATE, APRIL 17, 1876. TO THEO.)

Ramsgate A section of the long sandy beach that leads to Pegwell Bay from the port, at the southernmost tip of the village.

Now I am going to tell you about a walk we took yesterday. It was to an inlet of the sea, and the road thither led through fields of young corn and along hedges of hawthorn, etc. Arriving there, we saw to our left a high steep ridge of sand and stone as tall as a two-story house. On the top of it were old, gnarled hawthorn bushes, whose black and gray moss-grown stems and branches were all bent to one side by the wind; there were also a few elder bushes. The ground on which we walked was covered all over with big gray stones, chalk and shells. To the right lay the sea, as calm as a pond and reflecting the light of the transparent gray sky where the sun was setting. The tide was out and the water very low.

(Ramsgate, April 28, 1876. To Theo.)

Ramsgate "A high steep ridge of sand and stone as tall as a two-story house."

A School with a View

Ramsgate (Kent, England)
The road to the sea on a rainy day,
as seen from the school window.

The first thing that struck me was that
the windows of this not so very big
school look out onto the sea.
(RAMSGATE, APRIL 17, 1876. TO THEO.)

I wish you could catch a look out of the
windows of the school. The residence
looks out on a square (all the houses
in this square look the same, it's often
the case here), in the middle of which is
a large lawn enclosed by an iron fence
and lined with lilacs. This is where
the boys play at midday.
(RAMSGATE, APRIL 21, 1876. TO THEO.)

You really ought to have seen it this
week, when we had days of rain,
especially at dusk when the lamps
are lit and their light is reflected in
the wet streets.
(RAMSGATE, MAY 31, 1876. TO THEO.)

9

View of Royal Road Ramsgate
(Ramsgate, 6 Royal Road, May 31, 1876).
Pencil and ink on paper, 6.9x10.9cm.
Amsterdam, Van Gogh Museum
(Vincent van Gogh Foundation). FXXVI.

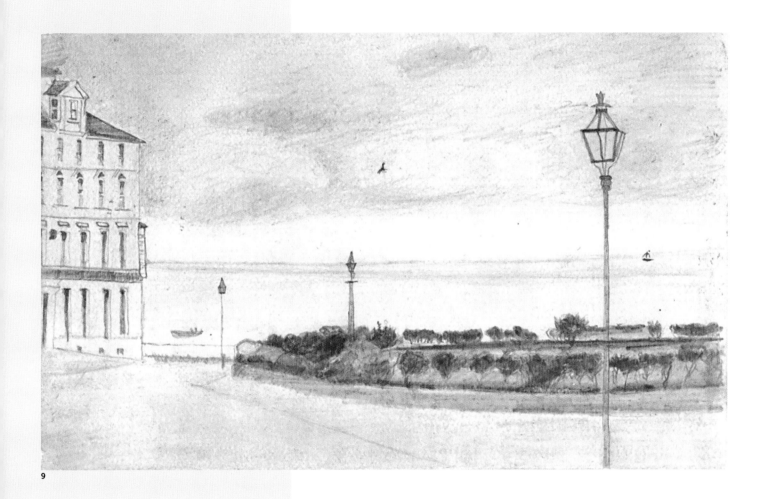

9

Did I write to you about the storm I watched recently? The sea was yellowish, especially close to the shore. On the horizon a streak of light, and above it immensely large dark gray clouds, from which one could see the rain coming down in slanting streaks. [...] in the distance the town, which, with its towers, mills, slate roofs, Gothic-style houses and the harbor below, between two jetties sticking out into the sea, looked like the towns Albrecht Dürer used to etch. [...] Enclosed is a little drawing of the view from the school window through which the boys follow their parents with their eyes as they go back to the station after a visit. Many a one will never forget the view from that window.

(RAMSGATE, MAY 31, 1876. TO THEO.)

Yellow Houses

Ramsgate (Kent, England)
Van Gogh loved these typical yellow houses, with their bow or shop windows surrounded by color. Very few examples remain. There are still some multicolored buildings along the sea.

On the waterfront, most of the houses are built of yellow brick in the style of those in Nassaulaan in The Hague, but they are higher and have gardens full of cedars and evergreen trees of a somber green. Dikes of stone, upon which you can walk, protect the harbor, where all sorts of ships are tied up. Yesterday everything was gray. By and by I shall go and unpack my trunks, which have just been delivered, and I am going to hang some prints in my room.

(RAMSGATE, APRIL 17, 1876. TO THEO.)

Ramsgate "Dikes of stone, upon which you can walk, protect the harbor, where all sorts of ships are tied up." (Ramsgate, April 17, 1876. To Theo.)

Van Gogh Yellow

Van Gogh was struck by Ramsgate's yellow houses. In 1876 he had not yet fully committed to painting, but later this color would permeate most of his descriptions of atmosphere, place, projects, and paintings, to the point of becoming "the high yellow note." To him, the color was both physical and psychological. He would search for it in sunny Provence. He would find it on the covers of his French naturalist novels.

Back in London, yellow was becoming the color of transgression and freedom. It appeared widely on posters, and starting in 1894, after Vincent's death, it was the dominant color in the quarterly journal *The Yellow Book*, published by the illustrator Aubrey Beardsley. The move was a clear nod to authors who were, at the time, considered "licentious," such as Guy de Maupassant, Emile Zola, Edmond de Goncourt and Jules de Goncourt, whose books had yellow covers. And in July 1890, during Vincent's last days, Oscar Wilde published *The Picture of Dorian Gray*, which contained a veiled reference to the character Lord Henry's yellow book.

The Novel Reader. This painting is among Vincent's lesser-known works but is perhaps the most emblematic of his passion for yellow. It has always been kept in private collections, but we know what it looks like: a woman is poring over a novel with a yellow cover; she is literally immersed in the yellow library behind her. It's an intense image. Vincent described it to Wil, whom the reader resembles, as featuring "the luxuriant hair very black, a green bodice, the sleeves the color of wine lees, the skirt black, the background all yellow, bookshelves with books. She's holding a yellow book in her hands." (Arles, c. November 12, 1888. To Wil.) He later described it to his friend Émile Bernard, the painter, as "the Woman Reading a Novel, black against a yellow bookcase." (Saint-Rémy, c. November 26, 1889. To É. Bernard.)

At least eighteen of Van Gogh's paintings depict books with yellow covers, or sometimes baby blue or red covers (Guzzoni 2020). They were mostly Parisian novels popular among the French bourgeoisie. These books constituted a new literary current, *naturalism*, which combined psychological storytelling with the precision of physical science. Van Gogh modeled the young reader after his sister Wil—he wanted her to read those novels and said so whenever he wrote to her. He thought it essential if she were to become a new, modern woman.

10
Still Life with Three Books
[*Braves Gens*, by J. Richepin, 1886; *Au Bonheur des Dames* by E. Zola, 1883; *La Fille Elise* by E. de Goncourt, 1877] (Paris, January–February 1887). Oil on panel, 31.1x48.5cm. Amsterdam, Van Gogh Museum (Vincent van Gogh Foundation). F335/JH1226.

10

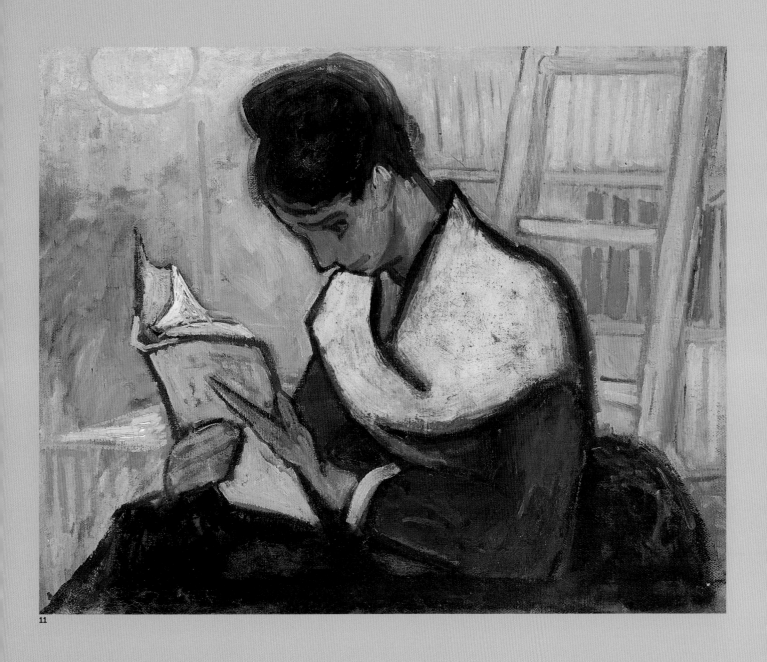

11

11
The Novel Reader (Arles, October–mid-November 1888). Oil on canvas, 73x92.1cm. F497/JH1632.

Simply a Man

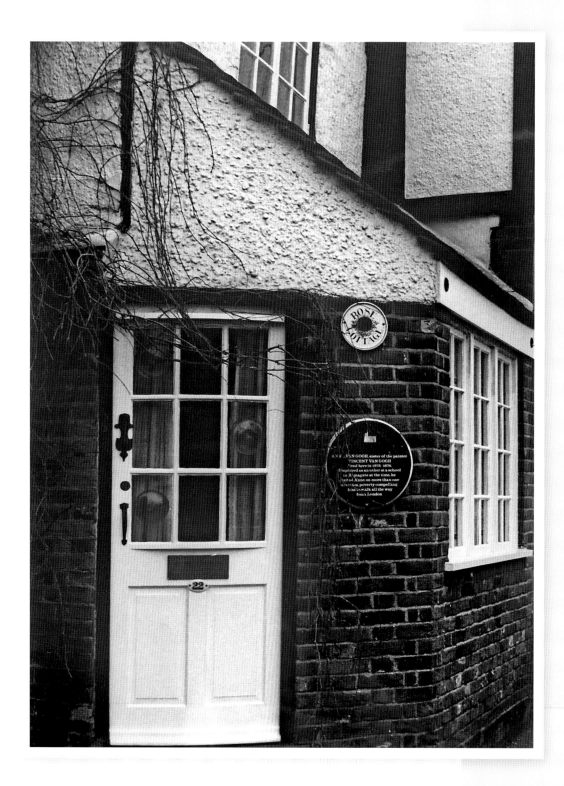

I live a rich life here, "having nothing yet possessing all." At times I am inclined to believe that I am gradually turning into a cosmopolite; that is, neither a Dutchman, nor an Englishman, nor yet a Frenchman, but simply a man.

(LONDON, FEBRUARY 9, 1874. TO CAROLINE VAN STOCKUM-HAANEBEEK.)

Welwyn (Hertfordshire, England)

A plaque marks the ancient Rose Cottage on 22 Church Street in the picturesque village of Welwyn, north of London. Vincent very much admired this house. His sister Anna lived there for a time.

Isleworth (Middlesex, England)

A 1715 building in Holme Court, at 158 Twickenham Road in Isleworth, a blue-collar suburb southwest of London. It housed the school run by Reverend Slade-Jones. Vincent, his assistant, lived in the back, with a view of an acacia tree.

The morning is beautiful, the sunlight falls across the enormous acacias in the courtyard, it lights up the roofs and windows visible beyond the garden. There are already gossamer threads in the garden, it makes the morning fresh and the boys run left and right to warm themselves up.

(ISLEWORTH, AUGUST 26, 1876. TO THEO.)

Welwyn The school where Anna van Gogh taught.

From Isleworth to Richmond, by River
October 29, 1876

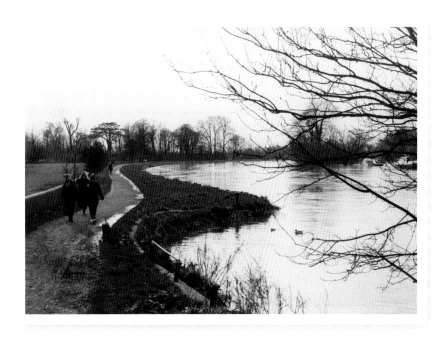

**Richmond upon Thames
(London, England)** The last stretch of the path along the Thames, between Petersham and Richmond.

Richmond The Lock and Weir Bridge, the footbridge over the Thames.

In the last week of June 1876, Vincent left his teaching post in Ramsgate and moved to Isleworth, ten miles southwest of London. He became assistant to Thomas Slade-Jones, a minister. He held his first sermon in Richmond, on October 29, 1876, after taking a 2.5-mile walk along the Thames.

Theo, your brother has preached for the first time, last Sunday [. . .]. May it be the first of many. It was a clear autumn day and a beautiful walk from here to Richmond along the Thames, in which the great chestnut trees with their load of yellow leaves and the clear blue sky were mirrored. Through the tops of the trees one could see that part of Richmond which lies on the hill: the houses with their red roofs, uncurtained windows and green gardens; and the gray spire high above them; and below, the long gray bridge with the tall poplars on either side, over which the people passed like little black figures.

(ISLEWORTH, NOVEMBER 3, 1876. TO THEO.)

Richmond The city on the wide river.

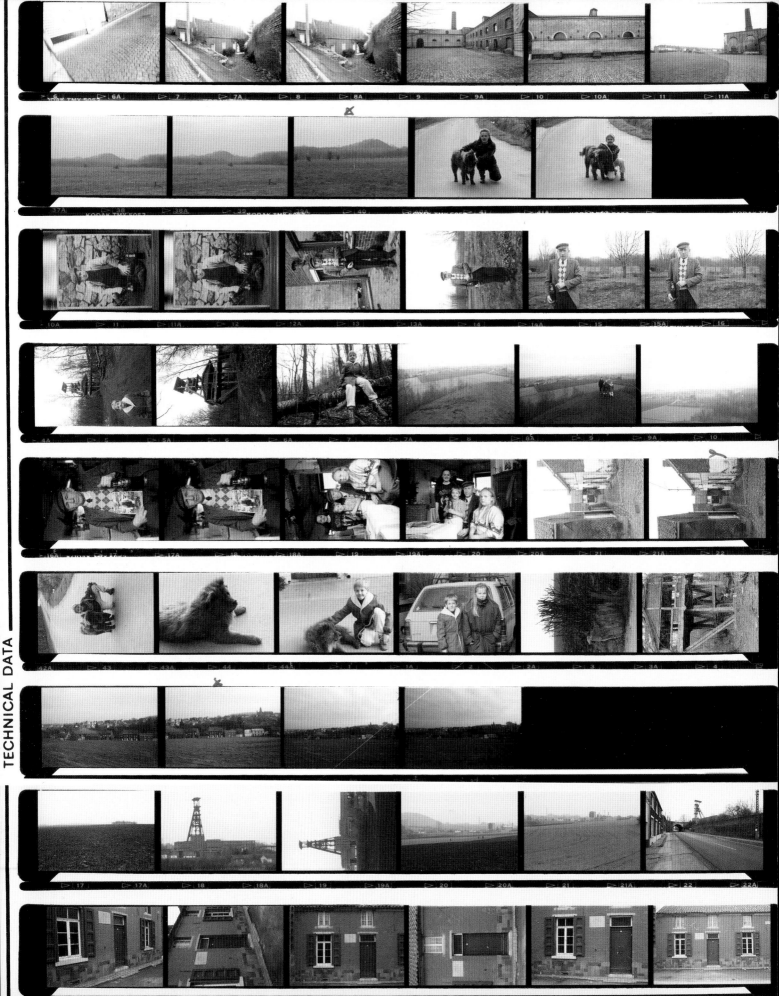

From the Borinage to The Hague and on to Antwerp

December 26, 1878–February 1886

The Faith of the Humble, in the Borinage

December 26, 1878 – October 1880

Van Gogh's brief, failed attempt to become a clergyman was a key event in his life. He seems to have pivoted in this direction during his last months in London (1876), but not because of his father's profession: the Reverend Theodorus had a strict way about him, and tensions between the two were high. Rather, Vincent had taken a liking to the sermons of the Reformed Baptist pastor Charles Haddon Spurgeon, delivered in the impressive Metropolitan Tabernacle (in Elephant and Castle, London). Vincent climbed into the pulpit for the first time in Richmond, after a walk along the Thames. He described the experience as like emerging from a "dark, underground vault into the friendly daylight." (November 3, 1876. To Theo.) This feeling stayed with him even after he joined the Walloon miners of the Borinage, in the Belgian province of Hainaut, where he arrived on December 26, 1878. Here, as we'll see, he wanted to experience what it was like to descend into the claustrophobic tunnels, several hundred feet underground, where miners extracted coal.

Before arriving in Belgium, Vincent returned to his family home in Etten, then moved to Dordrecht (the Netherlands) to work at the Blussé & Van Braam bookstore. He had continued to study the Bible and applied to the theology program at the University of Amsterdam but didn't get in. He was well-versed in modern languages—Dutch, English, French, and German—but he was not fond of Latin or Greek, which the program required. He lasted less than three months at a training course for Protestant missionaries in

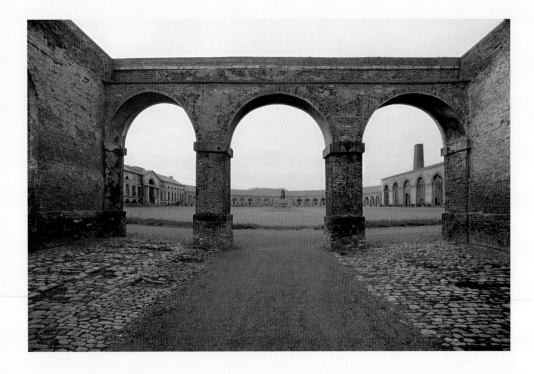

Hornu (Borinage, Hainaut, Belgium) The majestic remains of Le Grand-Hornu mine, a late neoclassical archaeological relic. It has been the site of the MAC (Musée des Arts Contemporains) since 2002. In Van Gogh's day, it was one of the biggest coal mines in the world.

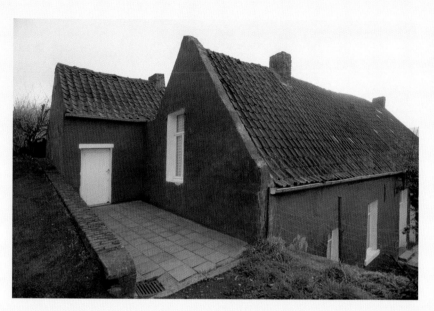

Colfontaine (formerly Wasmes, Borinage, Hainaut, Belgium) An old house with red-painted bricks. Van Gogh lived in Wasmes from January to August 1879.

Laeken, near Brussels. Back in Etten, Vincent's parents noticed his growing unease. He seemed unable to stick to one project or stay in one place. So when Vincent resolved to go to the Borinage, a gloomy coal mining area, his father decided to support him financially.

Vincent arrived in Pâturages, Mons, near the border with France, on December 26, 1878, lodging at first with a local peddler named Vanderhaegen. In January he took a six-month position as a lay preacher in Wasmes, which is now part of the city of Colfontaine, and went to live with Jean-Baptiste Denis, a baker who lived near the mines. It was a simple but comfortable home, especially when compared to the hovels in which the miners lived. In typical local style, the home was made of painted red bricks, bringing color to the dull, smoky landscape around the mines and the scattered piles of coal.

Vincent behaved just like a missionary. He gave away his good clothes and tore the shirt off his back to bandage wounds miners endured in gas explosions, such as the tragedy of April 17, 1879, when 250 miners died in the Agrappe mine in Frameries. He didn't hold back from those suffering from typhoid or silicosis, either. He even managed to convert an alcoholic who had verbally abused him. He soon left the comfort of Denis's home and found shelter in a hovel, where he slept on a straw bed. Meanwhile, he was waiting to be confirmed as a missionary. He walked all the way to Brussels to secure the approval of church authorities. But their rigid Protestant mindset could not fully grasp the motivations of this strange man, who seemed old beyond his years and dressed like a miner. Vincent didn't get his confirmation, but he decided to stay in the Borinage anyway.

He went to live with Charles Louis Decrucq in the village of Cuesmes (July–October 1880). His artistic vocation finally took off: he started to draw ragged people and the craggy faces of miners. By now, though, even Theo struggled to relate to his brother. He was not thrilled about Vincent's choices, which he thought were extreme. Correspondence between the brothers trailed off. In October 1880, Vincent left the Borinage for good—but he would never forget it. In a letter to the Belgian painter Eugène Boch, he said, "If you should ever go to Petit-Wasmes, please inquire whether Jean-Baptiste Denis (farmer) and Joseph Quinet (miner) are still living there, and tell them from me that I have never forgotten the Borinage and that I should still be delighted to see it again." (Arles, October 2, 1888. To Eugène Boch.)

Everywhere, Coal

Colfontaine (formerly Wasmes, Borinage, Hainaut, Belgium) The abandoned mine factories as seen from the back of Jean-Baptiste Denis's house, where Van Gogh lived for a spell.

12
Coalmine in the Borinage (Borinage, July–August 1879). Watercolor and pencil on paper, 26x28cm. Amsterdam, Van Gogh Museum (Vincent van Gogh Foundation). F1040.

12

Borinage View from above of a typical coal mound.

As far as I am concerned, you'll be aware that there are no paintings here in the Borinage, that by and large they do not even know what a painting is [. . .]. But that does not alter the fact that the country here is very special and very picturesque, everything speaks, as it were, and is full of character. Lately, during the dark days before Christmas, snow was lying on the ground. Everything reminded one then of the medieval paintings by, say, Peasant Brueghel, and by so many others who have known how to depict the singular effect of red and green, black and white so strikingly. And often the sights here have made me think of the work of, for example [. . .] Albrecht Dürer. [. . .] Everywhere round here one sees the large chimneys and the tremendous mountains of coal at the entrance to the mines, the so-called charbonnages.

(PETIT-WASMES, DECEMBER 26, 1878. TO THEO.)

The Return of the Miners

13

13

Miners in the Snow (Cuesmes, August–September 1880). Pencil, colored chalk, and watercolor on paper, 44x55cm. Otterlo, Kröller-Müller Museum. F831.

I have sketched a drawing representing miners, men and women, going to the shaft in the morning through the snow, by a path along a thorn hedge: passing shadows, dimly visible in the twilight. In the background the large mine buildings and the heaps of clinkers stand out vaguely against the sky.

(CUESMES, AUGUST 20, 1880. TO THEO.)

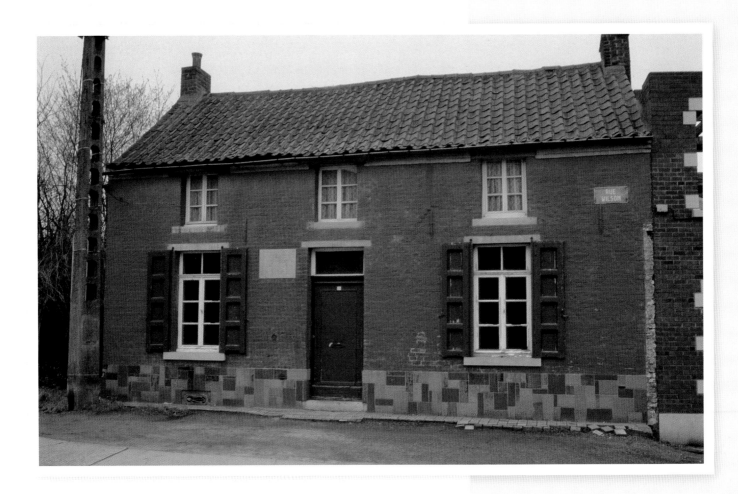

Borinage (Hainaut, Belgium)

A former miner photographed in 1990 with the lamp he used in the mines. He is holding a picture of himself at work. The mines were decommissioned in the 1970s.

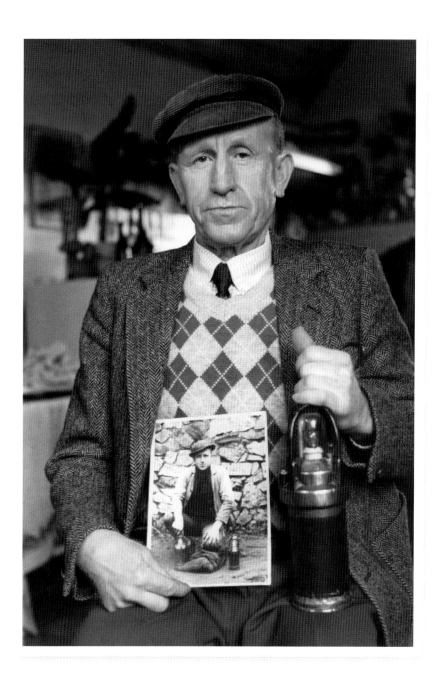

Colfontaine (formerly Wasmes, Borinage, Hainaut, Belgium)

The home of Jean-Baptiste Denis before renovations turned it into a museum (Maison Van Gogh). The baker lived between Rue Wilson and Rue du Petit-Wasmes, and Vincent could see the mine from his room. At the time, he was working as a door-to-door evangelist and catechist.

The Road to Courrières

In the winter of 1879, Vincent went to Pas-de-Calais, in northern France, about fifty miles from the Borinage. He wanted to visit the naturalist painter Jules Breton, but upon reaching his studio in Courrières, he was disappointed by the "inhospitable, stone-cold" look of the building (which was destroyed in World War II), and he didn't go in. Instead, he took to the countryside: he drew hay barns, the "almost coffee-colored (with whitish spots where the marl shows through)," and the "finer and brighter" French sky, very different from the one in the Borinage, which was "smoky" and "foggy." He found the flocks of crows made famous by Charles-François Daubigny and Jean-François Millet, his favorite artists.

He earned "a few crusts" here and there by trading his paintings. He camped out in the country, sleeping in barns or among bundles of firewood or in an abandoned carriage, finding himself covered in frost each morning. Feeling dejected, he'd tossed his pencil aside earlier. But now, in the French countryside, he was again seized by the desire to draw, and he couldn't help but obey. A year later, Vincent described these moments to his brother, saying how they had helped him find a new path with his pencil. His artistic journey had begun—in contact with nature and inspired, in these early days, by Jean-François Millet's paintings of farmers and humble workers.

Courrières (Pas-de-Calais, France)
The countryside around Courrières and the dark earth.

Courrières The countryside around Courrières at dawn, as Vincent saw it while sleeping outside.

I did go to Courrières last winter. I went on a walking tour in the Pas-de-Calais, not the English Channel but the department, or province. I had gone on this trip in the hope of perhaps finding some sort of work there, if possible—I would have accepted anything—but in fact I set out a bit reluctantly, though I can't exactly say why. But I had told myself, You must see Courrières. I had just 10 francs in my pocket and because I had started out by taking the train, that was soon gone, and I was on the road for a week, it was a rather gruelling trip. Anyway, I saw Courrières and the outside of M. Jules Breton's studio. (CUESMES, SEPTEMBER 24, 1880. TO THEO.)

In the Houses of Cuesmes

Cuesmes (Mons, Borinage, Hainaut, Belgium) The house at 3 Rue du Pavillon, immersed in nature, where Vincent lived with Charles Louis Decrucq, a miner, from August 1879 to October 1880. He set up a small studio there. Today it is home to a museum dedicated to Van Gogh's work.

14

The Magrot House (Cuesmes, 1879–1880).
Charcoal over graphite on wove paper,
23x29.4cm. Washington, DC, National Gallery
of Art, Armand Hammer Collection.

15

The Zandmennik House (Cuesmes, June–
September 1880). Charcoal over graphite on
wove paper, 22.8x29.4cm. Washington, DC,
National Gallery of Art, Armand Hammer
Collection. FXXXIII.

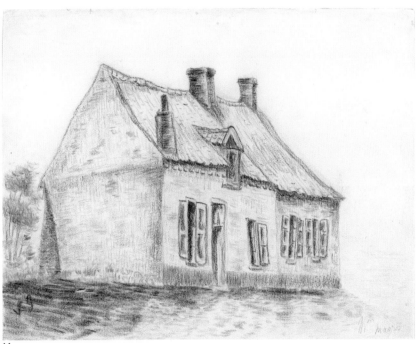

14

*Their dwellings are usually small and
should really be called huts; they lie
scattered along the sunken roads, in
the woods and on the slopes of the
hills. Here and there one can still
see moss-covered roofs.*

(Petit-Wasmes, December 26, 1878. To Theo.)

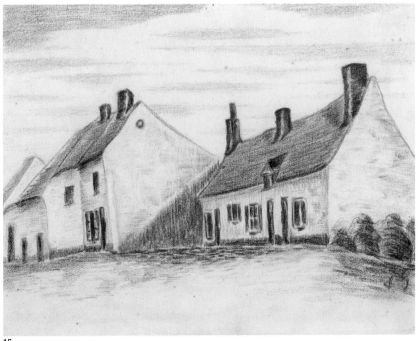

15

In the Belly of the Mine

Frameries (Borinage, Hainaut, Belgium)
One of the Borinage mines where Van Gogh is believed to have tended to the wounded. Gas explosions were frequent in those days—real-life catastrophes with dozens of victims. There is no solid evidence that Vincent was directly affected by the Agrappe explosion of April 17, 1878, though we do know that he treated many of the wounded. According to his own accounts, he descended into the mines at least once, in Marcasse. He wanted to understand the suffering, discomfort, and dangers miners faced every day. The Borinage was a boon for entrepreneurs and coal speculators but dire and miserable for those who worked there: they earned very low pay despite early aging and shortened life expectancy due to pulmonary illnesses.

Not long ago I made a very interesting expedition, spending six hours in a mine. It was Marcasse, one of the oldest and most dangerous mines in the neighborhood [. . .]. I had a good guide, a man who has already worked there for thirty-three years; kind and patient [. . .]. So together we went down 700 meters and explored the most hidden corners of that underworld. [. . .] A picture of the maintenages would be something new and unheard of—or rather, never-before-seen. Imagine a row of cells in a rather narrow, low passage, shored up with rough timber. In each of those cells a miner in a coarse linen suit, filthy and black as a chimney sweep, is busy hewing coal by the pale light of a small lamp. The miner can stand erect in some cells; in others, he lies on the ground.

(**Petit-Wasmes, between April 1 and 16, 1879. To Theo.**)

Out of the Darkness and into the Light

Colfontaine (formerly Wasmes, Borinage, Hainaut, Belgium) The house at 257–259 of today's Rue au Bois is now a private home. Van Gogh used it to host the Salon du Bébé (or Le Temple du Bébé), religious meetings with mining families.

I have already spoken several times here, both in a fairly large room especially designed for religious meetings and also at the meetings they usually hold in the evenings in the workmen's cottages, and which may best be called Bible classes [. . .]. If, with God's blessing, I were to get a permanent position here, I should welcome that with all my heart.

(Wasmes, December 26, 1878. To Theo.)

**Cuesmes, Van Gogh House
(Mons, Borinage, Hainaut, Belgium)**
A corner in the house of the Salon
du Bébé. Prior to renovation in 1990,
one of the walls was still in its original
state from when Vincent would hold
religious meetings here.

Van Gogh House The harmonium
that Van Gogh might have played
during religious meetings in Wasmes
was moved to the small museum
in Cuesmes.

Far, Far Away: Holland

1880–1885

In 1878, Vincent spent his last summer in the Borinage. His true passion for drawing was starting to emerge, and he was engrossed by it day and night. He started to focus on his favorite artist, Jean-François Millet, who also painted humble subjects. He pored over Charles Bague's drawing course, *Exercices au fusain*, sent to him by his former boss in The Hague, Hermanus Tersteeg. Vincent had come to terms with the fact that he would never become a clergyman—he hadn't done very well in that field. So he left Cuesmes for Brussels. He continued to draw from mid-October 1880 to mid-April 1881, in a small apartment on 72 Boulevard du Midi. He mostly worked in pen, hoping to make engravings and join the Royal Academy of Fine Arts, where tuition was free.

During this time, he developed a long-lasting friendship with the Dutch painter Anthon van Rappard, his elder by seven years. They both painted subjects live, "into reality," as he later wrote. They started to exchange letters with artistic annotations and thoughts on various locations that Van Rappard recommended visiting. Meanwhile, Vincent skipped the Royal Academy's entrance exam, just as he'd failed the theology entrance exam in Amsterdam in 1878. That earlier time, instead of studying Greek, he'd spent his time walking along the canals, looking for rare editions of books and prints, people watching in the Jewish quarter, and drawing large maps. On April 12, 1881, he left Brussels for his parents' house in Etten. He received "a box of paints from Uncle Cent that is rather good, certainly good enough to start with." (Etten, beginning of October 1881. To Theo.) Delighted, he experimented with a watercolor. He started drawing without rest, painting seeders and diggers. Every once in a while, he'd go to The Hague to learn from his distant cousin Anton Mauve, a leading figure in the Hague school.

Meanwhile, his relationship with his father was souring. Vincent had fallen in love with his cousin, Kee Vos-Stricker, a young widow with a four-year-old son. She rejected him and left for Amsterdam to stay with relatives. Stubborn and desperate, Vincent

Amsterdam, Herengracht 154 (the Netherlands) The University of Amsterdam's Theology Department building, where Van Gogh hoped to become a student in 1878.

Amsterdam, Jewish quarter
Bas-relief on the side of a house in what remains of the Jewish quarter. Vincent used to take long walks there. He was also privately schooled by a humble Jewish teacher recommended to him by Mendes da Costa, his professor of Greek and Latin.

went to look for her there, in vain. Back in Etten, on Christmas Day 1881, he got into yet another fight with his father, who ordered him in no uncertain terms to leave. He left for The Hague that same day to stay with Mauve. In January 1882, he rented a nearby studio: "a room and alcove" with decent lighting, thanks to a big south-facing window. But he had no money. He was forced to ask Mauve for help but grew embittered—what Mauve called "a yellow soap mood, or saltwater mood." (The Hague, on or about January 14, 1882. To Theo.)

Vincent continued to draw and to fight with Mauve, who wanted him to practice with gypsum molds. In the meantime, he met Sien (Clasina Maria Hoornik), a sick, alcoholic, and pregnant prostitute. Vincent moved to a new apartment with her but then spent several weeks in the hospital after contracting a venereal disease. In the city he met other young artists, like Théophile de Bock and Herman van der Weele. He connected with George Breitner over their shared passion for Zola's naturalist novels, and they painted together in The Hague's poorest neighborhoods. Van Rappard advised him to resume painting subjects in movement. He captured the movement of a falling leaf over the dunes of Scheveningen, the beach near The Hague, and the shimmering colors of the sky and stormy water.

He reluctantly left The Hague in the fall of 1883, after falling out with Sien and under pressure from his parents. He headed to the province of Drenthe, "far, far away." He was fascinated by the simplicity of the people of this region strewn with peat bogs and loved the colors of the countryside.

In December, he visited his parents, after they'd moved to Nuenen. He created some of his first masterpieces there, but staying at the family home would prove impossible.

An Impossible, Consuming Love

Amsterdam (the Netherlands)
Two views of the Keisergracht, the
long road along the canal. This was
where Vincent pursued his cousin,
Kee Vos-Stricker. Or rather, he requested
to meet her at the home of relatives,
but she refused to see him.

Vincent declared his love to Kee in Etten, in the fall of 1881. He told his brother about his desperate search for her in Amsterdam:

To express my feelings for Kee, I said resolutely, "She, and no other." And her "no, never never" was not strong enough to make me give her up. I still had hope, and my love remained, notwithstanding this refusal, which I thought was like a piece of ice that would melt. But I could find no rest. The strain became unbearable because she was always silent and I never received a word in answer. Then I went to Amsterdam. There they told me, "When you are in the house, Kee leaves it. She answers, 'Certainly not him,' to your 'she, and no other'; your persistence is disgusting." I put my hand in the flame of the lamp and said, "Let me see her for as long as I can keep my hand in the flame" [...]. But they blew out the lamp, I believe, and said, "You shall not see her." [...] And when I left Amsterdam, I had a feeling as if I had been on a slave market. [...] Then, not at once, but very soon, I felt that love die within me; a void, an infinite void came in its stead.
(THE HAGUE, ON OR ABOUT MAY 16, 1882. TO THEO.)

The Art World, a Family Calling

Vincent's passion for art, which began with his love of engravings and prints, endured throughout his brief career. But this was no accident. He was a son of art.

Uncle Cent, the businessman. Ever since the seventeenth century, there had always been a clergyman and an art dealer in the Van Gogh family. Uncle Cent (Vincent) had his own business in The Hague: he managed the legendary H. A. van der Burgh paint shop. Later, he directed the Vincent Van Gogh Art House, a gallery so sophisticated that it caught the attention of the royal cabinet. He also sold paintings at Spuistraat 10. Cent eventually became the director of the Goupil Gallery and its print shop.

The origins of the Maison Goupil. It all began with a contract signed in Paris on March 23, 1829, between Jean-Baptiste Adolphe Goupil, a young editor, and Joseph-Henry Rittner, a German merchant who managed an art shop at 12 Boulevard Montmartre. Their first enterprise was called Henry Rittner. It became Rittner & Goupil in 1831 and was used by artists and engravers of various nationalities. Besides the trade and reproduction of great masterpieces of the past, the business started to add contemporary art. In 1841, after the death of his associate, Goupil founded a new business, Goupil & Vibert. He finally opened a bona fide art gallery in 1846 and followed up with branches in New York (1848), Berlin (1852), Vienna (1858), The Hague (1861), and Brussels (1864). Uncle Cent was the first director of the Dutch branch. Two of his brothers, Hein and Cor, were also in the art trade. In 1861, Cent became a partner with a 30 percent stake, along with Léon Boussod. He eventually ceded management to Hermanus Gijsbertus Tersteeg, who ran it until 1914. Vincent worked for the business sporadically, at the London and Paris branches as well as in The Hague—but with little success. Theo, on the other hand, cut his teeth in the Brussels branch early on. He accepted a prominent position at the Paris office in 1878 and worked there for the rest of his short life. He often sent modern engravings to a very grateful Vincent.

The Goupil & Cie in The Hague, in a photo from the late 1800s.

16
The Potato Eaters
(Nuenen, April 16, 1885).
Oil on canvas, 81.5x114.5cm.
Amsterdam, Van Gogh
Museum (Vincent van Gogh
Foundation). F82/JH764.

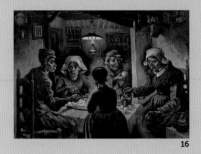

16

17

Sorrow (The Hague,
November 1882).
Lithograph from a version
of the original drawing,
38.5x29cm, now in a private
collection. F929/JH129.

In 1882, Van Gogh started to
etch versions of his paintings
and drawings. *Sorrow* was
one of these. A pregnant
Sien, his partner at the time,
modeled, looking ruined.

18

The Potato Eaters,
lithography from the
version of the painting
done on April 16, 1885.
The Hague, Kunstmuseum
Den Haag.

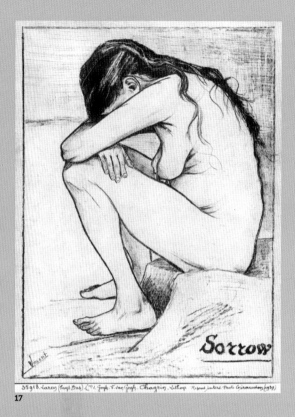

17

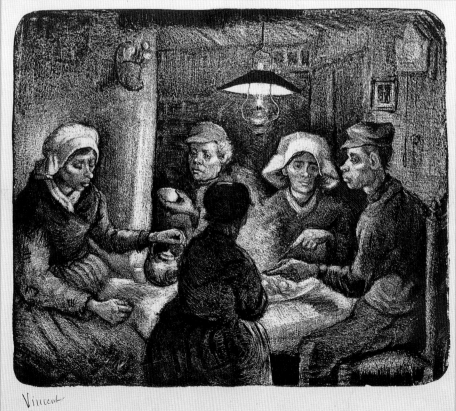

18

Eternal Sadness

19
Worn out (Etten, September–October 1881),
detail. Watercolor on paper, 23.5x31cm.
Amsterdam, P. & N. De Boer Foundation.
F863/JH34.

20
At Eternity's Gate (Sorrowing Old Man)
(Saint-Rémy-de-Provence, May 1890).
Oil on canvas, 80x64cm. Otterlo,
Kröller-Müller Museum. F62/JH922.

A worn-out old man, his head in his
hands, elbows on his knees, cap on his
head, clogs on his feet. He's not sleeping:
he's just "worn out," as Vincent notes
in English on the bottom left. (Human
suffering is not a new theme in the
history of art.) Vincent drew a sketch in
the long letter he sent to Theo from
Etten in mid-September 1881 (172N).
He called the man "an old, sick peasant."
He also explained that he'd been drawing
live subjects in Etten, where he had
set up a small studio in the parsonage
garden. He paid his models with spare
change. According to C. de Bruyn-Heeren
(1996), one of these models was Cornelis
Schuitemaker, a sixty-eight-year-old
farmer from Etten, who was named in
a letter on November 24, 1882 (286N).
A year after painting this watercolor,
Vincent reused the subject, with slight
variations, for a lithograph called *At
Eternity's Gate*. Other sources believe
the model was Adrianus Zuyderlansche,
an elderly man staying at the nursing
home in Etten (*Van Gogh's Inner Circle*
2019, p. 39). Whatever the case, Vincent
clearly used the same subject years later,
at the Saint-Paul de Mausole asylum in
Provence, this time against a colorful
backdrop. He did this very rarely, but it
was an apt theme to revisit, given the
strong discomfort he must have felt
at that time.

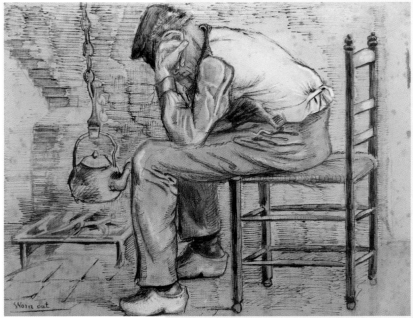

19

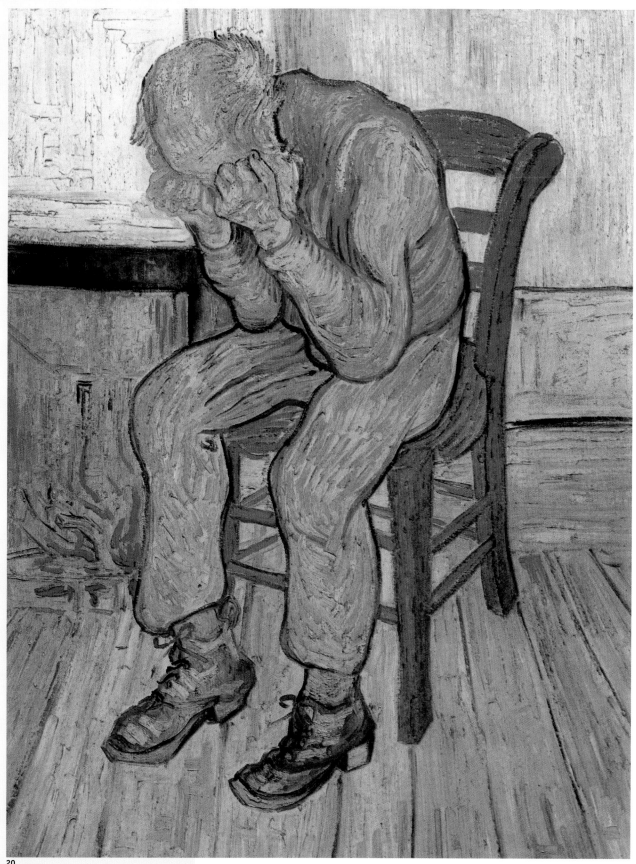

20

The Scheveningen of Old

21
Bleaching Ground at Scheveningen
(Scheveningen, The Hague, July 1882).
Watercolor heightened with white gouache,
31.8x54cm. Los Angeles, John Paul Getty
Museum. F946/JH158.

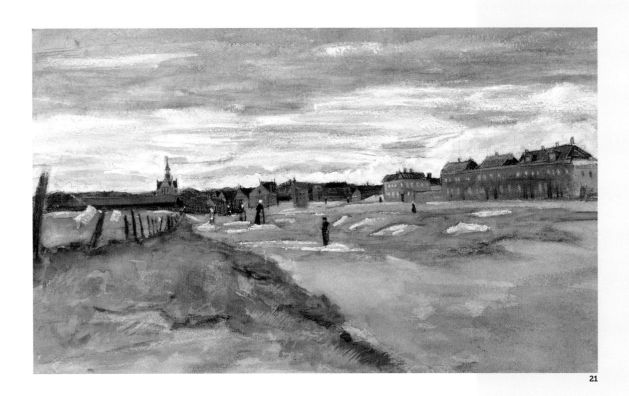

21

**Scheveningen (The Hague, the
Netherlands)** The beach and port at
Scheveningen, an important seaside
town in the Netherlands, near The
Hague. Vincent went there often,
sometimes with his partner Sien.

Tale of a Stolen Painting

A $100,000 heist. The theft of Van Gogh's *Beach at Scheveningen in Stormy Weather* figured among the top ten international art heists for a good fourteen years. This small painting was brazenly stolen from the Van Gogh Museum in Amsterdam in December 2002, along with *Congregation Leaving the Reformed Church in Nuenen* (1884–1885), illustrated on p. 90. Both works were found in 2016, in the den of a Camorra member in the Italian region of Campania, after a thorough investigation by the Neapolitan district attorney's office and the finance police. The theft, led by international organized-crime syndicates, caused tangible damage—a deep gash at the bottom left of the painting, which was very delicate due to its paper support. The work was returned to the museum and put on display after being restored to incorporate the missing colors. *Beach at Scheveningen in Stormy Weather* is a precious painting, among Vincent's first. He used a quick and soft brushstroke (a method he described a few days later in a letter to Theo).

Rain and storm. Vincent had been living in The Hague since January, and in late August 1882 he started making treks to see the stormy waters in Scheveningen, just over two miles from the capital. Two small landscape paintings came of this. One went missing, the other is reproduced on the opposite page.

All during the week we have had a great deal of wind, storm and rain, and I went to Scheveningen several times to see it. I brought two small marines home from there. One of them is slightly sprinkled with sand—but the second, made during a real storm, during which the sea came quite close to the dunes, was so covered with a thick layer of sand that I was obliged to scrape it off twice. The wind blew so hard that I could scarcely stay on my feet, and could hardly see for the sand that was flying around. However, I tried to get it fixed by going to a little inn behind the dunes, and there scraped it off and immediately painted it in again, returning to the beach now and then for a fresh impression. So I brought a few souvenirs home after all. But another souvenir is that I caught cold again.

(THE HAGUE, AUGUST 26, 1882. TO THEO.)

22

22
Beach at Scheveningen in Stormy Weather (Scheveningen, The Hague, August 1882). Oil on paper on canvas, 36.4x51cm. Amsterdam, Van Gogh Museum (Vincent van Gogh Foundation), on loan from A. E. Ribbius Peletier. F4/JH187.

It has been so beautiful in Scheveningen lately. The sea was even more impressive before the gale, than while it raged. During the gale, one could not see the waves so well, and the effect was less of a furrowed field. The waves followed each other so quickly that one overlapped the other, and the clash of the masses of water raised a spray which, like drifting sand, wrapped the foreground in a sort of haze. It was a fierce storm, and if one looked at it long, even more fierce, even more impressive, because it made so little noise. The sea was the color of dirty soapsuds. There was one fishing smack on that spot, the last of the row, and a few dark little figures. There is something infinite in painting—I cannot explain it to you so well [. . .]. Tomorrow I hope to go and work in the open air again.

(THE HAGUE, AUGUST 26, 1882. TO THEO.)

Lost at Sea, Upwind of the Dunes

Scheveningen (The Hague, the Netherlands) The dunes and the beach.

Memory of the past (The Hague, the Netherlands) This seventeenth-century map (J. van Swieten, Frederick de Wit, Constantijn Huygens, c. 1665, Amsterdam University Collection) depicts the road from The Hague to Scheveningen.

During the summer of 1882, Vincent often left The Hague to find peace among the dunes of Scheveningen. He meditated, sketched, and painted, using for the first time a tool he'd invented himself: the "perspective frame," which he later described to Theo. (The Hague, August 5 or 6, 1882. To Theo.) He also reminded his brother that they'd walked along this beach together ten years earlier. Now he lamented the old

Scheveningen, which was disappearing to make way for a touristy beach town.

And the sea and the beach, and the old part of Scheveningen. Delightful.
(THE HAGUE, JULY 23, 1882. TO THEO.)

What we saw in Scheveningen together— sand, sea and sky—is something I certainly hope to express sometime.
(THE HAGUE, AUGUST 5, 1882. TO THEO.)

This week I did a painting that I think would remind you a little of Scheveningen as we saw it when we walked there together: A large study of sand, sea and sky—a big sky of delicate gray and warm white, with a single small patch of soft blue shimmering through—the sand and the sea light, so that the whole becomes golden, but animated by the boldly and distinctively colored figures and fishing smacks, which tend to set the tonal values [...]. You can see that I am plunging full speed ahead into painting, I am plunging into colour. I have refrained from doing so up till now and I am not sorry for it [...]. But now that I sense I have gained the open sea, painting must go full speed ahead as fast as we are able.
(THE HAGUE, SEPTEMBER 3, 1882. TO THEO.)

The Damp Colors of the Woods

At the end of summer in 1882, Vincent visited the woods by The Hague. The ground was already covered in yellow leaves. He was experimenting with oil painting and created a haunting view from below that juxtaposed the autumnal melancholy of the beech woods (of which we can see only trunks standing in a bed of dead leaves) with the graceful shape of a woman leaning against a tree. In reality, no one was there. Only later—inspired by a print by the English illustrator Perry McQuoid—did he add the image of the woman in a hat, "a girl in white leaning against a tree." (The Hague, September 12–17, 1882. To Anthon van Rappard.)

Yesterday evening I was working on a slightly rising woodland slope covered with dry and moldering beech leaves. The ground was light and dark reddish brown, emphasized by the weaker or stronger shadows of trees casting half-obliterated stripes across it. The problem, and I found it a very difficult one, was to get the depth of color, the enormous power and solidity of that ground—and yet it was only while painting it that I noticed how much light there was still in that dusk—to retain the light and as well as the glow, and depth of that rich color, for there is no carpet imaginable as splendid as that deep brownish-red in the glow of an autumn evening sun, however toned down by the trees. [...] It had struck me how firmly the saplings were rooted in the ground—I started on them with the brush, but because the ground was already impasted, brushstrokes simply vanished into it. Then I squeezed roots and trunks in from the tube and modelled them a little with the brush. Well, they are in there now, springing out of it, standing strongly rooted in it. In a way I am glad that I never learned painting. In all probability I would have learned to ignore such effects as this.

(The Hague, September 3, 1882. To Theo.)

23

Girl in White in the Woods (The Hague, end
of August–September 1882). Oil on paper
mounted on canvas, 39x59cm. Otterlo,
Kröller-Müller Museum. F8/JH182.

23

The Wild, Unspoiled Drenthe

24

Women on the Peat Moor (Nieuw-Amsterdam, October 1883). Oil on canvas, 26.8x37.5cm. Amsterdam, Van Gogh Museum (Vincent van Gogh Foundation). F19/JH409.

24

The Drenthe, in the northeast of the Netherlands, is among the least populated regions of the country, though today it draws a decent amount of tourism. In Van Gogh's time, only shepherds, hired hands, and painters like Van Rappard and Mauve would go to Hoogeveen. A year before heading to the Drenthe (he left The Hague on September 11, 1883), Vincent wrote to Van Rappard that he expected it to be wild and untouched, like the Brabant of his youth, twenty years earlier. (The Hague, August 13, 1882. To Van Rappard.) As he wrote to Theo:

To give you an example of the true character in these parts: as I sat painting that cottage, two sheep and a goat came and started to graze on the roof of the house. The goat climbed up onto the ridge and looked down the chimney.

(HOOGEVEEN, ON OR ABOUT SEPTEMBER 14, 1883. TO THEO.)

Hoogeveen Working in the fields.

25
Cottages (Nieuw-Amsterdam, September–
November 1883). Oil on canvas, 35.4x55.7cm.
Amsterdam, Van Gogh Museum (Vincent van
Gogh Foundation). F17/JH0395.

Hoogeveen (Drenthe, the Netherlands)
Cottages in the country.

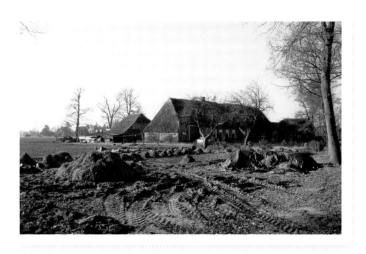

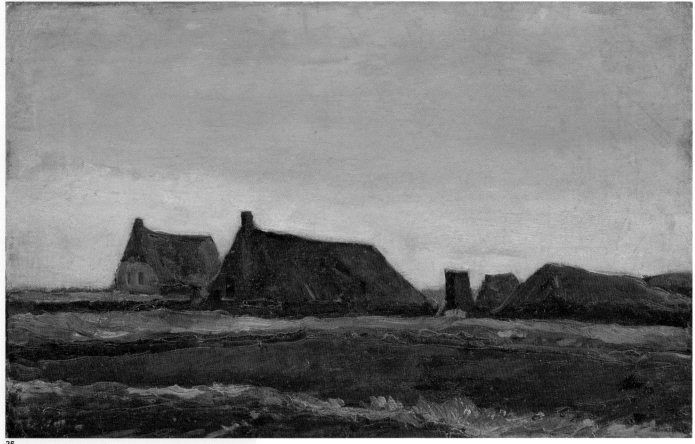

25

The Drawbridge

26

Drawbridge in Nieuw-Amsterdam
(Nieuw-Amsterdam, October 1883).
Watercolor on paper, 39x81cm. Groningen,
Groninger Museum. F1098.

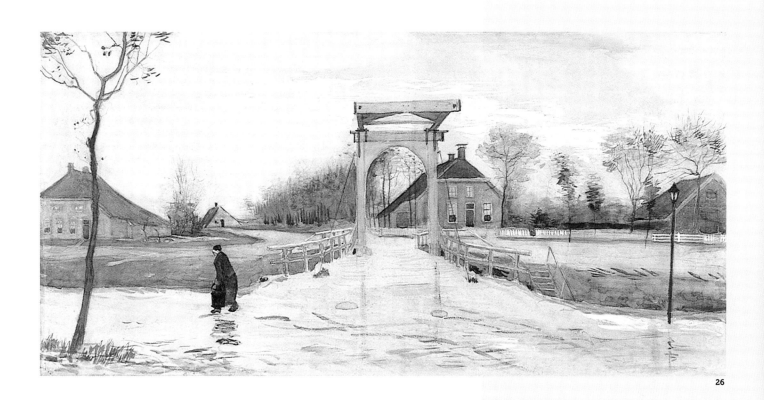

26

In late September 1883, Vincent
moved from Hoogeveen to Nieuw-
Amsterdam, several miles away in the
far southeast of the Drenthe. In October
he painted a bright watercolor of
the town's characteristic drawbridge.
The structure of the bridge has
changed somewhat since then, but it
still stands today.

Nieuw-Amsterdam (Drenthe, the Netherlands) The drawbridge.

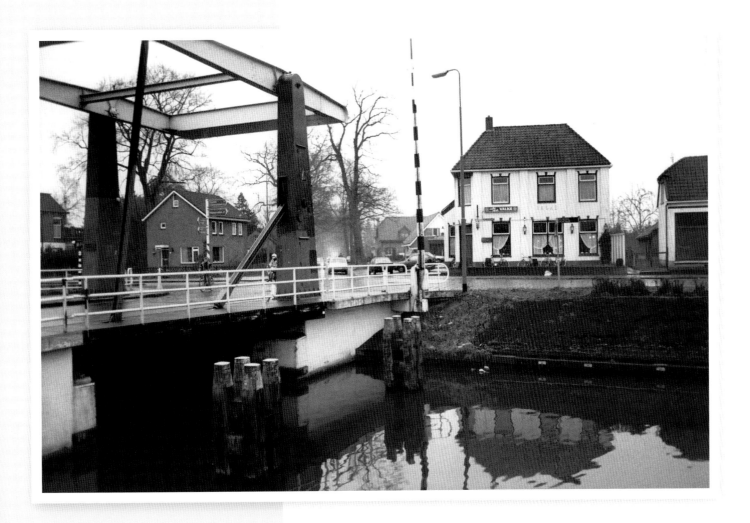

To Zweeloo on a Barge

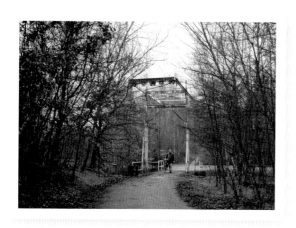

Drenthe, the Netherlands The
canal that connects Zweeloo to
Nieuw-Amsterdam.

Drenthe A face typical of Drenthe.

**Nieuw-Amsterdam (Drenthe,
the Netherlands)** The Scholte Inn,
where Van Gogh stayed.

*This time I am writing to you from the
remotest corner of Drenthe, where I
have arrived after an endless passage
by barge through the heathland [. . .].
Level planes or strips, varied in color,
that grow narrower and narrower as
they approach the horizon [. . .]. In
general the figures that now and then
put in an appearance on the flats
are full of character; and sometimes
they have an exquisite charm.*

**(Nieuw-Amsterdam, October 3, 1883.
To Theo.)**

Lost in a Symphony of Corot

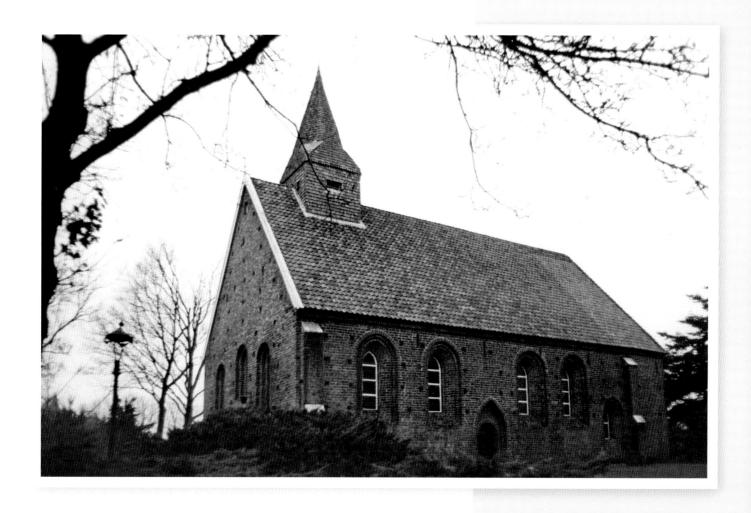

Zweeloo (Drenthe, the Netherlands)
The Reformed church and its cemetery.

Imagine a trip across the heath at
3 o'clock in the morning in a small open
cart (I went with the man with whom I'm
lodging, who had to go to Assen market),
along a road, or "diek" as they call it here,
which had been banked up with mud
instead of sand. It was even better than
the barge. When it was just starting to
get light, and the cocks were starting
to crow everywhere round the huts
scattered over the heath, everything, the
few cottages we passed—surrounded
by wispy poplars whose yellow leaves
one could hear falling—a stumpy
old tower in a little churchyard with
an earth bank and a beech hedge,
the flat scenery of heath or cornfields,
everything was exactly like the most
beautiful Corots. A stillness, a mystery,
a peace as only he has painted it. When
we arrived at Zweeloo at 6 o'clock in
the morning it was still quite dark [...].

The ride into the village was so
beautiful. Enormous mossy roofs of
houses, stables, covered sheepfolds,
barns. The very broad-fronted houses
here are set among oak trees of a
superb bronze [...]. The day was over
and from dawn till dusk, or rather
from one night till the next, I had
lost myself in that symphony.

(NIEUW-AMSTERDAM, NOVEMBER 2, 1883.
TO THEO.)

Back in Nuenen with the Family

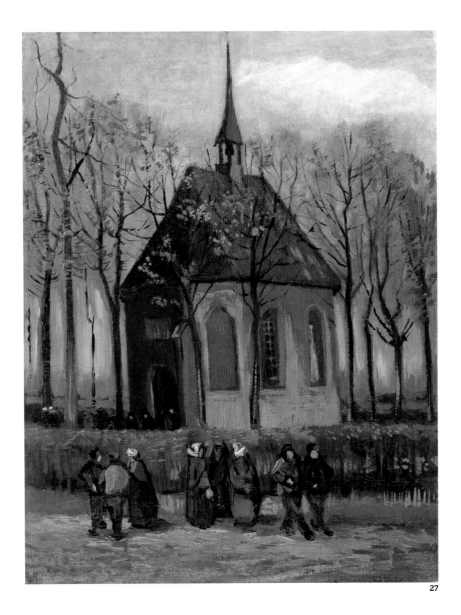

27

Nuenen (North Brabant, the Netherlands) A windmill in the Nuenen countryside.

Nuenen The Reformed church of Nuenen, where Vincent's father presided.

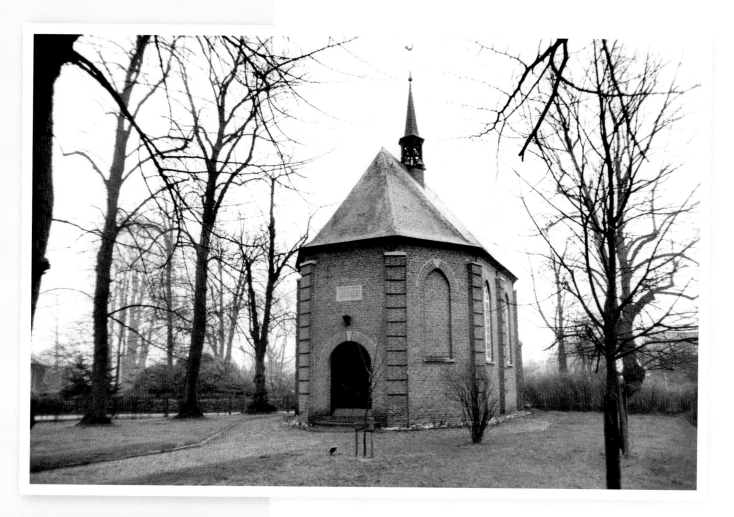

Perhaps you were rather astonished when I told you briefly that I intended to go home for a while, and that I should write you from here [...]. So for several reasons I made up my mind to go home for a while. A thing which, however, I was very loath to do.

(NUENEN, DECEMBER 6, 1883. TO THEO.)

After enjoying the solitude and open landscapes of the Drenthe, Vincent returned to Nuenen, in North Brabant, where he spent a difficult period with his parents.

Still Life with Bible

A Bible, a candle burned down to a stub, extinguished. In the foreground, a book with a yellow cover, ruined. It's Zola's *La Joie de Vivre*, a naturalist novel published in Paris in 1884. Van Gogh seems to have read it in April (Nuenen, April 9, 1885. To Theo), not long after the death of his father. His family had asked him to send their father's Bible to Theo, but Vincent used it as a model for his still life. It doesn't seem that he ever sent it on. (Nuenen, November 3 or 4, 1885, and Nuenen, November 7, 1885. To Theo.) This 1882 edition of an eighteenth-century Dutch translation is now at the Van Gogh Museum in Amsterdam (*Van Gogh's Inner Circle* 2019, fig. 136), but in 1990 it was still in Nuenen, as seen in our photograph.

Theodorus van Gogh's Bible in the Nuenen priory. A Dutch edition from 1882, it can be found at the Van Gogh Museum in Amsterdam.

Despite its title, Zola's novel does not instill a joy for life—far from it. The twelfth novel in the Rougon-Macquart series (*Natural and Social History of a Family under the Second Empire*), it is very much in line with the naturalist style of the time, in that it speaks of financial woes, suicides, and treachery. Certainly it dovetails with the concept of *vanitas* represented by the extinguished candle (which alludes to the death of Vincent's father and the passing of time), and with the Bible, opened to Isaiah 53:3: "He is despised and rejected by men; a man of sorrows and acquainted with grief."

A still life askew. Vincent made deliberate use of the color yellow (a few days before making this painting, he'd studied the "symphony in yellow" of autumn leaves). The table is angled—neither edge is visible—and the Bible is placed on it at an unnatural tilt, as if perched on an invisible lectern. Other artists of the day, including Cézanne—the master of balancing objects on improbable surfaces—experimented with similar still lifes. Even though it is 448 pages long, this yellow book in duodecimo format appears very small compared to the Bible. The proportions are correct, but the artist "corrected the Bible's positioning, painting it from a less slanted angle" compared to his original idea as seen in reflectographies (Guzzoni 2020, p. 214, n. 15). In those days, Vincent was arguing bitterly with his mother and his sister Anna, who said he "spared no thought for anything or anyone." They wanted him to leave Nuenen. The conflict is suggested here by the Bible's juxtaposition with Zola, whom Theodorus hated. A few weeks later, Vincent left the Netherlands for good.

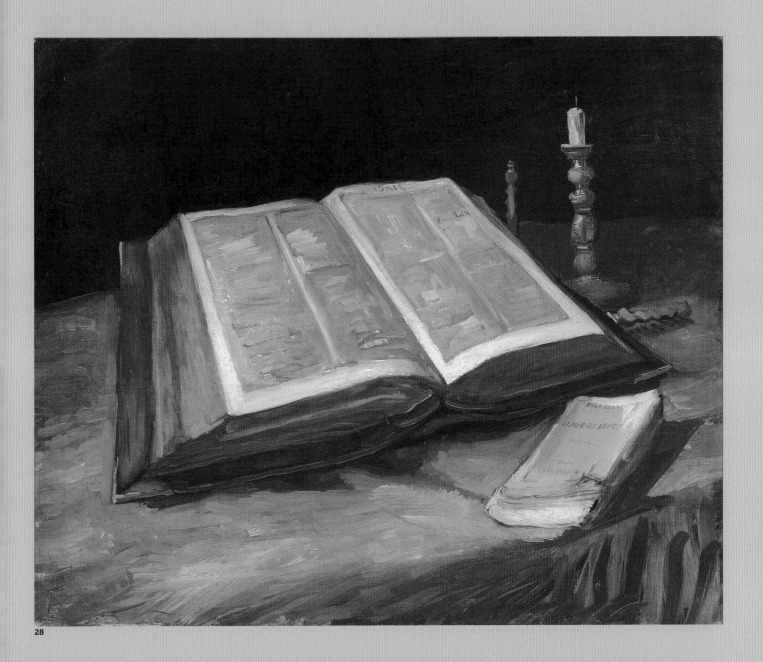

28

I send you a still-life of an open—so a broken white—Bible bound in leather, against a black background, with a yellow-brown foreground, with a touch of citron yellow.
(NUENEN, C. OCTOBER 28, 1885. TO THEO.)

Trouble at the Vicarage

29
The Parsonage Garden at Nuenen (Nuenen, January–February 1884). Oil on paper on panel, 25x57cm. Groningen, Groninger Museum. Stolen on March 29, 2020.

29

This painting was stolen on March 29, 2020, from the museum at Singer Laren, where it was on loan from Groningen for an exhibition. At the time, the museum was closed due to COVID-19 restrictions. A ransom was demanded, but at the time of writing, the work is still at large.

Nuenen (North Brabant, the Netherlands) The parsonage gardens that Vincent painted in 1884.

30

The Vicarage at Nuenen (Nuenen,
September–October 1885). Oil on canvas,
33x43cm. Amsterdam, Van Gogh Museum
(Vincent van Gogh Foundation). F182/JH948.

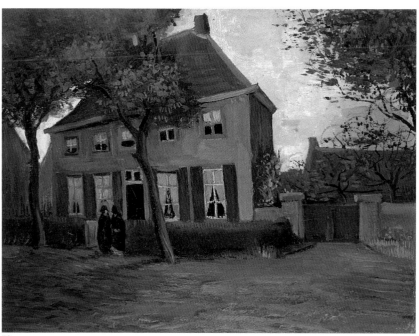

30

Nuenen The parsonage where Vincent
spent two turbulent years with his
family, starting in December 1883. He
was painting a lot, but he was also
becoming bitter. Constant mood swings
made him almost impossible to be
around. While staying in the house,
Vincent used the laundry room as a
space to paint. He then moved next
door and set up shop near the pigsty.

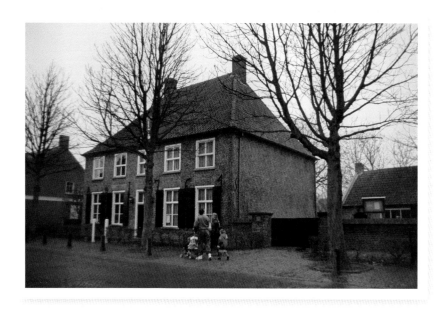

Farmers and Their Mills

31
Water Mill at Opwetten (Nuenen, November 1884). Oil on canvas on panel, 44.9x58.5cm. Last purchased at a Sotheby's auction (London, June 20, 2013, lot 336). F48/JH527.

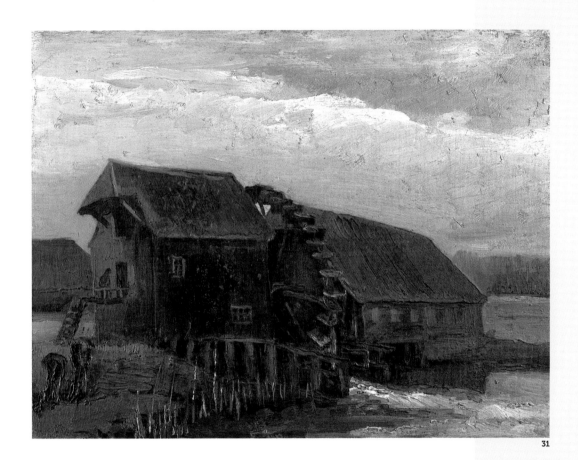

31

Opwetten (North Brabant, the Netherlands) The house and mill Van Gogh painted in 1884. Time seems to have stood still here.

32

Farmhouse in Nuenen (Nuenen, May 1885).
Oil on panel, 64x78cm. Amsterdam, Van Gogh
Museum (Vincent van Gogh Foundation).
F83/JH777.

**Nuenen (North Brabant,
the Netherlands)** Farmhouse.

32

A Rubens Blonde in Antwerp

November 28, 1885–February 1886

By 1885, Vincent's stay in Nuenen had become unbearable. After his father died, he moved to Antwerp, against Van Rappard's advice. His friend had warned him not to go unless he was sure he was going to find something there. "[But] I can't possibly calculate the ins and outs beforehand," Vincent said to his brother, realizing he could no longer hide out in Nuenen.

Antwerp in those days was a charming port city on the banks of the wide Schelde River. Vincent rented a small room above a paint shop at 194 Lange Beeldekensstraat, the so-called Rue des Images. It was November 1885, he was penniless, warm meals were scarce, and he ate nothing but bread. "Thus one becomes more of a vegetarian than is good for one," he wrote to Theo.

He liked the port and other parts of the city. "This morning I took a long walk in the pouring rain [...]. The various warehouses and storage sheds on the quays look splendid [...]. The contrast is particularly marked for one who has just arrived from the sand and the heath and the tranquility of a country village." He was starting to take a greater interest in Japanese art, following in the footsteps of the Goncourt brothers and other artists interested in new ideas in painting. "Well, those docks are one huge Japonaiserie, fantastic, peculiar, unheard of [...]. Everything could be done there, townscapes, figures of the most diverse character, ships as the main subject with water and the sky a delicate gray—but, above all—Japonaiseries." (Antwerp, November 28, 1885. To Theo.)

By now, Vincent saw everything in terms of color, light, shadow, and contrast. His was the gaze of an artist. Back in The Hague, he had already started to describe his painting style: "I sit with a white board before the spot that strikes me—I look at what's before my eyes—I say to myself, this white board must become something—I come back, dissatisfied—I put it aside, and after I've rested a little, feeling a kind of fear, I take a look at it—then I'm still dissatisfied—because I have that marvellous nature too much in mind for me to be satisfied—but still, I see in my work an echo of what struck me." (The Hague, September 3, 1882. To Theo.)

Antwerp was also Rubens's city. Vincent saw his works in many places, first of all at the Moderne Museum (now Royal Museum of Fine Arts). On January 18, 1886, he started winter courses at the Royal Academy of Fine Arts, after meeting its director, Charles Verlat. Here he took lessons in drawing from classical casts and living models.

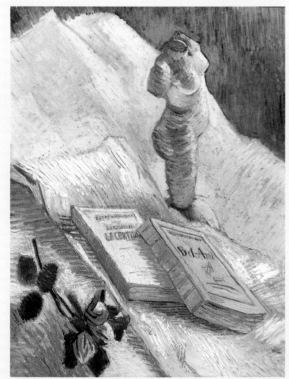

A Rubens Blonde in Antwerp

November 28, 1885–February 1886

Antwerp (Belgium) The Royal Academy of Fine Arts, where Van Gogh began winter courses on January 18, 1886.

Just like Tiburce, the main character in Théophile Gautier's *The Fleece of Gold*—which Vincent very likely read (Fossi 1993)—Vincent went roaming the streets of Antwerp looking for a blond model, someone who would resemble a Rubens subject. (Antwerp, December 14, 1885. To Theo.) But he was also comfortable criticizing Rubens, saying he preferred Rembrandt, Eugène Delacroix, and Millet for their expressiveness and depth of feeling. As he told Theo in a letter, "Nothing touches me less than Rubens expressing human sorrow. To explain my meaning more clearly, let me begin by saying that even his most beautiful weeping Magdalenes or Mater Dolorosas always simply remind me of the tears of a beautiful prostitute who has caught a venereal disease." (Antwerp, January 12–16, 1886. To Theo.)

Vincent started to paint the ballerinas he saw in the cabarets. Around then he also painted a skull with a lit cigarette in its mouth (now at the Van Gogh Museum in Amsterdam), in grim irony. He himself smoked and drank like a madman. The Royal Academy of Fine Arts finally gave him the opportunity to study live nude models, not just gypsum casts. His obsession with perfection grew. After lessons at the Academy ended, he attended an evening drawing course at a school on the Grote Markt, the

Antwerp, 2 Leopold de Waelplaats The building that housed the Moderne Museum in Van Gogh's day. Here Vincent studied Rubens, who had a strong influence on his art. Today many of Rubens's paintings are found in the Royal Museum of Fine Arts.

main square in the old city center. Stress and poor (limited) nutrition landed him in the hospital, with ten teeth badly damaged: this was too much, he wrote to Theo. He felt like a forty-year-old, even though, in February 1886, he was only thirty-three. He felt the urge to join his brother in Paris, in part because he was constantly fighting with people at the Academy, believing them to be "still spiteful."

He left Antwerp at the end of February. He felt in parting that he would have appreciated the city more had he arrived there knowing what he knew now. "One always begins by coming in green. I hope, though, to come back to Antwerp sometime." But he never would.

City Life

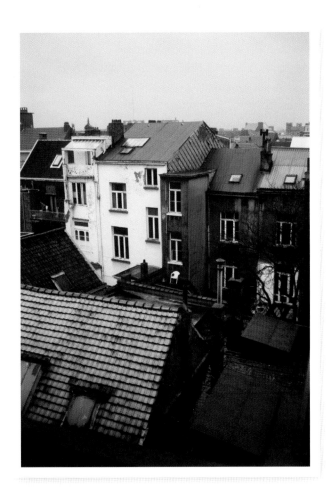

34
Backyards of Old Houses in Antwerp in the Snow (Antwerp, December 1885–February 1886). Oil on canvas, 43.7x33.7cm. Amsterdam, Van Gogh Museum (Vincent van Gogh Foundation). F260/JH970.

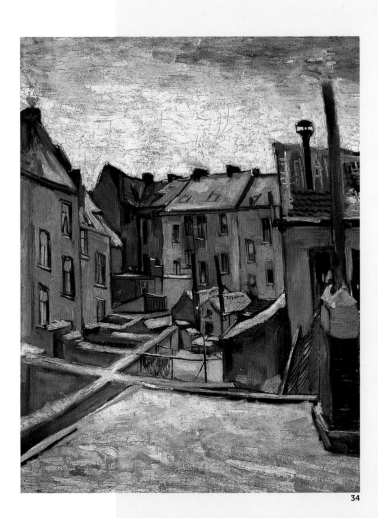

34

Antwerp (Belgium) In early December, Van Gogh painted some old houses from his bedroom window. The painting is reproduced here, alongside a photo from our 1990 tour.

35
View of Het Steen (Antwerp, December 1885).
Pencil, pen, ink, chalk on paper, 13.1x21.1cm.
Amsterdam, Van Gogh Museum (Vincent van
Gogh Foundation). F1351/JH977.

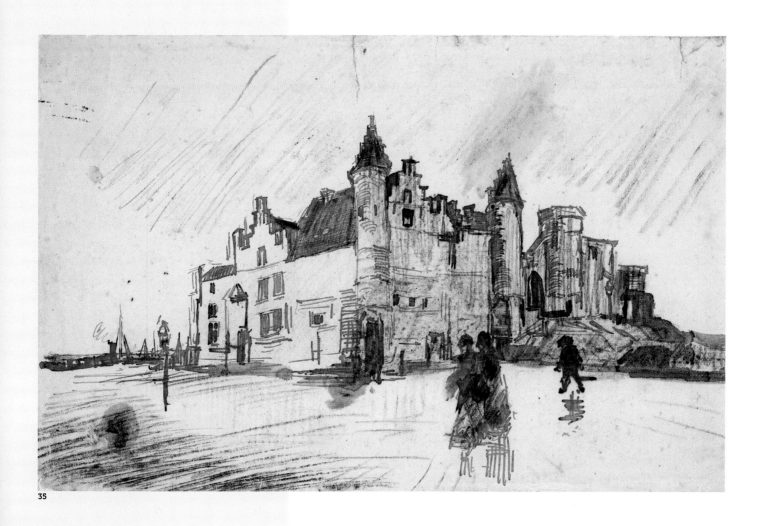

35

Antwerp The medieval fortress of
Het Steen.

Paris, a Modern City

Late February 1886–
February 19, 1888

In the Heart of Montmartre

"The French air clears up the brain."

36
Plaster Cast of a Woman's Torso (Paris, February–March 1887). Oil on canvas, 40.8x27.1cm. Amsterdam, Van Gogh Museum (Vincent van Gogh Foundation). F216g/JH1055.

Paul Cézanne, *L'Amour en Plâtre* (1895). London, Courtauld Gallery.

A nd mind my dear fellow, Paris is Paris. There is but one Paris and however hard living may be here, and if it became worse and harder even—the French air clears up the brain and does good—a world of good." (Paris, September–October 1886. To H. M. Livens.) Vincent had arrived in Paris in late February 1886. He was writing to Horace Mann Livens, a young English painter he'd met at the Academy in Antwerp while practicing on gypsum casts of ancient sculptures. The letter, which sold at auction in 1995 and is in a private collection, is a rare testament to Vincent's time in Paris: only ten letters document the two years he spent there.

In this first letter, Vincent talked about his new landscape studies, "frankly *green*, frankly *blue*." He said that since life is found in color, "true drawing is modeling with color." He reiterated his respect for all-stars like Delacroix and mentioned artists he'd never heard of before—peers or people not much older than himself. In Antwerp, he hadn't known about the impressionists. Now, he told his friend that he wasn't "one of the club" but that he admired Degas's nude figures and Monet's landscapes. But Vincent hadn't moved to Paris to join the impressionists. His three months in Antwerp had been miserable, economically and physically. He'd failed to work with live models or find women who would pose naked, so he'd settled for gypsum casts—a common practice in the academies. He also used casts while working at home in Paris. He owned a few small casts of ancient Venus figurines, which led to sketches, drawings, and eventually to sublime still lifes—like *Still Life with Plaster Statuette, a Rose and Two Novels* (fig. 33, p. 99) and *Plaster Cast of a Woman's Torso*. These seem to have predated some of Cézanne's similar experiments, such as his *L'Amour en Plâtre* (1895), now at the Courtauld in London. The tradition of inserting casts or statuettes into larger paintings has been alive and well since the Renaissance. It took on new life after Vincent's experiments, and then, after Cézanne's practice, with artists like Matisse and Picasso at the beginning of the twentieth century.

Antwerp had dashed Vincent's hopes of selling his work. But in Paris (which he'd already visited in 1873 and 1875), he was exchanging paintings left and right, and becoming fast friends with new artists. He also tried to sell some of his paintings for fifty francs each, through several different dealers, but to little avail.

36

In the Heart of Montmartre

"The French air clears up the brain."

To Vincent and his peers, Paris was the quintessential modern city. It was the home of grand boulevards and train stations in cast iron, of *guinguettes* (typical open-air bars and restaurants) and cabarets and mills turned into dance halls, of bridges and picturesque river views. It was the setting of Maupassant's and Zola's naturalistic novels. Its galleries and vibrant art markets attracted throngs of painters from around the world and a few art critics as well. Above all, it was Theo's city. In 1882, he'd been promoted to art director at the former Goupil & Cie Gallery at 19 Boulevard Montmartre. The business had since become Boussod & Valadon, and Theo was spearheading the move to add impressionist painters to its widening repertoire—in direct competition with the impressionist dealer of choice, Paul Durand-Ruel. Theo had keen acumen and saw great potential in avant-garde art, though Goupil's more traditionalist bent favored painters like Millet, Delacroix, Jean-Baptiste-Camille Corot, and Daubigny: the same artists being sold by other Parisian art dealers at "exorbitant prices," as Vincent said in his letter to Livens. (Paris, September or October 1886. To H. M. Livens.)

Theo was supportive of Vincent's planned move to Paris, but he also had reservations. At the time, Theo was living at 25 Rue Laval (now Rue Victor Massé), in an elegant building that combined neo-Gothic and neo-Renaissance styles. His neighborhood lived and breathed art in all forms. Maurice Ravel lived a few feet away. Down the road was the Bal Tambourin, one of Vincent's chief haunts, and the famous cabaret Le Chat Noir. H. Vieille's store, which sold canvases and frames, was in the same neighborhood, and in the 1870s, the American impressionist Mary Cassat had had a studio nearby.

Paris, 54 Rue Lepic, VIII arrondissement
Vincent and Theo moved to the fourth floor of this building in June 1886. Vincent stayed here until leaving for Arles on February 20, 1888. He often painted wide views of the city from his window.

37

But Theo's apartment was too small and not an ideal space for painting. So he asked Vincent to detour through Nuenen and stay there until June, giving him time to find a better living arrangement for them. But without warning, Vincent landed in Paris like a meteor on February 28, 1886 (or the day before). He'd been drowning in debt in Antwerp and left without settling it, as he later confessed in a letter. As soon as he arrived, he ripped out a page from his notebook, wrote a message in French, and sent it to his brother at the gallery. This important piece of history may have survived because, about a month later, Theo jotted down a laundry list on the back of the page. Vincent's message was resolute, with a touch of anxiety:

37
Montmartre the Quarry and Windmills (Paris, June–July 1886). Oil on canvas, 32x41cm. Amsterdam, Van Gogh Museum (Vincent van Gogh Foundation). F230/JH1177.

"My dear Theo, Don't be angry with me for arriving out of the blue. I've given it so much thought and I'm sure we'll gain time this way. Shall be at the Louvre from midday onwards, or earlier if you like. Please let me know what time you can get to the Salle Carrée [...] come as soon as you can."

(Paris, around February 28, 1886. To Theo.)

Theo welcomed him, of course. The brothers shared the apartment on Rue Laval until June, then moved to a larger place on the top floor of 54 Rue Lepic, halfway up the hill of Montmartre. Vincent's bedroom opened onto vast views of Paris. Starting then, he painted at least 280 works of art, with new colors and experiments, including still lifes, his first sunflowers, and studies of plaster casts. He also painted dozens of plein air panoramas, for which his model was the picturesque, almost rural Montmartre, with its wide green spaces, its mills surrounded by vegetable gardens, its cabarets and coffee shops. Asnières (now Asnières-sur-Seine), north of Paris, would provide a similar model later on.

Artists in Cafés

Henri de Toulouse-Lautrec, *Portrait of Vincent van Gogh* (Paris, 1887). Amsterdam, Van Gogh Museum (Vincent van Gogh Foundation).

Henri de Toulouse-Lautrec, who was eleven years younger than Vincent, first met Van Gogh at Fernand Cormon's studio, at 104 Boulevard de Clichy. Many young artists would congregate there, including Émile Bernard and Georges Seurat. Toulouse-Lautrec and Van Gogh became lifelong friends, their closeness apparent in Toulouse-Lautrec's intense pastel of Vincent in a Paris café. In January 1890, during the Les XX exhibition in Brussels, Toulouse-Lautrec even came to the point of challenging one detractor of Van Gogh to a duel. Theo had sent six canvases for the exhibition.

One of Van Gogh's first self-portraits in Paris. He painted himself in traditional clothing, with a pipe in his mouth and looking far older than his thirty-three years.

Up and Down the Old Steps

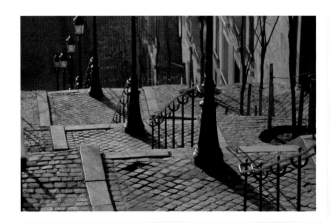

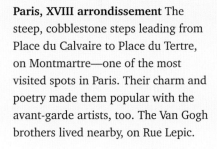

Paris, XVIII arrondissement The steep, cobblestone steps leading from Place du Calvaire to Place du Tertre, on Montmartre—one of the most visited spots in Paris. Their charm and poetry made them popular with the avant-garde artists, too. The Van Gogh brothers lived nearby, on Rue Lepic.

39

View of Paris from Montmartre
(late summer 1886). Oil on canvas,
38.5x61.5cm. Basel, Kunstmuseum
Basel. F262/JH1102.

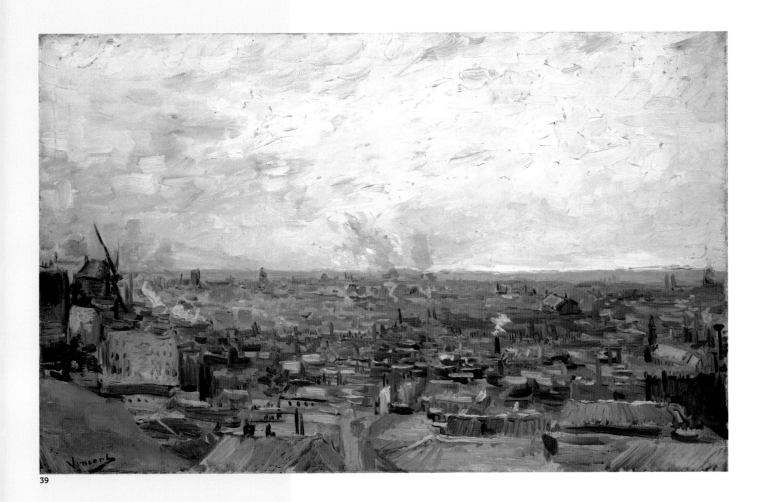

39

A view from the "gray" city, as in Zola's
beautiful description.

*The windows had almost always been
left open; she could not cross the room,
could not stir or turn her head, without
catching a glimpse of the ever-present
panorama.*

(ÉMILE ZOLA, *A LOVE EPISODE*, 1878)

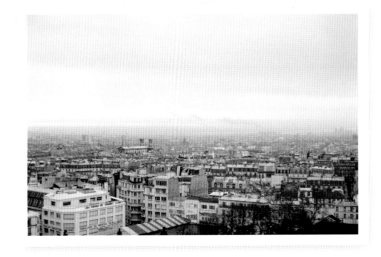

Paris The modern city as seen from
Montmartre, a symphony in gray.

A Room with a View of Paris

Variable weather. The Van Gogh brothers' apartment on Rue Lepic, in the heart of Montmartre, ended up being everything Vincent had hoped for. He could finally develop new experiments with light, color, angle, and views. His room, in the back of the building, looked out over a garden of ivy and wild vines. His view was magnificent, with Meudon and Saint-Cloud in the background and, as Theo told a friend in The Hague, "a piece of sky above it that is almost as big as when one stands on the dunes." Vincent could see infinite atmospheric variations from his window, Theo added, leading to an equally infinite number of representations.

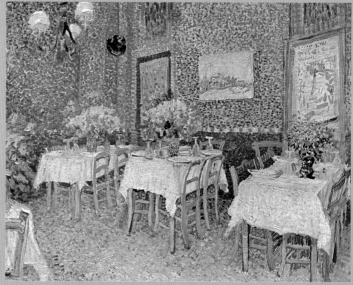

40

Unusual technique, unusual composition.

In the spring of 1887, Vincent's friendship with Seurat—who was not only a painter but also a theorist experimenting with the technique of pointillism—led him to create the beautiful canvas on the opposite page, which also exists in another variant. Vincent used an unusual composition technique and view angle, which were partly inspired by the foregrounds and color schemes of Japanese engravings. The horizon is smack in the middle of the painting, with the Trocadéro and its palace in the southern distance, as if to divide the canvas symmetrically. It looks as if he used pointillism in some parts of the work, following Seurat's instructions for deconstructing primary colors. In other clearly distinguishable areas, he laid on color in a different way—full-on freestyle. Seurat's technique of laying out dots clearly seemed too rigid for him. It demanded time and clashed with his preference for speed. Vincent likely decided that pointillism didn't suit the spontaneity of his brushstrokes, and he soon abandoned it.

40
Interior of a Restaurant,
(Paris, June–July 1887).
Oil on canvas, 56x45.5cm.
Otterlo, Kröller-Müller
Museum. F342/JH1256.

The inside of this restaurant, probably in Asnières, near northern Paris, is an example of Van Gogh's temporary interest in Seurat's pointillism.

41
View of Paris from Vincent's Room in the Rue Lepic,
(Paris, March–April 1887).
Oil on canvas, 46x38cm.
Amsterdam, Van Gogh
Museum (Vincent van Gogh
Foundation). F341/JH1242.

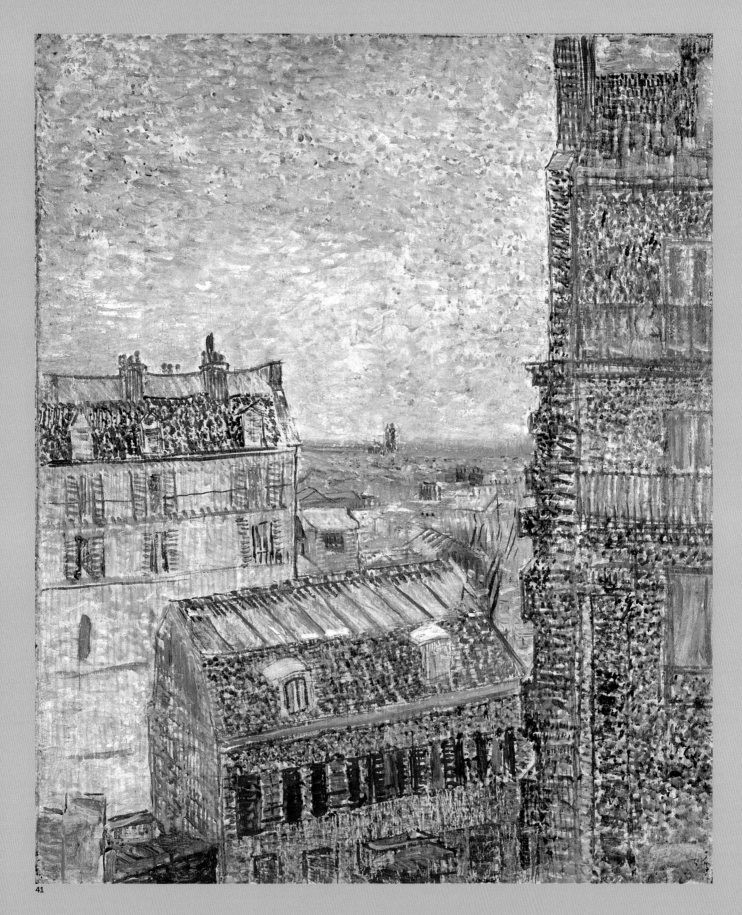

41

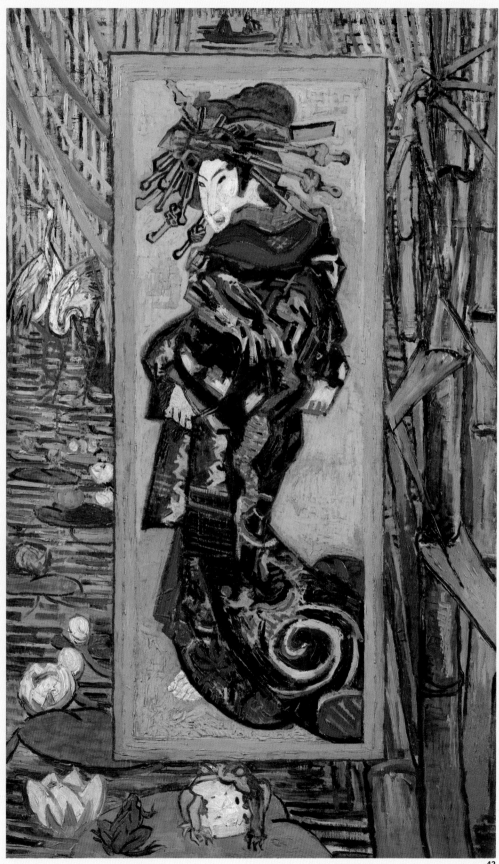

Japanese Influence

Courtesan: After Eisen,
inspired by *Courtesan* by
Kesai Eisen (1790–1848), (Paris,
October–November 1887).
Oil on cotton, 100.7x60.7cm.
Amsterdam, Van Gogh
Museum (Vincent van Gogh
Foundation). F373/JH1298.

The cover of *Paris Illustré.
Le Japon,* May 1886, included
a print of the original woodcut
of Courtesan by Keisai Eisen
(1790–1848).

Vincent seemed happy in Paris. He was painting at a good pace, and Theo wrote to his mother that his brother seemed like a new man—Theo almost couldn't recognize him: "He is progressing tremendously in his work and this is proved by the fact that he is becoming successful. He has not yet sold paintings for money but is exchanging his work for other pictures. In that way we obtain a fine collection, which, of course, also has a certain value." (Paris, June–July 1887. Theo van Gogh to Anna Cornelia van Gogh-Carbentus.)

Around this time, Vincent met Pissarro, Monet, Alfred Sisley, Degas, Renoir, and Seurat after some of them showed their work at the eighth and last impressionism exhibition at the Maison Dorée on Rue Laffitte, in May 1886. Other artists, including Toulouse-Lautrec and Bernard, he met at the studio of Fernand Cormon, a penniless but friendly traditionalist painter. He also became a regular at Père Tanguy's paint shop at 14 Rue Clauzel, where he exhibited his canvases, although he was unable to sell any. Tanguy's wife was apparently somewhat tetchy, but Vincent and Tanguy became close. Meanwhile, Theo started to complain about living with Vincent—he'd become intolerable. In a letter to his sister Wil, he described Vincent as having two separate personalities: "the one marvelously gifted, fine and delicate, and the other selfish and heartless." But Theo also recognized him as a great artist, predicting that his work "will definitely stand him in good stead later, and then it may be sublime."

Vincent often painted along the Seine. He would leave Paris and join some of the impressionists at Asnières. Bernard's parents were renting a house there (February 1887), and the mother had a wooden studio built for the two artists in her garden at Avenue de la Lauzière. That fall, Vincent decided to organize an exhibition with his painter friends, whom he called impressionists of the "Petit Boulevard," a reference to the more established artists of the "Grand Boulevards." The exhibit, held at the Restaurant du Chalet au Grand Bouillon (at 43 Avenue de Clichy), included works by Bernard, Toulouse-Lautrec, Louis Anquetin, and obviously Van Gogh. Gauguin stopped by after a trip to Martinique and exchanged paintings with Vincent for the first time. In the winter of 1888, Vincent became unwell and his "mood"—he used the English term—started to deteriorate. When Gauguin left for Pont-Aven, in Brittany, Van Gogh felt compelled to leave, too. He found it impossible to work in Paris "unless one has a refuge where one can recuperate and regain one's tranquility and poise." He chose Provence, but before leaving, he filled Theo's apartment with his paintings and some of the Japanese prints he'd used as backdrops and inspiration for his landscapes.

This was his way of saying goodbye to Theo. Vincent saw him only a few times after that, and rarely in happy circumstances. It was also a farewell to the Paris he sometimes loved and often hated.

The Paint Shop

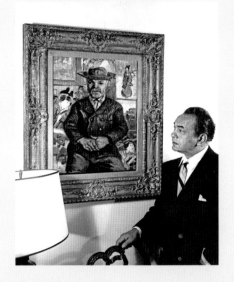

Little Caesar's Van Gogh Actor Edward G. Robinson proudly admires his Van Gogh painting: the second version of *Portrait of Père Tanguy*, which was one of the masterpieces of his art collection after he acquired it in January 1950. In 1956 the portrait was sold to Stavros S. Niarchos.

Paris, 14 Rue Clauzel Père Tanguy's shop was on this road, at the foot of Montmartre. Van Gogh exhibited his first paintings there. After Vincent's death, Theo left many of his brother's paintings on deposit with Tanguy. None were sold before the shopkeeper's death on February 6, 1894. They were later retrieved by Jo Bonger-van Gogh, Theo's widow.

43

Portrait of Père Tanguy (The Man with the Bizarre Hat) (Paris, fall–winter 1887). Oil on canvas, 65x51cm. Stavros Niarchos Collection, formerly belonging to Edward G. Robinson. F364/JH1352.

Van Gogh's brushstrokes fully capture Père Tanguy's good-natured personality, seen through his gaze and patient pose, hands clasped. In contrast, Madame Tanguy's personality was rather abrasive. Vincent had left some paintings at the shop, hoping for good exposure. But the wife butted in.

The man with the bizarre hat, depicted by Van Gogh on a "Japanese" background in various paintings, drawings, and incisions, is the legendary "Père Tanguy," painted and mentioned more than once not only by artists like Van Gogh and E'mile Bernard, but also by a writer and refined critic such as Octave Mirbeau, who on February 13, 1894, wrote an article about him for the "Echo de Paris."

I saw Tanguy yesterday and he has put a canvas I've just done in the window [. . .]. I realize that these big, long canvases are hard to sell, but later on people will see that there's fresh air and good humor in them. The whole lot would do well as decoration for a dining room or a country house.

(PARIS, JULY 23 OR 25, 1887. TO THEO.)

I had plenty of canvases and Tanguy was very good to me. In fact he still is, but his old witch of a wife realized what was going on and complained. So I gave Tanguy's wife a piece of my mind [. . .]. Old man Tanguy is sensible enough to keep quiet, and will do whatever I want anyway.

(PARIS, JULY 17–19, 1887. TO THEO.)

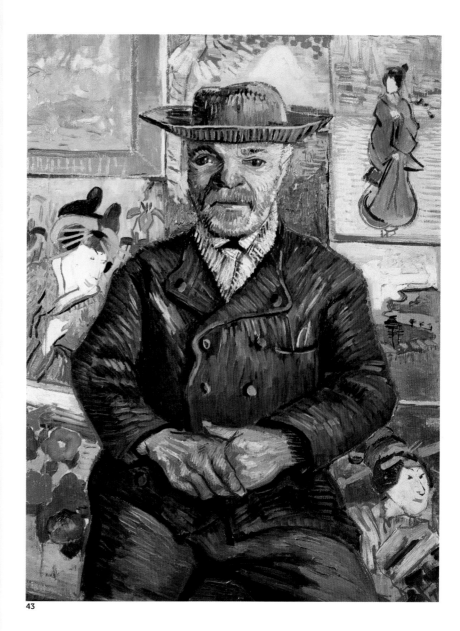

43

Portrait of Père Tanguy

The paint trader. Julien Tanguy was born on June 28, 1825, in Plédran, northern France. He moved to Paris in 1860 and settled on Rue Clauzel, at the foot of Montmartre, where he began to mix and prepare paint colors (*broyeur de couleurs*). Around 1871, he took up the profession in earnest. Because he'd been imprisoned for revolutionary activities, he was forced to open his shop in his wife's name. He soon became the main supplier of the impressionist painters, including Pissarro, Renoir, Monet, Gauguin, and especially Cézanne, who used to store his artwork at the shop—a common practice among artists. Tanguy was a kind, good-natured man, a guiding light for young artists; he was particularly generous with them. Not long after arriving in Paris, Van Gogh too started going to his shop. They would talk about art in the back of the shop, where Vincent saw Cézanne's artwork for the first time.

A volcano for a hat. There are two known versions of the *Portrait of Père Tanguy*. In both, the background is covered in variations of Japanese prints (see fig. 43, p. 119), and Vincent expands Père Tanguy's strange hat into a snowcapped Mount Fuji, as it appears in the famous *Thirty-Six Views of Mount Fuji* series by Utagawa Hiroshige. The scene in the painting resembles the view from the river Sagami, depicted in a Hiroshige print that Vincent owned. Tanguy's brain seems to bubble up like a volcano. Many of the borrowed images are highly recognizable, especially the one on the bottom right. Vincent dedicated an entire painting to Keisai Eisen's courtesan (*Courtesan: After Eisen*). The image had appeared on the cover of *Paris Illustré*'s feature on Japan (pp. 116–117).

44
Portrait of Père Tanguy
(Paris, fall–winter 1887).
Oil on canvas, 92x73cm.
Paris, Musée Rodin.
F363/JH1351.

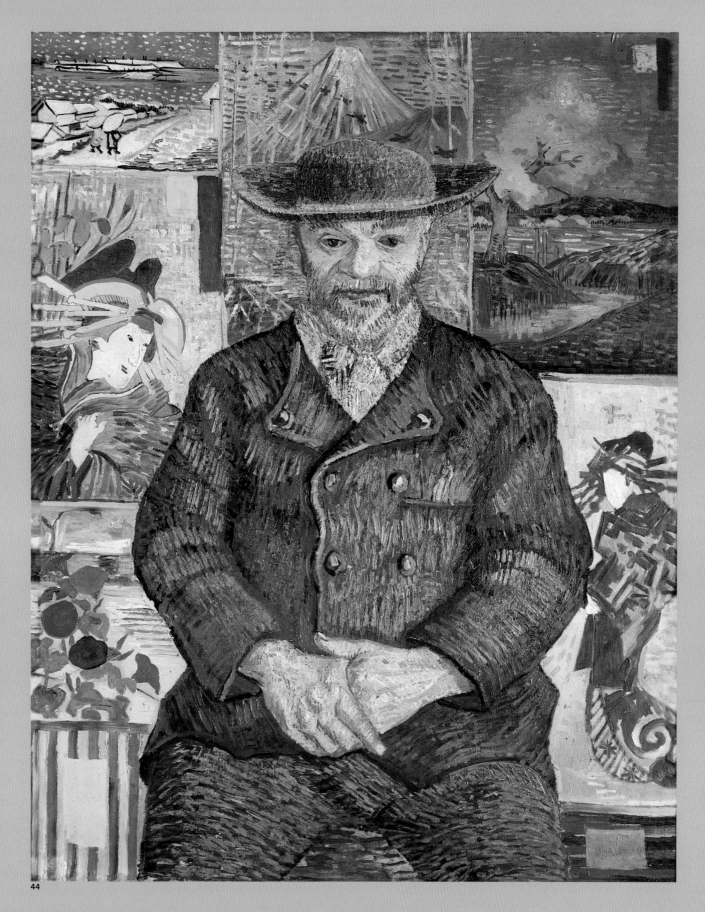

An Artist's Paradise: Les Fusains

Paris, 7 Rue Calaincourt The building where Henri Toulouse-Lautrec had his studio, near Rue Tourlaque. Young artists, including Vincent, used to attend weekly meetings here.

Many avant-garde artists used this charming alcove in Montmartre as a workspace. Other such artists' quarters around Paris included the Bateau Lavoir, popular with Picasso and Georges Braque in the early 1900s; La Ruche; and the Cité Falguière, where Gauguin, Brancusi, Modigliani, and Chagall worked. The first workshops were built at Les Fusains with what was left of pavilions created for the 1889 Exposition Universelle. The retreat became popular a few years after Van Gogh's death with artists like André Derain, Renoir, and Pierre Bonnard, and later Ernst, Miró, and Magritte. Vincent would have liked it there. He'd always wanted to create a community of artists but had never managed to. Les Fusains closed to the public after a few sculptures were stolen from the courtyard.

Paris, 22 Rue Tourlaque
Here and opposite, the workshops
in the Cité des Artistes (also known
as Les Fusains) in February 1990.

A *Guinguette* in Montmartre

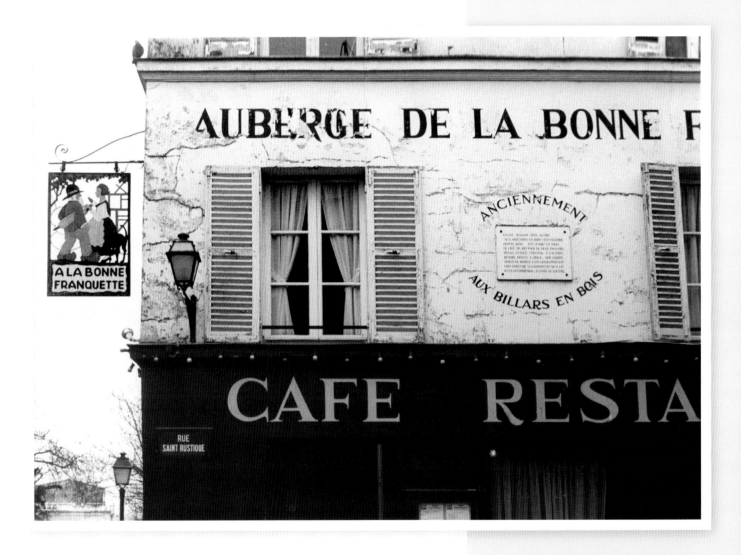

Paris, Montmartre, Rue Saint Rustique La Bonne Franquette, a typical Parisian restaurant with a terrace, known as a *guinguette*. In Van Gogh's day, it was popular with artists and art dealers; now it's a charming tourist destination.

45

Terrace of a Café on Montmartre (La Guinguette) (Paris, October 1886). Oil on canvas, 49x64cm. Paris, Musée d'Orsay. F238/JH1178.

45

At the end of the nineteenth century, Paris and its environs were bursting with *guinguettes*. The name is of uncertain origin, but it described an open-air establishment with a terrace, where food and drinks were served. The only surviving example is La Bonne Franquette, located at the top of Montmartre. Vincent used to sit under its pergola with Pissarro, Sisley, Cézanne, Toulouse-Lautrec, Renoir, Monet, Zola, and Père Tanguy. During his initial stay in Paris, he painted this terrace with the rather dark colors that had marked his previous artistic phase. A similar terrace sits in the background of *The Moulin Le Radet seen from rue Girardon* (see p. 126). Later, Utrillo and his mother, the painter Suzanne Valadon, would also frequent this establishment; in 1896 they lived on the corner of Rue des Saules and Rue Corot.

Of Artists and Their Mills

46

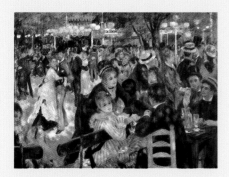

Pierre-Auguste Renoir, *Bal du Moulin de la Galette* (1876). Paris, Musée d'Orsay.

Renoir had already captured this corner of Montmartre in 1876 in one of his most famous paintings. It looks like a festive, open-air dance hall.

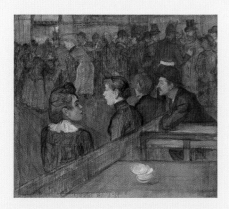

Henri de Toulouse-Lautrec, *Moulin de la Galette* (1889). Chicago, Art Institute of Chicago.

In 1889, Toulouse-Lautrec painted this mill with almost photographic precision. He saw it as a disreputable place for illicit affairs.

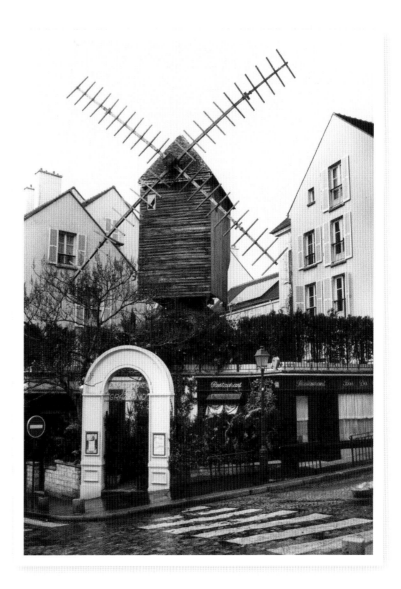

Paris, Le Radet mill as seen from Rue Girardon This mill, the same "Moulin" as in the painting on the opposite page (fig. 46), is often confused with the "real" Moulin de la Galette, one of the Moulins Debray known also as Le Blute-Fin, depicted on page 129 (fig. 47). The misunderstanding comes from the fact that the name Moulin de la Galette appears on both versions of Van Gogh's paintings. Le Radet mill (or Moulin Chapon) had sometimes adopted the name La Galette after one of its specialties paired with wine on tap. The inscriptions on the painting bear this out.

Le Moulin de Blute-Fin: The Real Galette

Mills and flatbread. There's a big disagreement over which was the "true" Moulin de la Galette: it's either the one shown on the opposite page, Le Moulin de Blute-Fin, or Le Radet mill, which was often referred to as "la Galette" because of the inscription on the building. A galette is a type of flatbread that was served in Montmartre restaurants around Rue Lepic, where the Van Gogh brothers lived.

At the time, the area was surrounded by greenery, allowing these establishments to set up large outdoor spaces, terraces, *guinguettes*, and dance floors. They even incorporated old windmills, many of which still stand today. Such mills often had a sort of wooden viewing platform, accessible via steep stairs that were later replaced with cement supports. Paris must have looked magnificent from those lookouts.

A real head-scratcher. Parisians took the city's picturesque windmills for granted, but to an outside artist, they represented something typically Parisian, even to a Dutchman used to seeing windmills. Van Gogh completed dozens of practice drawings and paintings of Montmartre's windmills, which had been converted into popular bars and restaurants. The subject he drew the most, Le Blute-Fin, or La Galette, was used only as a panoramic viewpoint. Other mills contained enough space to drink and eat, or to stay for a dance. Three Montmartre windmills survived into the late 1980s (a more modest one slightly off the beaten path was called Le Moulin au Poivre). They were known as the Moulins Debray, after the family that owned them. Around Vincent's time, the Debray family sold the Moulin Le Radet and transferred its nickname, Moulin de la Galette, to the Blute-Fin. In short, a real head-scratcher. These establishments have been revived for tourism and still offer amazing views. The painting reproduced here was rediscovered only in 2010 after spending thirty-five years in storage at the Museum de Fundatie in Zwolle (the Netherlands). It had been bought at an antique shop in Paris in 1975.

Paris, Montmartre
The "real" Moulin de la Galette, Le Blute-Fin, is still standing in the heart of Montmartre. It is no longer surrounded by fields.

47
Le Moulin de Blute-Fin
(Paris, fall 1886). Oil on canvas, 55.2x38cm. Zwolle, Museum de Fundatie.

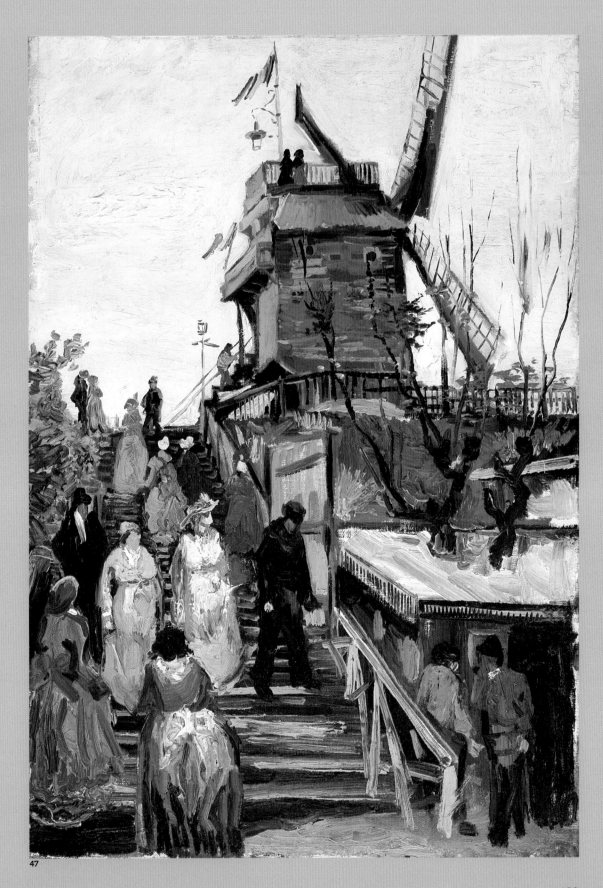

47

Le Moulin de Blute-Fin: The Real Galette

48

48
Le Moulin de la Galette or
The Blute-Fin Windmill
(Paris, fall 1886). Oil on
paper, 61x50cm. Buenos
Aires, Museo Nacional de
Bellas Artes. F348/JH1182.

49
Windmills on Montmartre
(Paris, 1886). Oil on canvas,
46.5x38cm. Tokyo, Artizon
Museum (formerly in
New York, J. S. Lasdon
Collection). F273/JH1116.

**Paris, Quartier Pigalle,
Boulevard de Clichy**
The Moulin Rouge nightclub
in the early 1900s. After
the transformation of
Montmartre's mills into
restaurants and dance halls
proved popular, this fake
mill was inaugurated in
Pigalle, a year after Van
Gogh's death. The cancan
dance is said to have been
invented here.

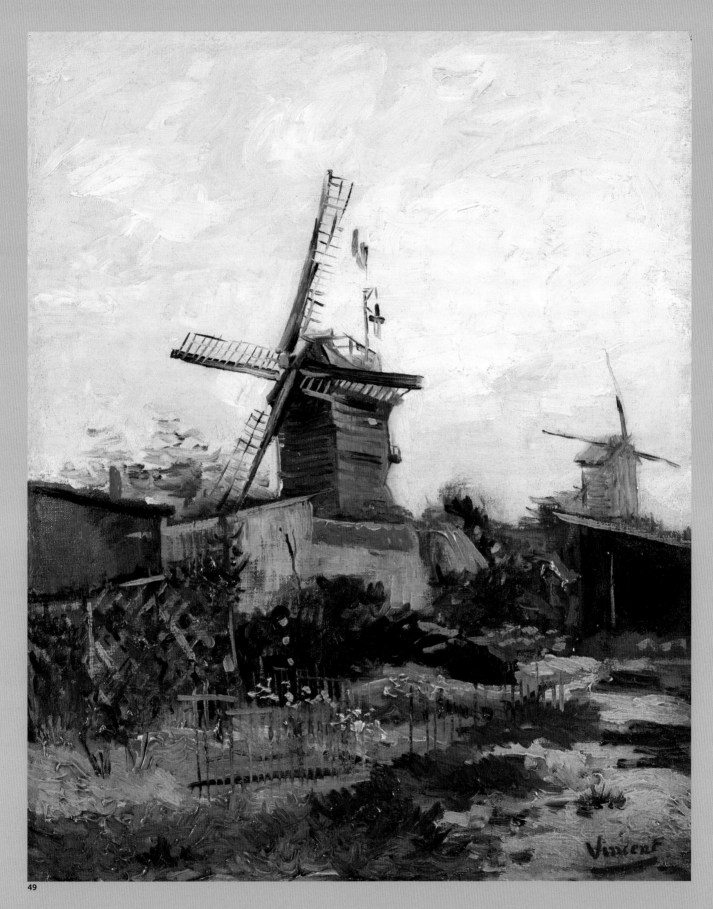

49

The Pont du Carrousel

50

Pont du Carrousel (Paris, June 1886).
Oil on canvas, 31x44cm. Copenhagen, NY
Carlsberg Glyptotek. F221/JH1109.

The Pont du Carrousel is among the
most classic views that Vincent painted
during his first few months in Paris. It
depicts the Louvre from the other side
of the Seine and differs little from our
photograph, taken from the pedestrian
path along the Rive Gauche. The paint-
ing, which is now in Copenhagen,
belonged to Père Tanguy.

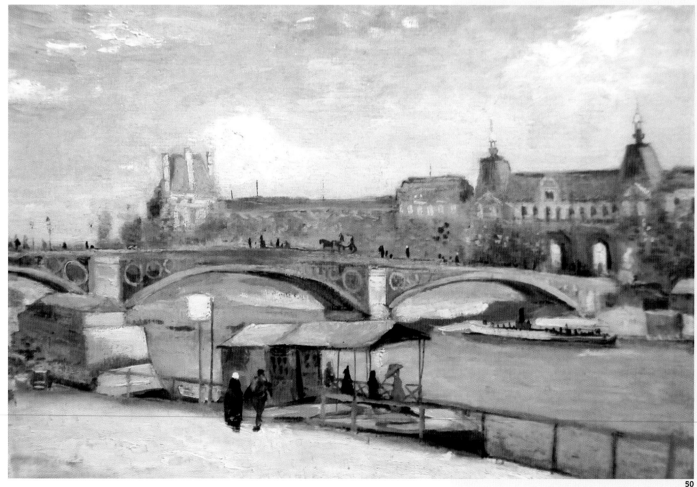

50

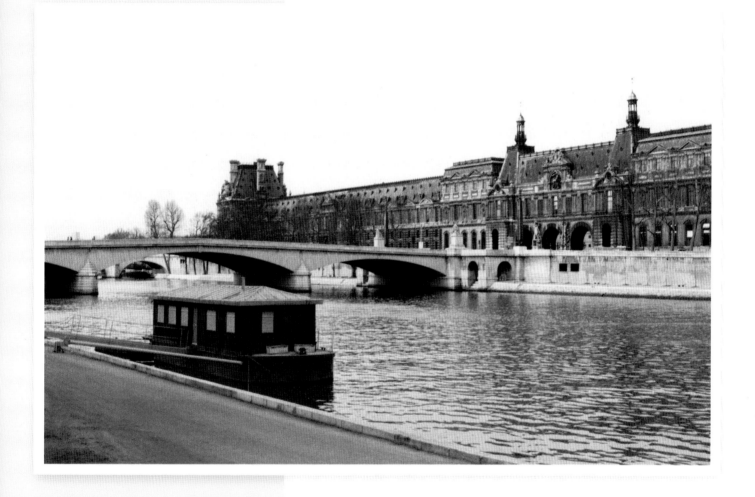

Paris View of the Pont du Carrousel
from the Left Bank, looking across at
the Louvre.

In Asnières with Bernard
(Summer 1887)

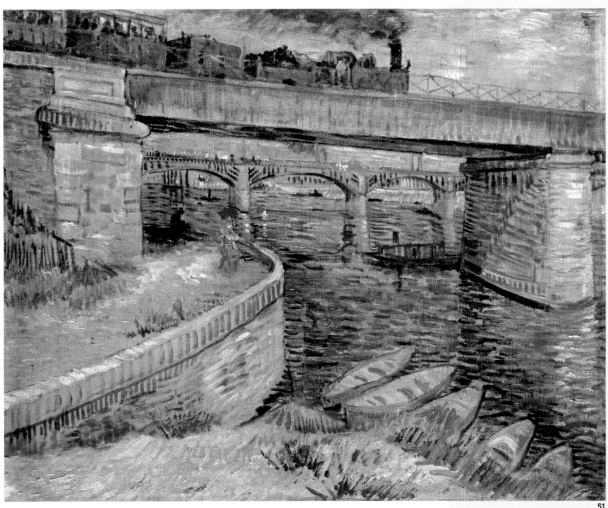

51

In the summer of 1887, Vincent went to Asnières, just north of Paris. It was a favorite destination among the impressionists. He would arrive by crossing the bridge that can be glimpsed in the background of his painting. In the foreground are boats and a woman in pink standing on the riverbank with an umbrella. A steam engine—a symbol of modernity—is passing along the railroad bridge over the river.

Asnières-sur-Seine (Hauts-de-Seine, France) Railroad bridge.

The Washhouse Barge

Asnières-sur-Seine (Hauts-de-Seine, France) Large boat docked on the Seine.

Van Gogh's interest in lighting was growing, thanks in part to his exposure to the landscapes of the impressionists. This is clear from his beautiful and little-known painting of a laundry boat docked on the Seine in Asnières, where Vincent and Bernard went often. In this painting, Vincent stressed horizontal and diagonal brushstrokes to emphasize the reflection of the light on the water. He was realizing his desire to see more color in his paintings, as he'd stated in a letter to Wil.

Asnières-sur-Seine The house on Avenue de la Lauzière, where Bernard stayed.

52

The Laundry Boat on the Seine at Asnières
(Paris, summer 1887). Oil on canvas, 19x27cm.
Richmond, Virginia Museum of Fine Arts.
F311/JH1325.

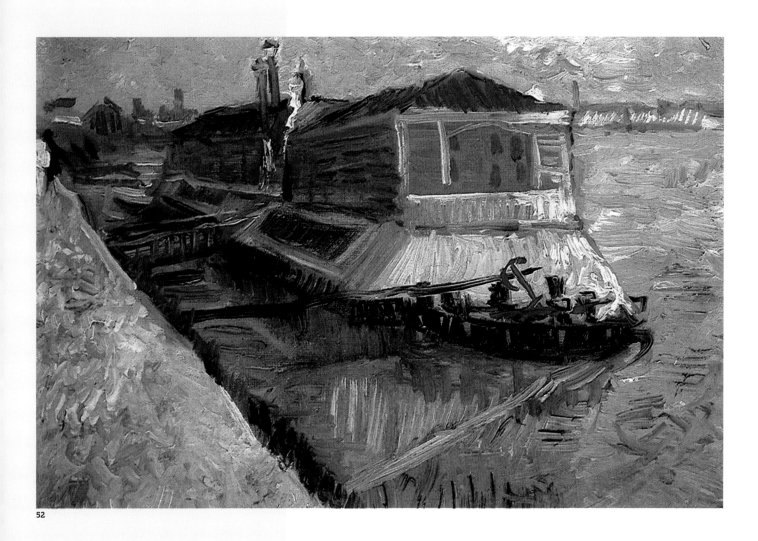

52

Portrait of the Artist as a Young Man

"There is no such thing as a true portrait." Portraits are one of the most fascinating and complex themes in the history of Western art (Fossi 1996). "There is no such thing as a true portrait; they are all delusions; and I never saw any two alike," Nathaniel Hawthorne wrote defiantly in 1850 in *The American Notebooks*. Renaissance thinkers believed that portraits approached divinity because of their many expressive varieties. Since then, they have continued to captivate painters and, via the self-portrait, inspired them to immortalize their own image on canvas, sometimes recording every change in their physical or emotional state. Van Gogh was certainly not the first artist to paint dozens of self-portraits—even within a few days of each other and never in the same exact way. We only need to think of Francisco Goya, Diego Velázquez, or Delacroix.

By the sixteenth century, self-portraits had taken on a life of their own. Even though the term wasn't used until the twentieth century, after Van Gogh's death, Vincent had someone to look up to in this genre: Rembrandt, a compatriot no less, had painted dozens of self-portraits in the seventeenth century. In some he is young, elegant, and confident; in later, sparer compositions, his face is marked by grief.

No two are alike. Vincent used a mirror to paint himself, a common practice at the time. But he never represented himself with the confidence or dynamism of a young Rembrandt. Rather, he portrayed himself wearing different clothes, attitudes, and moods, and he used disparate techniques, as seen in these five examples, among dozens of others. Three of them were created in Paris, between 1887 and 1888, and two in Provence, in 1889, as he was recovering at Saint-Paul de Mausole.

53
Self-Portrait (Paris, fall 1887). Oil on canvas, 47x35cm. Paris, Musée d'Orsay. F320/JH1334.

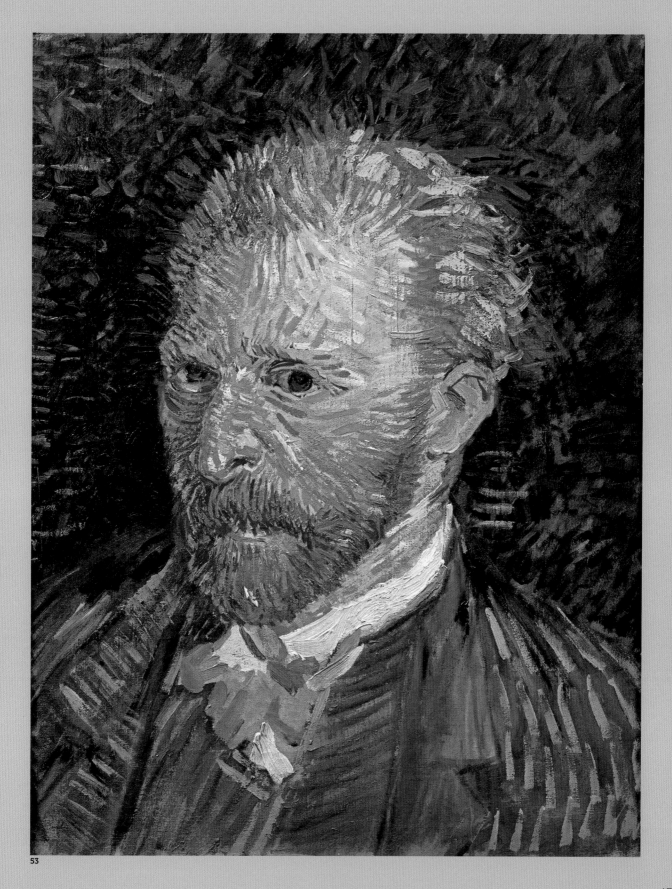

53

Portrait of the Artist as a Young Man

54

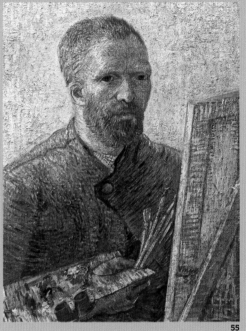

55

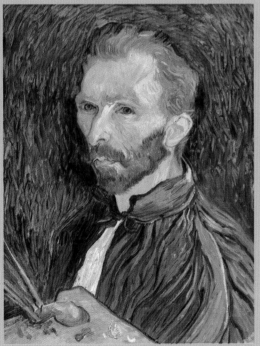

56

54
Self-Portrait with Straw Hat (Paris,
August–September 1887). Oil on cardboard,
40.5x32.5cm. Amsterdam, Van Gogh
Museum (Vincent van Gogh Foundation).
F469/JH1310.

55
Self-Portrait as a Painter (Paris,
December 1887–February 1888). Oil on
canvas, 65x50.5cm. Amsterdam, Van Gogh
Museum (Vincent van Gogh Foundation).
F522/JH1356.

56
Self-Portrait with Palette (Saint-Rémy-
de-Provence, late August 1889). Oil on
canvas, 57.79x44.5cm. Washington, DC,
National Gallery of Art. F626/JH1770.

57
Self-Portrait (Saint-Rémy-de-Provence,
September 1889). Oil on canvas, 65x54.2cm.
Paris, Musée d'Orsay. F627/JH1772.

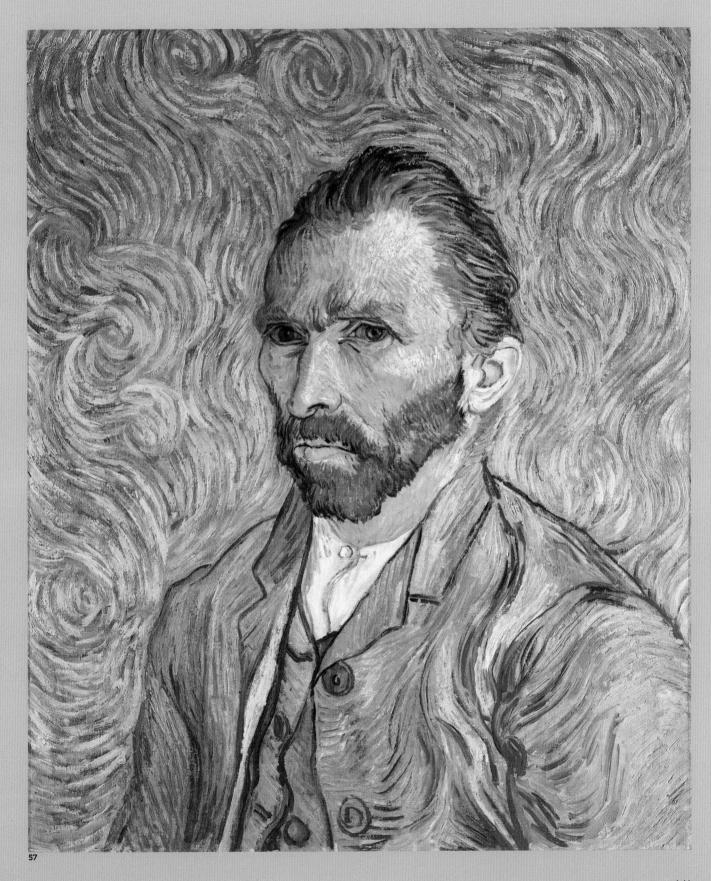

SUBJECT 18-St. Remy — guisto di St. Remy dall'alto
TECHNICAL DATA

Provence, Studio of the South

February 20, 1888–May 16, 1890

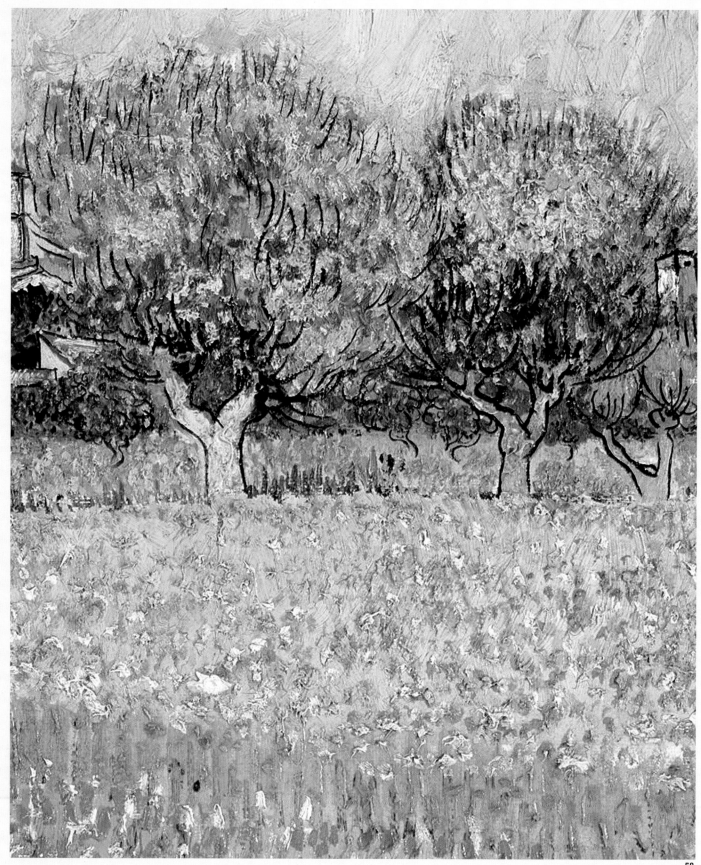

In Search of Light and Sun

(February 20, 1888–May 8, 1889)

**Les Alpilles (Bouches-
du-Rhône, France)** A rocky
outcrop near Les-Baux-
de-Provence, northeast of
Arles, similar to what Van
Gogh saw as he traveled
from Paris to Arles on
February 19 and 20, 1888.

After a series of disappointments, Vincent left Paris on February 19, 1888, in search of light and sun. The spell had broken—he would return only once more, two years later, for a handful of days, before his last, fateful move to Auvers. He had done well in Paris. He'd organized a sort of artist consortium, promoted art exchanges, pushed Theo toward impressionism, and engaged with galleries and exhibitions. He was also tuned into the troubles of the art world, which was wobbling between calls for innovation and the traditional leanings of the bourgeoisie. But it was a harsh world, even setting aside his mood swings, anxieties, and irritable disposition. He bitterly observed that "it seems to me almost impossible to be able to work in Paris," as he lacked "a refuge where one can recuperate and regain one's tranquility and poise. Without that, one would get hopelessly exhausted." (Arles, February 21, 1888. To Theo.) Yet even after moving to Arles, Vincent continued to give advice to Theo. His brother had to meet the demands of his more traditional clients even as the younger crowd's increasingly modern preferences gained traction among critics. Theo knew that "the young school of painting concentrates particularly on getting sunshine into their pictures." This was why Vincent had left for the south, Theo told his sister: Arles would help him "get his bearings" before he would probably move on to Marseille. (Paris, February 24–26, 1888.) Theo and Vincent had become closer than ever, even if physically distant. Theo also told Wil that he'd discovered surprising qualities and an uncommon sensitivity in Vincent. He knew that he would miss him.

At that time, the train ride from Paris to Arles took a day and a half. Vincent had a lot of time to think, as his letters bear out. In particular, he was struck by the sight of a new landscape on the last stretch of his journey, after Tarascon. From his window, "I noticed a magnificent landscape of immense yellow rocks, strangely intricate with the most imposing shapes." The narrow valleys of the Alpilles mountain range contained "rows of small round trees with foliage of olive-green or gray-green, which could well be lemon trees." He'd left in search of sun, but first he found snow. He launched into comparisons: Arles appeared flat to him, not much bigger than Breda or Mons. The snowy hilltops of the Alpilles "with the summits white against a sky as luminous as the snow, were just like winter landscapes done by the Japanese." By now, he was seeing Japan in everything—an idealized Japan. He painted himself as a Buddhist monk and started to use a two-dimensional, almost graphic style intentionally devoid of the linear perspective of the humanistic tradition. His outlines looked like they were drawn in pen, even as he filled them with powerful brushstrokes of color.

In Arles, Vincent initially stayed at the Hotel Restaurant Carrel on Rue de la Cavalerie. He met a pair of foreign artists and started painting a few local people, in somewhat

In Search of Light and Sun

February 20, 1888–May 8, 1889

awkward poses. Meanwhile, in Paris, three of his paintings went on display at the IV Exposition de la Société des Artistes Indépendants. In early May, he rented the east wing of the Yellow House, on 2 Place Lamartine, to use as a studio. On that same square, he moved into a room above the Café de la Gare, run by the Ginoux family.

He painted still lifes, flowering trees, the Langlois Bridge series. He wrote to his friend Bernard that he was convinced of "the absolute necessity of a new art of color, of drawing and—of the artistic life." Nature in all its manifestations attracted him: the sea at Saintes-Maries-de-la-Mer, the iris fields, the grain, along with the iron bridge over the Rhône, the cafés, the faces of the people, the tree-lined streets with Roman sarcophagi. His studies were entirely focused on chromatic tonalities—he was convinced that the painter of the future would have to be "a colorist such as there hasn't been before." He compared Provence to his home country; it seemed identical to Holland "in character." The difference was in the intensity of color. Here, brown tones gave way to "sulfur everywhere where the sun beats down."

59
Letter to Émile Bernard with a sketch of the Langlois Bridge. (Arles, March 18, 1888. To É. Bernard, 587F.) New York, Morgan Library & Museum, Thaw Collection.

Vincent had always been somewhat obsessed with color. Now it was as if he were looking at the world through a chromatic prism and seeing infinite combinations of primary colors. His palette—which he'd regularly described since his first experiments in Holland and Belgium—had changed. He regretted his former use of so many dark colors and marked the names of colors in French above each detail in his sketches. He spoke and wrote fluent French, even though he struggled with the Provence accent (he confused the Langlois Bridge with "l'Anglais" bridge.) He wrote in pen: "Bleu, citron vert pâle, vert-blanc, jaune citron, chrome 1, chrome 2, chrome 3, cobalt très clair, orange, blanc, rose." He asked Theo for tubes of paint—he wanted more zinc oxide, ultramarine, Paolo Veronese green, Prussian blue, chrome yellow—and went through rolls and rolls of canvas. He was even more intent on painting live subjects, including his starry skies, which were actually far more realistic than art historians have believed.

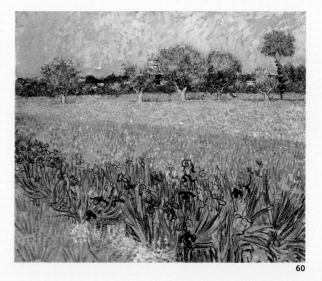

60

60
Field with Irises near Arles (Arles, May 1888). Oil on canvas, 54x65cm. Amsterdam, Van Gogh Museum (Vincent van Gogh Foundation). F409/JH1416.

As time passed, he began to criticize Gauguin, in person, and Bernard, by letter. *They* didn't feel compelled to trek through the fields with their easels. He watched women gathering olives, whereas *they* have "probably never seen an olive tree." (Saint-Rémy-de-Provence, c. November 19, 1889. To Theo.) Vincent's relationship with Gauguin became embattled and his mood increasingly unstable, leading him to the point of self-harm. After Vincent cut off part of his ear, Gauguin left Arles and the two never saw each other again. Van Gogh was shaken: his breakdowns were becoming more and more frequent, and after multiple stays at the hospital in Arles, he was admitted to a mental institution at Saint-Rémy. He would be there for a year.

Mon cher Bernard, ayant promis de
t'écrire, je veux commencer par te
dire que le pays me paraît aussi
beau que le Japon pour la limpidité
de l'atmosphère et les effets de couleur
gaie. Les eaux font des tâches d'un
bel émeraude et d'un riche bleu dans les
paysages ainsi que nous le voyons
dans les crépons. Des couchers de soleil
orangé pâle faisant paraître bleus les
terrains. Des soleils jaunes splendi...
Cependant je n'ai encore guère vu le
pays dans sa splendeur habituelle d'été
Le costume des femmes est joli et le dimanche
surtout on voit sur le boulevard des
arrangements de couleur très-naïfs et
bien trouvés. Et cela aussi sans doute
s'égayera encore en été

59

An Absinthe-Colored Sky
(The Trinquetaille Bridge)

Van Gogh painted at least two versions of the bridge that connects Arles to the suburb of Trinquetaille, on the other side of the Rhône. Both are in private collections.

The earlier of the two (fig. 62) depicts the left bank—there are sailboats on the river and people walking along the riverbank. Van Gogh described it to his painter friend John Russell as "a view of the river with a greenish yellow sky." (Arles, June 17, 1888. To J. P. Russell.) To Theo he wrote, "I have a view of the Rhône—the iron bridge at Trinquetaille—in which the sky and the river are the color of absinthe; the quays, a shade of lilac; the figures leaning on their elbows on the parapet, blackish; the iron bridge, an intense blue, with a note of vivid orange in the blue background, and a note of intense malachite green." (Arles, June 28, 1888. To Theo.)

The later version (fig. 61), was painted "on a gray morning [. . .] the sky, pale blue." (Arles, October 13, 1888. To Theo.) It showed an even bolder angle, where vanishing lines fanned out in all directions. Studies from this time made their way into other series, such as the Langlois Bridge series (pp. 152–155).

61

The Trinquetaille Bridge (Arles, October 1888). Oil
on canvas, 72.5x91.5cm. Sold at auction by Christie's
(New York, June 19, 1987, lot 78). F481/JH1604.

62

Le Pont de Trinquetaille (Arles, June 1888). Oil
on canvas, 65x81cm. Sold at auction by Christie's
(New York, November 3, 2004, lot 41). F426/JH1468.

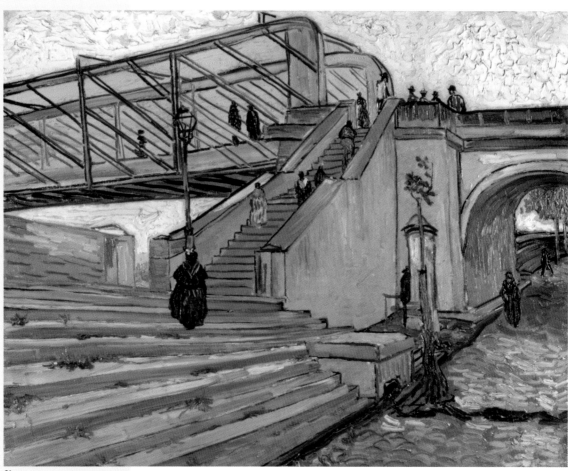

61

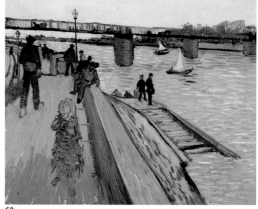

62

A Day and a Night on the Beach

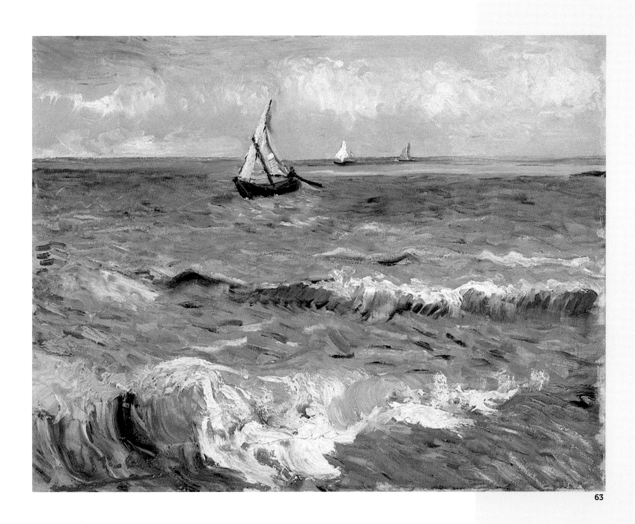

63

"Early tomorrow I start for Saintes-Maries on the Mediterranean," Vincent wrote to Theo between May 29 and 30, 1888. It's not clear when he actually left—probably a few days later because of high winds. We do know what he brought with him: "I am taking two canvases, but I'm rather afraid it will probably be too windy to paint. You go by diligence, it is 50 kilometers from here. You cross the Camargue, grass plains where there are herds of fighting bulls and also herds of little white horses, half wild and very beautiful." (Arles, c. May 28–29, 1888. To Theo.)

The result was a few splendid seaside landscapes, as he described a few days later. "The Mediterranean has the colors of mackerel, changeable I mean. You don't always know if it is green or violet, you can't even say it's blue, because the next moment the changing light has taken on a tinge of pink or gray." Vincent walked along the deserted beach at night: "The shore here is sandy, neither cliffs nor rocks—like Holland without the dunes, and bluer." He didn't find it cheerful, but it wasn't sad, either. Just beautiful. He looked at the sky and the stars: "The deep blue sky was flecked with clouds of a blue deeper than the fundamental

64

Fishing Boats on the Beach at Saintes-Maries-de-la-Mer (Saintes-Maries-de-la-Mer, June 1888). Oil on canvas, 64.5x81cm. Amsterdam, Van Gogh Museum (Vincent van Gogh Foundation). F415/JH1460.

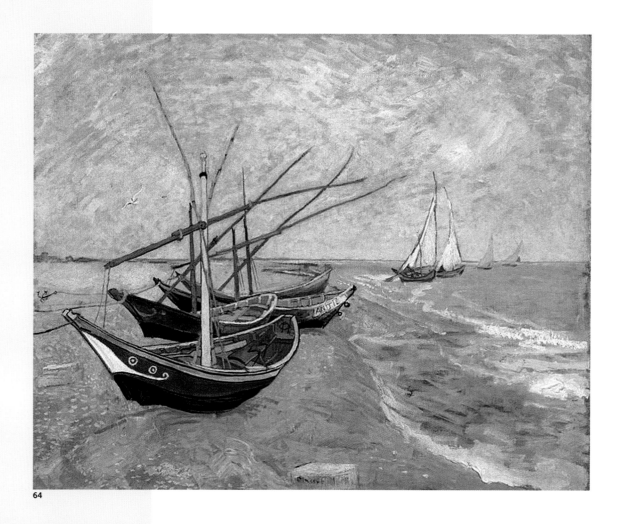

64

blue of intense cobalt, and others of a clearer blue, like the blue whiteness of the Milky Way. In the blue depth the stars were sparkling, greenish, yellow, white, pink, more brilliant, more emeralds, lapis lazuli, rubies, sapphires." (Saintes-Maries-de-la-Mer, June 3–4, 1888. To Theo.)

**Saintes-Maries-de-la-Mer
(Bouches-du-Rhône, France)**
Indigenous Camargue horses.

The Bridge of the "Englishman"

The original drawbridge, built in the eighteenth century, passes over the canal that runs from Arles to Bouc. People called it the Pont de Langlois, after its owner, but its official name was Pont de Réginel. It was later renovated and reinforced but then destroyed during World War II. Its replacement (see page 155) was not an exact match, nor was it built in the same place, but it was an apt tribute to Van Gogh's masterpiece. On arriving in Arles in February 1888, Vincent took an immediate liking to this drawbridge, maybe because it reminded him of the canals of his native land. But because he misunderstood the local dialect, he thought it was called the bridge *de l'Anglais,* or "of the English." It took him only a few weeks to paint this subject on four canvases, which are now in museums at Otterlo (F397), Cologne (FCXC), and Amsterdam (F400), and in a private collection (F571). He also created a watercolor and three drawings that are in Los Angeles County Museum of Art (F1471), Stockholm (Staatsgalerie, F1470), and Providence, Rhode Island (Rhode Island School of Design Museum, F1216), respectively.

Vincent incorporated the first known sketch in a famous letter to Émile Bernard, reproduced on page 147. He also painted a preliminary study that is now in a private collection. Both contained two figures that never made it into a final painting (see p. 154).

A funny thing. A letter to Theo contains one of the first descriptions of this subject.

It is a drawbridge over which passes a little cart, standing out against a blue sky—the river blue as well, the banks orange colored with grass and a group of women. (ARLES, MARCH 16, 1888. TO THEO.)

Vincent was visualizing Provence in outlines and clearly defined spaces, often with human subjects in the foreground, as in Japanese xylography. The result was a "funny thing," different from his Parisian work. The loose, free brushstrokes of the Paris days were gone, replaced by "colors like stained glass, and a design of solid outlines." At the end of March, happy with his results, he considered sending this version of the *Langlois Bridge at Arles* to Hermanus Tersteeg in The Hague. He wanted to extend an olive branch after having severed relations for a long time. Other versions followed, including a watercolor he sent to Theo to explain the framing of the scenery and the blaring vividness of the colors. Today, *Langlois Bridge at Arles* is among the most unforgettable scenes Van Gogh painted in Arles. Film directors including Minnelli and Kurosawa have used it in their work.

In 1956, Kirk Douglas played a convincing Vincent van Gogh in Vincente Minnelli's *Lust for Life*, based on the Irving Stone novel of the same name. The movie, which retraces the milestones of Van Gogh's life, was shot on location with no expenses spared. The production even borrowed some two hundred original paintings and had others copied specifically for the film. In this frame, Douglas/Van Gogh is at work near the Langlois Bridge. By that time, the bridge had been destroyed, along with nine others on that canal. The only one still standing was the Fos Bridge, dismantled in 1959. The scene was likely filmed there.

65

*The Langlois Bridge at
Arles with Women Washing*
(Arles, March 1888). Oil on
canvas, 54x65cm. Otterlo,
Kröller-Müller Museum.
F397/JK1368.

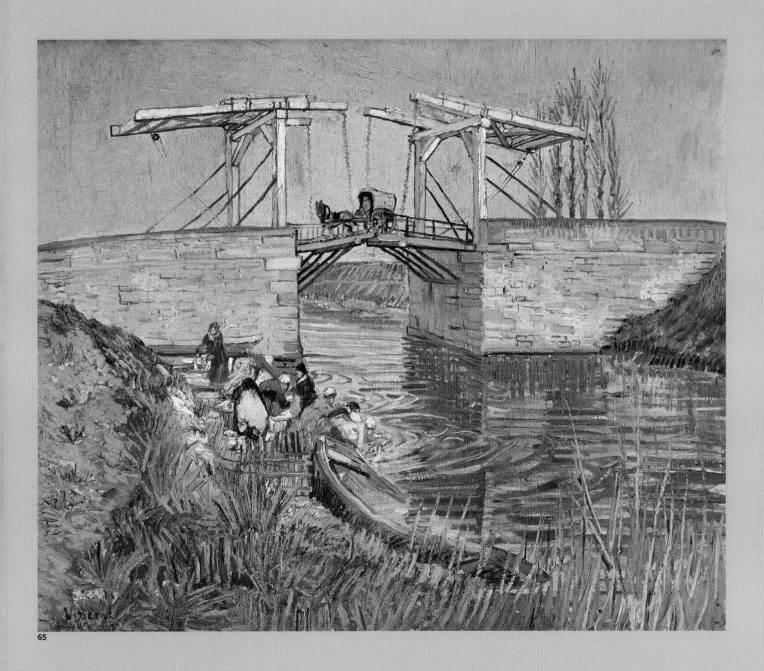

65

The Bridge of the "Englishman"

As beautiful as Japan. *My dear Bernard, [. . .] I want to begin by telling you that the country struck me as being as beautiful as Japan for the limpidity of the atmosphere and gay color effects. The water makes patches of a beautiful emerald and a rich blue in the landscapes, such as we see in crepons [Japanese prints]. The pale orange setting sun making the land appear blue. Splendid yellow suns. Meanwhile I haven't really seen the country in its normal summer splendor [. . .]. There would be perhaps a real advantage as well for artists who love the sun and color that exist in the Midi. If the Japanese are not working in their country it is certain that their art continues in France. At the top of this letter I am sending you a small sketch of a study that I am trying to make something of—sailors with their sweethearts going up to the town, which is profiled by the strange silhouette of its drawbridge on a huge yellow sun. [See page 147.]*

(Arles, March 18, 1888. To É. Bernard.)

66

66
Two Lovers (Fragment)
(Arles, March 1888).
Oil on canvas, 32.5x23cm.
F544/JH1369.

This is the last remaining
fragment of a tableau
(as Van Gogh called his
large-format paintings)
with the Langlois Bridge.

67
The Langlois Bridge at Arles
(Arles, May 1888). Oil on
canvas, 49.5x64.5cm.
Cologne, Wallraf-Richartz
Museum. F570/JH1421.

Port-de-Bouc (Bouches-du-Rhône, France) Current
iteration of the Langlois
Bridge, several miles from
the original site.

Arles (Bouches-du-Rhône, France) The Langlois Bridge
(renovated in 1930 and
destroyed in 1944) in a
photo from the early 1900s.

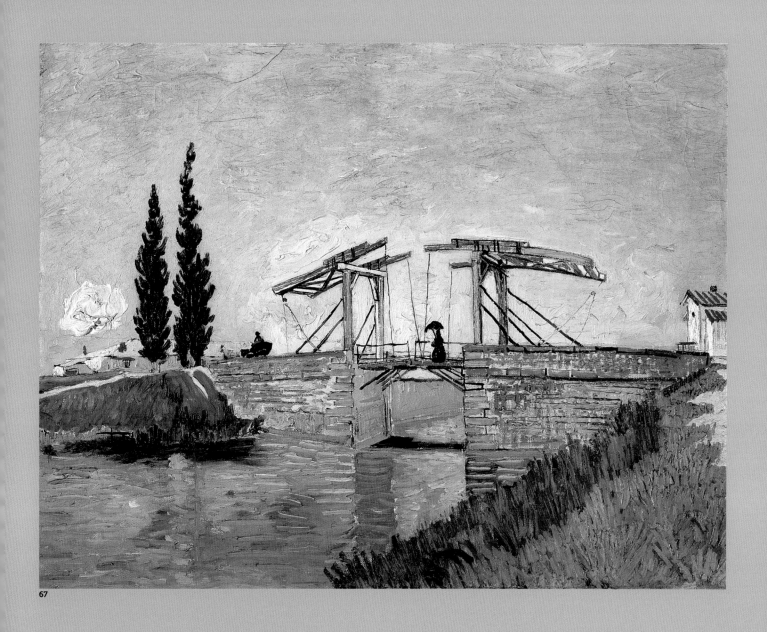

67

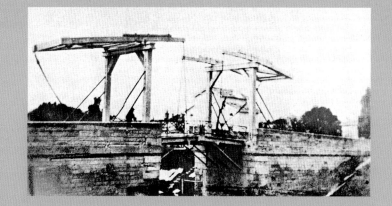

Crau Is to Van Gogh as Aix Is to Cézanne

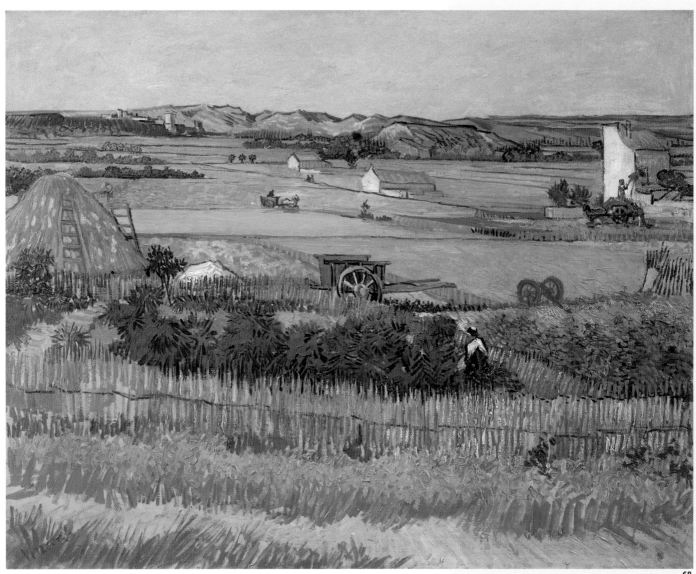

68

Plaine de la Crau (Provence)
The Crau and the ruins of Montmajour Abbey in the background.

The Plaine de la Crau in Provence, known simply as the Crau, lies between Arles, Salon-de-Provence, and the Gulf of Fos. Its 230 square miles form a sort of triangle, surrounded by the Alpilles massif in the north, the Étang de Berre and the Mediterranean to the south and southeast, and the river Rhône delta to the west. Vincent painted here many times between June 12 and 20, 1888. He wanted to study the fields of grain and the harvest. His colors glowed with the gold and bronze of ripe grain, blended with the red of the farmhouse roofs, and he wrote that "the green azure of the white-hot sky, imparts a delicious, exceptionally harmonious color." The landscape reminded him of works painted some forty miles away by "père Cézanne."

The countryside near Aix—where Cézanne works—is just the same as here, it is still the Crau. When I get back home with my canvas and I say to myself, Hullo, I've got old Cézanne's very tones, all I mean is that [. . .] one must be making the same mental calculation to arrive at the same tones.

(ARLES, JUNE 12 OR 13, 1888. TO THEO.)

Vincent told his friend Bernard that he felt much better here than in the north:

I even work right in the middle of the day, in the full sun, with no shade at all, out in the wheat fields, and lo and behold, I am as happy as a cicada. My God, if only I had known this country at 25 instead of coming here at 35! At that time I was fascinated by gray, or rather lack of color.

(ARLES, JUNE 19, 1888. TO É. BERNARD.)

Among the Ruins of Montmajour

Montmajour (Arles, Bouches-du-Rhône, France) The ruins of the medieval abbey, on a hill overlooking the Crau.

Vincent spent a lot of time at Montmajour. In July 1888 he spent a whole day there amid the ruins of the abbey, fig trees, ivy, and white rocks. It reminded him of Paradou Park from Zola's realist novel *La Faute de l'Abbé Mouret* (1875).

I have come back from a day at Mont Majour, and my friend the sub-lieutenant kept me company. The two of us explored the old garden and stole excellent figs there. If it had been bigger it would have made me think of Zola's Paradou, great reeds, vines, ivy, fig trees, olive trees, pomegranates with lusty flowers of the brightest orange, hundred-year-old cypresses, ash trees and willows, rock oaks, half-demolished flights of steps, ogive windows in ruins, blocks of white rock covered with lichen, and scattered fragments of collapsed walls here and there among the greenery. I brought back another big drawing, but not of the garden.

(ARLES, JULY 9 OR 10, 1888. TO THEO.)

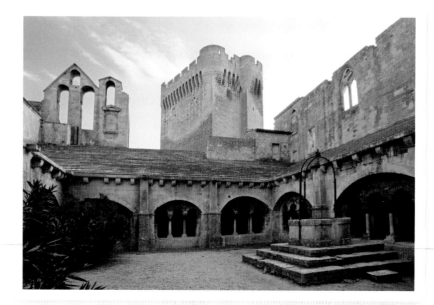

69

The Hill with the Ruins of Montmajour
(Arles, July 1888). Pen on paper, 47.5x59cm.
Amsterdam, Van Gogh Museum (Vincent van
Gogh Foundation). F1446/JH1504.

What struck Vincent most about
Provence was the "space and air,"
as he wrote to his sister.

69

You cannot know what this means,
because this is exactly what we do
not have in our country—but one
distinguishes the color of things at
an hour's distance; for instance the
gray-green of the olive trees and
the grass green of the meadows,
and the pink-lilac of a dug-up field. In
our country we see a vague gray line
on the horizon; here even in the far,
far distance the line is sharply defined,
and its shape is clearly distinguishable.
(ARLES, BETWEEN JUNE 16 AND 22, 1888.
TO WIL.)

A High Yellow Note on Rue Mireille

70
La Maison de la Crau (The Old Mill)
(Arles, September 10, 1888). Oil on canvas,
64.77x53.97cm. Buffalo, Albright-Knox
Art Gallery. F550/JH1577.

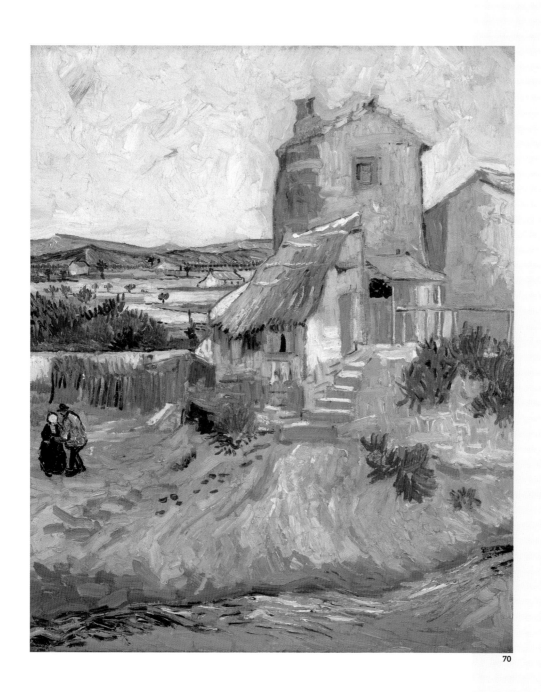

70

This painting, now in Buffalo, New York, dates to when Vincent was furnishing the Yellow House he'd rented from the Ginouxs. His paintings from this time highlight the "high yellow note" he'd searched for (and found) in Provence.

Arles (Bouches-du-Rhône, France)
The old mill on Rue Mireille, in Moulèyres, near Arles. Vincent painted it all in yellow. It is the only remaining mill in the area.

Chrome Yellow and Sunflower Orange

Eleven shades of chrome. Van Gogh created eleven known paintings of sunflowers, four in Paris (June–September 1887, with the flowers on a table) and seven in Arles (August 1888–January 1889, with varying numbers of flowers in a vase). Each is a different take on the beautiful yellow-and-orange flower. In this Paris version, Vincent examined the minute details of a withering bloom leaning against another that's upside down. Thick layers of paint play with the different tonalities of yellow, orange, and brown. The background is abstract, rendered with quick strokes in shades of blue—a vortex that highlights the contours of the flowers. Fine brown lines delineate the petals. When seen up close, these sunflowers instill an almost tactile feeling and create the illusion of a magnified subject.

Yellow tones. In the Arles series (like the paintings done in Paris, these are in museums across the world), the two-tone ceramic vase is always the same, but the hues, number of sunflowers, and their positioning are different each time. In the version that now resides in London, a few flowers are about to open, others are fully in bloom, and still others are wilted. In the background, a blue line separates two shades of yellow; that same line divides the two similar colors of the vase, which reflects light off its glazed surface. He inverted the two yellows in the background to give the vase more prominence. Vincent's signature blazes in that same shade of blue.

71

71
Still Life with Two Sunflowers (Paris, August–September 1887). Oil on canvas, 43.2x61cm. New York, Metropolitan Museum of Art. F375/JH1329.

72
Vase with Twelve Sunflowers (Arles, August 1888). Oil on canvas, 92.1x73cm. London, National Gallery. F454/JH1562.

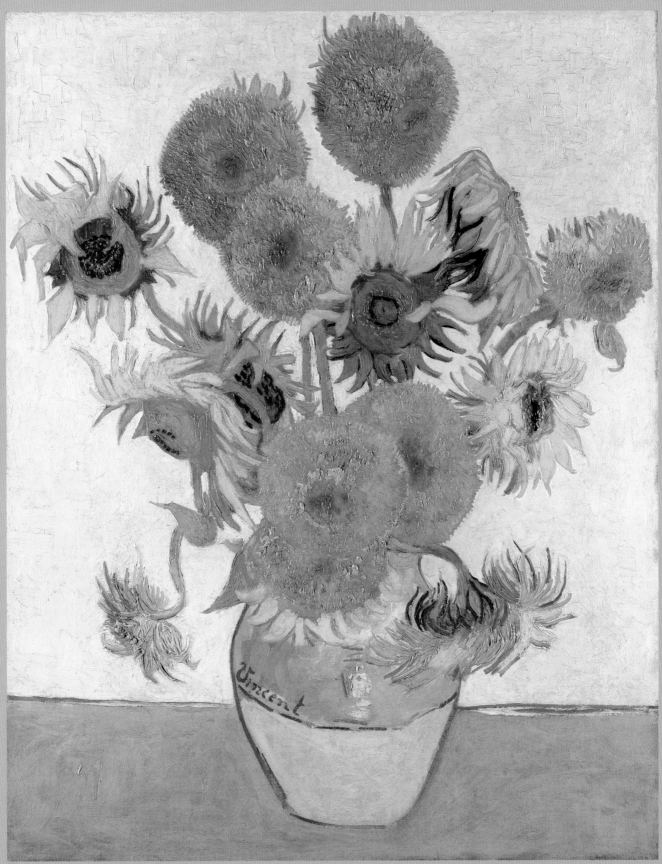

72

Art Exchanges

73

Self-Portrait (Dedicated to Paul Gauguin) (Arles, September 1888). Oil on canvas, 61.5x50.3cm. Cambridge, Harvard Art Museums/Fogg Museum. F476/JH1634.

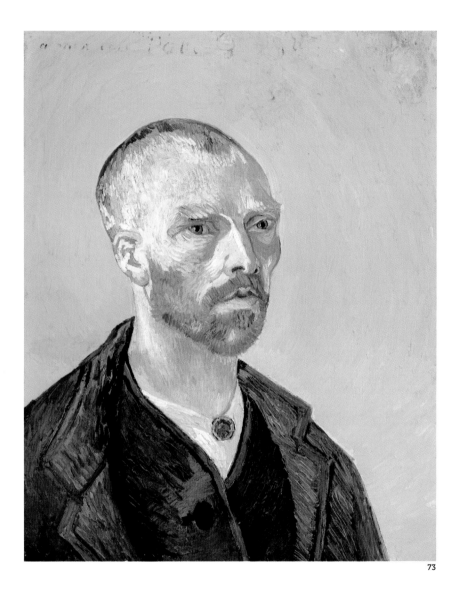

73

Before Gauguin reached Arles, he and Vincent exchanged self-portraits, emulating a longstanding tradition among Japanese artists. While Vincent used a neutral background, Paul played with a few different colors, mimicking a Japanese tapestry. In his painting for Gauguin, Vincent portrayed himself as a Japanese monk:

I've a portrait of myself, all ash gray. The ashen color—which has been obtained by mixing malachite green with orange lead—on pale malachite background, all in harmony with the reddish-brown clothes. Not wishing to exaggerate my own personality, however, I aimed rather for the character of a bonze, a simple worshipper of the eternal Buddha.
(ARLES, OCTOBER 3, 1888. TO PAUL GAUGUIN.)

In his self-portrait, Gauguin included the profile of their mutual friend Émile Bernard in the background, on the far right. In turn, Bernard gave Van Gogh a portrait of himself with a likeness of Gauguin hanging on the wall (Amsterdam, Van Gogh Museum). Gauguin is dressed as Jean Valjean, the main character in Victor Hugo's *Les Misérables*, as indicated by the inscription. Where Vincent painted a neutral background, Gauguin added floating flowers, as if on a wallpaper, echoing the Japanese style.

In Arles, Gauguin captured Van Gogh in the Yellow House as he painted the vase with sunflowers.

Paul Gauguin, *Vincent van Gogh Painting
Sunflowers*, also known as *The Painter
of Sunflowers* (Arles, October 1888).
Amsterdam, Van Gogh Museum
(Vincent van Gogh Foundation).

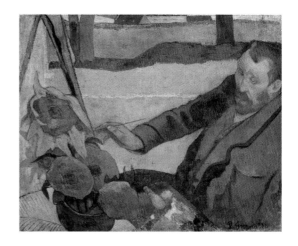

Paul Gauguin, *Self-Portrait with Portrait of
Bernard (Les Misérables)* (Pont-Aven, late
September 1888). Amsterdam, Van Gogh
Museum (Vincent van Gogh Foundation).

Yellow Like Home

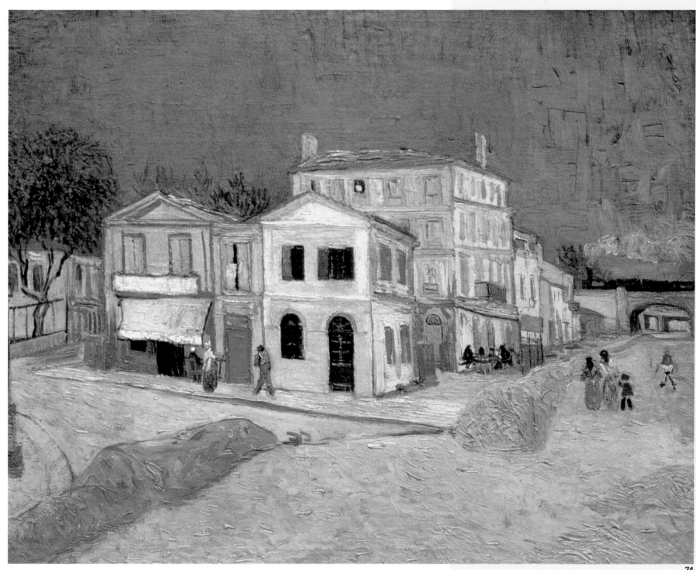

74

Arles (Bouches-du-Rhône, France)
The Yellow House after the bombing of
June 25, 1944. It's still the most famous
yellow house in the world, though
it was heavily damaged by Allied
bombing and later demolished. Vincent
lived there from September 17, 1888,
after furnishing it in preparation for
a visit from Paul Gauguin.

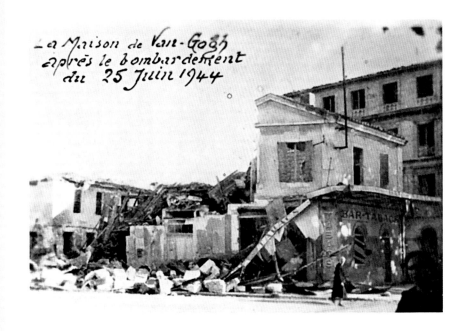

Vincent of Place Lamartine wrote
in Arles:

*I have just sent you a roll of small
pen-and-ink drawings, a dozen I
think. By which you will see that if
I have stopped painting, I haven't
stopped working. You will find among
them a hasty sketch on yellow paper,
a lawn in the square as you come
into the town, with a building at the
back, rather like this.*

And this is how he spoke of the
Yellow House:

*Well, today I've taken the right
wing of this complex, which
contains 4 rooms, or rather two
with two closets. It is painted
yellow outside, whitewashed
inside, in full sunlight. I have
taken it for 15 Fr. a month. Now
my idea would be to furnish one
room, the one on the first floor, so
as to be able to sleep there. This
[house] will remain the studio
and the storehouse for the whole
campaign, as long as it lasts in the
South, and now I am free of all the
innkeepers' tricks: they're ruinous
and they make me wretched.*

(Arles, May 1, 1888. To Theo.)

Furniture for Nine and a Half Weeks

Gauguin arrived at the train station in Arles at 4:00 a.m. on October 23, 1888, after traveling for two days from Pont-Aven in Brittany. Theo had persuaded him to go—he'd sent Gauguin the train fare and enough money to cover the debts he'd racked up in Brittany (he'd managed to sell some of Gauguin's paintings in Paris). Theo was hoping that a friendly face would raise his brother's increasingly miserable spirits. Vincent still wanted Arles to become a "studio of the South" for himself and his friends. He wasn't expecting Gauguin to join him in Arles—the other painter seemed hesitant in his letters. Concerned that his friend might not like his new surroundings, he carefully selected the guest room décor. Even so, Paul stayed in Arles for only nine and a half weeks, unable to put up with Vincent's crises.

Vincent first painted his own famous bedroom in the Yellow House in October 1888. He had decorated it with care and detail. The painting depicted here is preserved in Amsterdam: its colors were altered by a flood in 1889, while Van Gogh was in the hospital at Arles. Luckily, he'd described it to Theo on October, 16, 1888, and to Gauguin the day after, explaining that he used those particular colors (which we can no longer see) to express the idea of "utter repose":

[. . .] the walls pale lilac, the ground a faded broken red, the chairs and the bed chrome yellow, the pillows and the sheet a very pale green-citron, the blanket blood red, the washstand orange, the washbasin blue, the window green.

(ARLES, OCTOBER 17, 1888. TO PAUL GAUGUIN.)

Later, in Saint-Rémy-de-Provence, Vincent painted two other versions, one currently held in Paris at the Musée d'Orsay and the other at the Art Institute of Chicago. The Paris painting (details) is reproduced on pages 170–171.

75

Bedroom in Arles (Arles, October 1888).
Oil on canvas, 72.4x91.3cm. Amsterdam,
Van Gogh Museum (Vincent van Gogh
Foundation). F482/JH1608.

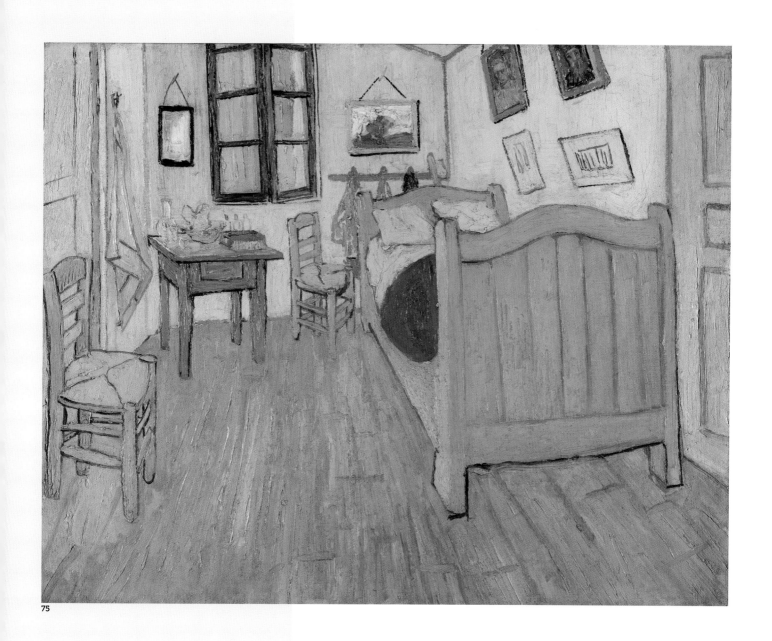

75

A Chair, a Bed, a Nightstand

76–78
Bedroom in Arles (Saint-Rémy-de-Provence, September–October 1889), details. Oil on canvas, 57.3x74cm (full painting, not shown). Paris, Musée d'Orsay. F483/JH1793.

76

These details are from the second version of *Bedroom in Arles*, created between September and October 1889 at the Saint-Paul de Mausole asylum in Saint-Rémy-de-Provence. Vincent had bought all the furniture in September 1888:

My dear Theo, [...] yesterday I was busy furnishing the house. [...] I have bought one walnut bed and another in white deal which will be mine and which I'll paint later. Then I got bedclothes for one of the beds, and two mattresses. If Gauguin comes, or someone else, there is his bed ready in a minute. I wanted to arrange the house from the start not for myself only, but so as to be able to put someone else up too. [...] I have bought 12 chairs, a mirror and some small necessities [...]. For a visitor there will be the prettier room upstairs, which I shall try to make as much as possible like the boudoir of a really artistic woman. Then there will be my own bedroom, which I want extremely simple, but with large, solid furniture, the bed, chairs and table all in white deal. Downstairs will be the studio, and another room, a studio too, but at the same time a kitchen. Someday or other you shall have a picture of the little house itself in bright sunshine, or else with the window lit up, and a starry sky.

(ARLES, SEPTEMBER 9, 1888. TO THEO.)

77

78

Les Alyscamps and the Ancient Sarcophagi

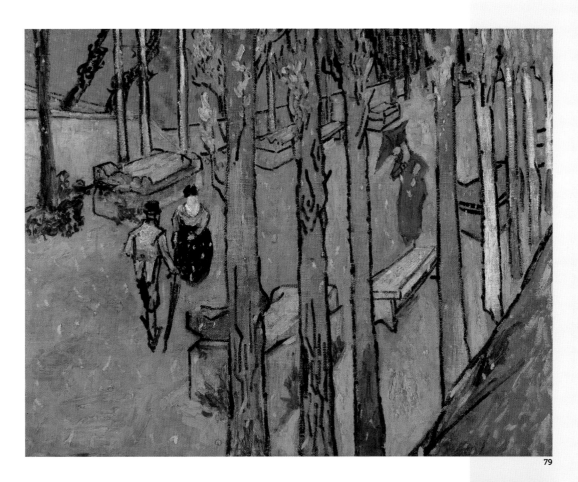

79

I think you will like the fall of the leaves that I have done. It is some poplar trunks in lilac cut by the frame where the leaves begin. These tree-trunks are lined like pillars along an avenue where to right and left there are rows of old Roman tombs of a blue lilac. And then the soil is covered, as with a carpet, by a thick layer of yellow and orange fallen leaves. And they are still falling like flakes of snow. And in the avenue little black figurines of lovers. The upper part of the picture is a bright green meadow, and no sky or almost none. The second canvas is the same avenue but with an old fellow and a woman as fat and round as a ball.

(Arles, c. November 3, 1888. To Theo.)

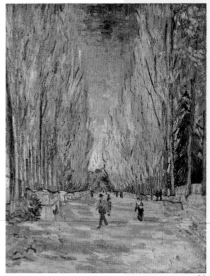

80

79

Les Alyscamps: Falling Autumn Leaves (Arles, November 1, 1888). Oil on canvas, 72.8x91.9cm. Otterlo, Kröller-Müller Museum. F486/JH1620.

80

Les Alyscamps (Arles, November 1888). Oil on canvas, 91.7x73.5cm. Sold at auction by Christie's (New York, November 4, 2003, lot 25). F569/JH1623.

Les Alyscamps (Arles, Bouches-du-Rhône, France) A window into the Roman past of Arles, in the southeastern part of the city near the old walls. Les Alyscamps, "the way of the Elysian Fields," is a necropolis flanked by ancient sarcophagi. Van Gogh painted several versions of this beautiful avenue, two of which can be seen here, in the fall of 1888.

Gauguin, Van Gogh, and the Arlésienne

Painted in less than an hour. *I have an Arlésienne at last, a figure (size 30 Canvas) slashed on in an hour, background pale lemon, the face gray, the clothes black, deep black, with unmixed Prussian blue. She is leaning on a green table and seated in an armchair of orange wood.*
(ARLES, NOVEMBER 3, 1888. TO THEO.)

It is not clear which painting he was talking about because there are two versions. It is difficult to establish whether both or just one was painted in an hour, or in three-quarters of an hour—as Vincent reported in separate letters to Theo on November 3, 1888, and on January 22, 1889, after sending him several paintings. The version in fig. 81—the one now in Paris—is more hurried in its execution, which would argue that it took very little time to paint. In this canvas, which is on a thinner canvas, the woman is posing with a pair of gloves and a red umbrella. (The red changed color over time, which happened often in Van Gogh's paintings.) The woman is resting her cheek on her left hand. The objects on the table seem to have been added later.

The painting that's in New York has similar dimensions but is on a thicker canvas. This is apparently the most complete version, the one heaviest with significance. The three well-worn books on the table—two with red covers and one with a yellow cover—were probably Vincent's. We don't know their contents, but we can guess they were novels. Until 1895, this painting was in Arles at the home of Madame Ginoux, the woman depicted. It was sold for sixty francs to Ambroise Vollard, a Paris art dealer. Henri Laget, editor of the magazine *Province Antique*, brokered the sale.

A melancholic Arlésienne. We know a lot about the woman in the Arlésian dress. Forty years old at the time, she was named Marie Julien. In 1866, she married Joseph-Michel Ginoux; the couple managed the Café de la Gare at 30 Place Lamartine in Arles. Vincent lodged in that building, in a room he rented starting in early May 1888. He painted the building many times and continued to sleep there even after renting the right wing of the Yellow House

81-82
The Arlésienne (Arles, the Yellow House, November 1888), full painting and detail. Oil on canvas, 91.4x73.7cm. Paris, Musée d'Orsay. F498/JH1624.

83
The Arlésienne (Arles, the Yellow House, November 1888). Oil on canvas, 92.5x73.5cm. New York, Metropolitan Museum of Art. F498/JH1624.

81

82

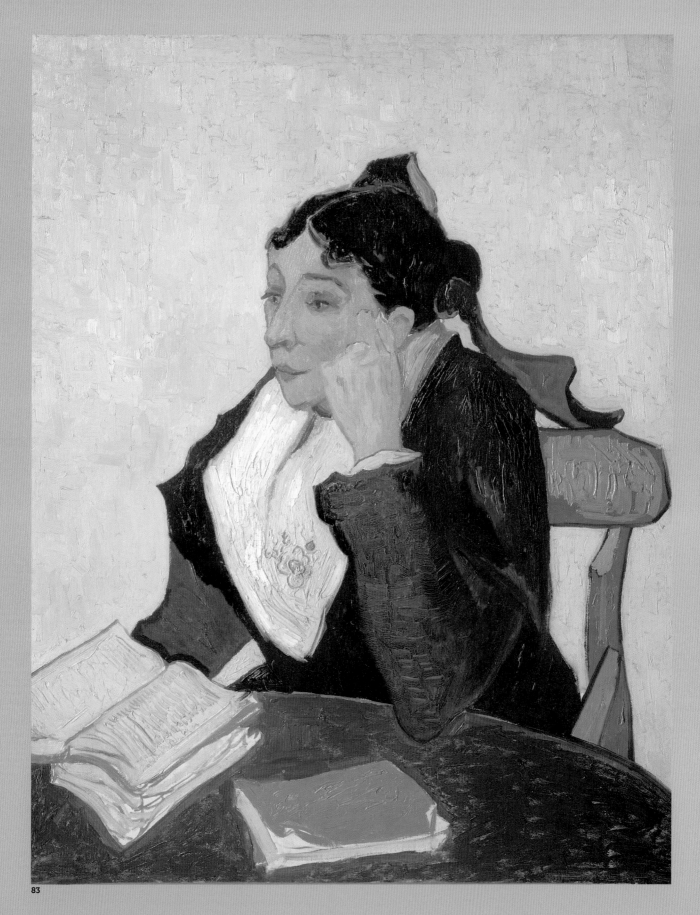

Gauguin, Van Gogh, and the Arlésienne

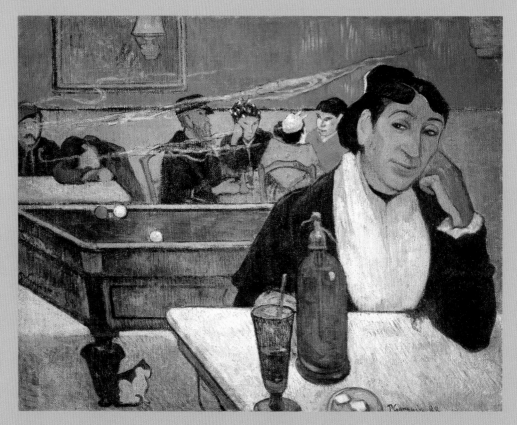

Paul Gauguin, *Night Café, Arles* (Arles, the Yellow House, November 1888). Oil on canvas, 73x92cm. Moscow, Pushkin State Museum of Fine Arts.

84
The Arlésienne with a Pink Background, (Saint-Rémy-de-Provence, February 1890). Oil on canvas, 65x54cm. São Paulo, Museu de Arte de São Paulo Assis Chateaubriand F498/JH1894.

84

(at number 2 of the same square) that same month. He'd wanted to set up a separate studio for himself and for any other artists that might come to work with him.

One model, two painters. When Van Gogh was admitted to the psychiatric hospital in Saint-Rémy-de-Provence in 1889, he revisited the subject of Madame Ginoux more than once, this time from the front. (A canvas from this series is now in the Galleria Nazionale d'Arte Moderna in Rome; another, seen here, is in Brazil.) The frontal view, replicated in several drawings (F540–F543), was inspired by a drawing by Gauguin that is now at the Fine Arts Museums of San Francisco. Vincent's first two versions, set against a yellow backdrop, were painted under very unusual circumstances. In late October or early

Paul Gauguin painting Madame Ginoux: frame from the feature film *At Eternity's Gate* (2018), directed by Julian Schnabel, with Oscar Isaac in the role of Gauguin and Emmanuelle Seigner as Madame Ginoux. Van Gogh, played by Willem Dafoe, is not seen here, but in the following scene he is in the far right of the room, painting his first version of *The Arlésienne* (fig. 82, p. 174).

November 1888, Gauguin, who was living and working with Van Gogh in the Yellow House, had asked Madame Ginoux to pose for him. He wanted to paint the Café de la Gare at night, with the billiards table and drowsy patrons in the background. What Madame Ginoux didn't know was that Gauguin was using her as a stand-in for a prostitute, like the ones who brought their clients there at night. In Gauguin's painting (opposite), the Arlésienne is in the foreground, striking a somewhat suggestive pose. She looks pensive or annoyed, sitting at a table with a bottle and a glass, her left hand on her cheek. It was the rainy season, and even Vincent was at home. Taking advantage of the opportunity, he resolved to paint the same portrait but from a different position—placing himself further to the right of Gauguin. To understand the event, Julian Schnabel faithfully reconstructed the scene in his 2018 film *At Eternity's Gate.*

Brothels

Vincent just wanted to be left alone, especially by people he didn't even know. Apparently the people of Arles were a little too curious about him:

All I would ask is that people whom I do not even know by name [. . .] do not meddle with me when I am busy painting, or eating, or sleeping, or taking a turn at the brothel.
(Arles, March 22, 1889. To Theo.)

Arles (Bouches-du-Rhône, France)
The riverbank in the old town. The brothels frequented by Van Gogh and Gauguin were in the old part of the city, along the Rhône on Rue du Grand Prieuré, near the Porte de la Cavalerie.

Arles Rue du Grand Prieuré, red-light district in the late 1800s.

I have already written you a thousand times that my night café isn't a brothel; it is a café where night prowlers cease to be night prowlers, because they flop down at a table and spend the whole night thus without prowling at all. It may happen that a whore brings her fellow along.

(ARLES, OCTOBER 5, 1888. TO É. BERNARD.)

I saw a brothel here last Sunday—not counting the other days—a large room, the walls covered with blued whitewash—like a village school. Fifty or more military men in red and civilians in black, their faces a magnificent yellow or orange (what hues there are in the faces here), the women in sky blue, in vermilion, as unqualified and garish as possible. The whole in a yellow light. A good deal less gloomy than the same kind of offices in Paris. There is no "spleen" in the air here. For the moment I am still lying low and keeping very quiet, for first of all I must recover from a stomach disorder of which I am the happy owner, but after that I shall have to make a lot of noise, as I aspire to share the glory of the immortal Tartarin de Tarascon.

(ARLES, C. OCTOBER 19, 1888. TO É. BERNARD.)

A Desperate Act

December 23, 1888. In December 1888, Vincent suffered a nervous breakdown and cut off part of his ear with a razor blade. He and Gauguin had gotten into yet another argument, and Gauguin had decided to leave. According to lore, Vincent wrapped the ear in bloody paper and delivered it to a prostitute named Rachel in the middle of the night. However, Bernadette Murphy's research (Murphy 2016) found that the young woman in question was actually Gabrielle Berlatier—not a prostitute but an eighteen-year-old waitress, the daughter of a farmer who lived north of Arles. Police officer Alphonse Robert, who arrived at the brothel after Van Gogh hurt himself, had revealed the girl's name to a reporter in 1936. But the papers reported that her name was Rachel—probably an alias, given her young age and the nature of the establishment. The woman later married and lived a long life. Until recently, the family never divulged the truth, but Berlatier's heirs finally gave Murphy permission to reveal her name.

85
Self-Portrait with Bandaged Ear (Arles, January 1889). Oil on canvas, 60x49cm. London, Cortauld Gallery. F527/JH1657.

A rather serious wound. It was long believed that Vincent had severed only a small piece of his left lobe. But the wound was actually far more serious: he'd almost completely removed his left auricle. Félix Rey, the doctor who treated Vincent in Arles, later sketched it. The drawing was in the archives of Irving Stone, author of *Lust for Life*, which inspired Vincente Minnelli's film with Kirk Douglas. Stone had met the doctor in Arles on August 18, 1930, and asked him to sketch the wound.

Arles, Rue du Bout (Bouches-du-Rhône, France) Location of the brothel where Vincent delivered his ear to Gabrielle Berlatier.

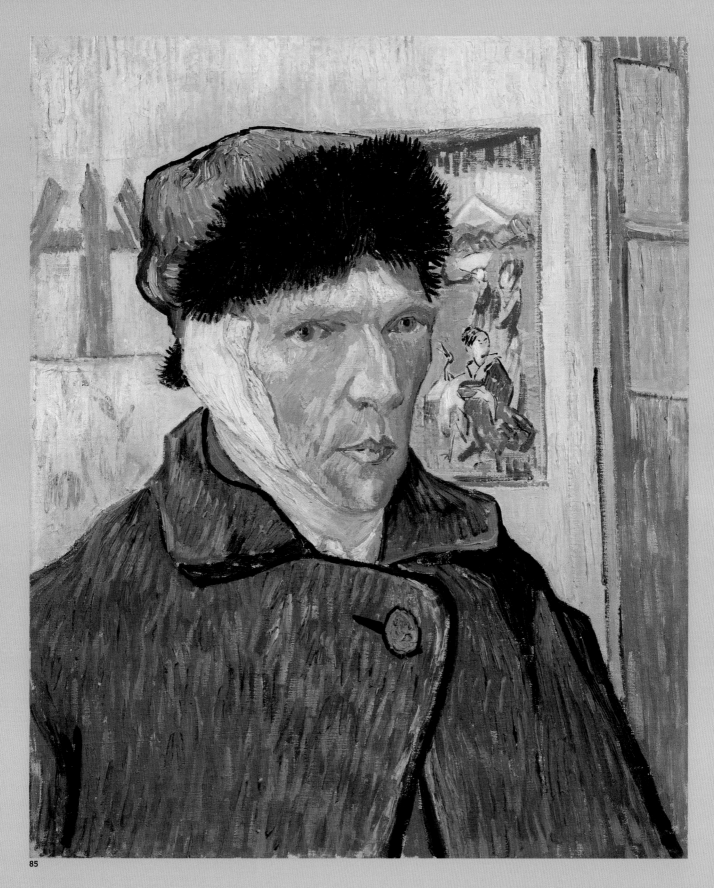

85

The Hospital in Arles

86

Garden of the Hospital in Arles
(Arles, April 1889). Oil on canvas,
73x92cm. Winterthur, Oskar Reinhart
collection am Römerholz. F519/1687.

86

Arles (Bouches-du-Rhône, France)
The garden of the Hotel-Dieu, which
once housed the hospital. Vincent was
committed after cutting off part of his
ear on December 23, 1888. He would
return several times in the following
months. His attending physician was
Félix Rey (for whom the square was
named); Van Gogh portrayed him in
a painting that is now at the Pushkin
State Museum of Fine Arts in Moscow.
The painting of the hospital garden
is quite true to life. The building
now hosts an exhibition space
(Espace Van Gogh).

87

Secluded in Saint-Rémy

May 8, 1889–May 16, 1890

My poor boy, our neurosis, etc., comes, it's true, from our way of living, which is too purely the artist's life, but it is also a fatal inheritance, since in civilization the weakness increases from generation to generation. If we want to face the real truth about our constitution, we must acknowledge that we belong to the number of those who suffer from a neurosis which already has its roots in the past." (Arles, May 4, 1888. To Theo.)

Vincent wrote this letter to Theo a few months before cutting his ear. He was trying to explain his depression but also Theo's, as if to console him for his discontent as a gallerist. After injuring his ear, Vincent was forced to reflect on what had led him to act this way and why. "I knew well enough that one could fracture one's legs and arms and recover afterward," he observed, "but I did not know that you could fracture the brain in your head and recover from that too." (Arles, January 28, 1889. To Theo.)

He learned that "I still have a sort of 'what is the good of getting better?' feeling about me, even in the astonishment aroused in me by my getting well, which I hadn't dared hope for," adding, in the same heartfelt letter, "let me go quietly on with my work; if it is that of a madman, well, so much the worse. I can't help it. However, the unbearable hallucinations have ceased, and are now getting reduced to a simple nightmare, in consequence of my taking bromide of potassium, I think [...]. And once again, either shut me up in a madhouse right away—I shan't oppose it, for I may be deceiving myself—or else let me work with all my strength, while taking the precautions I speak of."

Dr. Rey committed Vincent to the hospital in Arles and kept him in solitary confinement for two or three days. In a 1922 letter, the doctor described the cell as a sort of isolated apartment. But things were deteriorating. In March, about eighty inhabitants of Arles signed a petition claiming that Vincent was not fit to live in society. Vincent told Theo about it on March 19. He knew that if he didn't keep his indignation in check, he would only make matters worse. Vincent was once again committed, the Yellow House was closed, and eventually—after some highs and lows and some hospitalizations and releases in Arles—he was committed to Saint-Rémy, a psychiatric hospital in the beautiful medieval monastery of Saint-Paul de Mausole, run by Dr. Théophile Peyron. Vincent stayed there from May 8, 1889, to May 16 of the following year. When we visited in 1990, it was still being used as a psychiatric clinic, and the only accessible areas were the cloister and chapel. Today, it's possible to walk the halls and visit Vincent's old room. Vincent's stay was lengthy, but he was the only patient allowed to leave and walk around outdoors to paint. He completed some 150 paintings and 100 drawings in twelve months. He painted the wild natural ravines, olive trees in fields, the harvest, and extraordinary landscapes beneath starry skies, the sun, or the moon. The director also gave him a room to work in, in addition to his bedroom. Despite all these accommodations, his letters to Theo were infused with a persistent, if lucid, melancholy.

Secluded in Saint-Rémy

May 8, 1889–May 16, 1890

Vincent was feeling increasingly alone. "And yet very often terrible fits of depression come over me, and besides the more my health comes back to normal, the more my brain can reason coldly, the more foolish it seems to me, and a thing against all reason, to be doing this painting which costs us so much and brings in nothing, not even the outlay." (Saint-Rémy, October 25, 1889. To Theo.) At one point between December 24 and 30 of that year, he tried to end his life by swallowing paint.

He was finally released on May 16, 1890, and a day later he was in Paris with Theo. Meanwhile, Theo had married and had a son. In his goodbye to Provence, Vincent wrote, "I came to the south and threw myself into work for a thousand reasons—looking for a different light, believing that observing nature under a brighter sky might give one a more accurate idea of the way the Japanese feel and draw. Wanting, finally, to see this stronger sun, because one has the feeling that unless one knows it one would not be able to understand the pictures of Delacroix, as far as execution and technique are concerned, and because one feels that the colors of the prism are veiled in the mists of the north." (Saint-Rémy, September 10, 1889. To Theo.) Up next was the picturesque village of Auvers-sur-Oise and the last act of Vincent's tormented life.

88

88
Corridor in the Asylum
(Saint-Rémy-de-Provence, October 1889). Oil color and essence over black chalk on pink Ingres paper, 65.1x49.1cm. New York, Metropolitan Museum of Art. F1529/JH1808.

**Saint-Rémy-de-Provence
(Arles, Bouches-du-Rhône,
France)** The cloister in
Saint-Paul de Mausole.
Vincent walked its halls
during his long stay there.

Into the Wild

89

The Gorge (Les Peiroulets) (Saint-Rémy-
de-Provence, October 1889). Oil on canvas,
73x91.7cm. Boston, Museum of Fine Arts.
F662/JH1804.

89

**Saint-Rémy-de-Provence (Bouches-
du-Rhône, France)** A nearby quarry.
Van Gogh was captivated by the truly
wild landscape around the asylum.
The shapes and outlines in his paintings
from around this time became ever
more distorted, as if to underscore his
mental state.

90
Olive Grove (Saint-Rémy-de-Provence, summer 1889). Oil on canvas, 72x92cm. Otterlo, Kröller-Müller Museum. F585/JHJ1758.

Saint-Rémy-de-Provence During the summer of 1889, while at Saint-Rémy, Vincent painted many olive trees—about fifteen paintings in all.

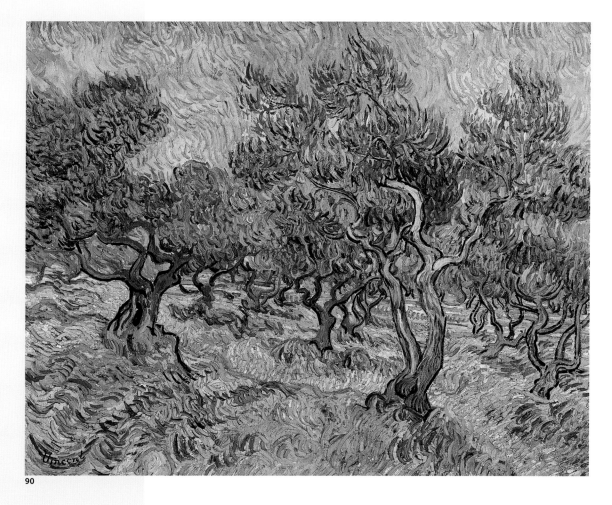

90

The Stars, the Moon, and a Nebula: Vincent's "Vision"

An immense sea of gold dust and diamonds.
"Nothing in this world can elevate thoughts of
the infinite more than the silent contemplation
of a starry sky on a clear night. Millions of little
fires everywhere in the blue dark. They vary in
color and clarity: some shine brightly, in constant
motion, intermittent. Others shine with more
consistent splendor, tranquil and soft. Many
send us their rays in bursts, as if struggling to
penetrate the depths of space. To fully appreciate
this performance in all its magnificence, it's
necessary to choose a night with a perfectly pure,
transparent atmosphere, with no interference
from moonlight, nor from dusk or dawn. The sky
thus becomes an immense sea of gold dust and
diamonds. Before such splendor, the senses, the
spirit, the imagination, are rapt." (Guillemin 1864, p. 2)

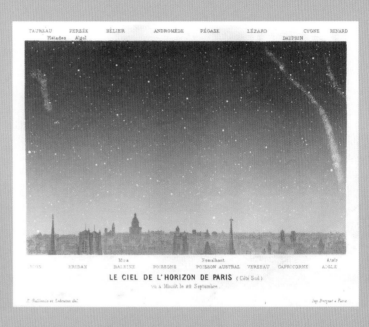

E. Guillemin, *Le ciel de
l'Horizon de Paris* (Paris,
southern night sky, view at
midnight on September 22),
from Amédée Guillemin,
*Le Ciel. Notions d'Astronomie
à l'usage des gens du monde
et de la jeunesse* (Hachette,
Paris, 1864, first edition).

Amédée Guillemin was a science writer and journalist who had been
publishing books on astrophysics since the 1860s. His work was rigorous
in content but easily accessible and beautifully illustrated. It included black-
and-white drawings of stars and nebulae that had just been discovered in
observatories around the world. Images in color were courtesy of his brother
Ernest, who supplied eleven beautiful illustrations of the blue, starry sky over
Paris at midnight, done with photographic exactitude and astrophysical
precision according to the various months of the year.

The Big Dipper and the gas lampposts along the river. A fascination with
the night sky goes back to the dawn of humankind. Artists have portrayed it—with
various intents and methods—throughout the centuries. It is a highly challenging
subject to paint. Around Van Gogh's time, many painters were showing revived
interest in the effects a starry sky could have on a landscape or a cityscape. Among
them were Millet, one of Vincent's favorite artists (Thomson 2008, fig. 19, p. 31),
and James Whistler, another painter he loved.

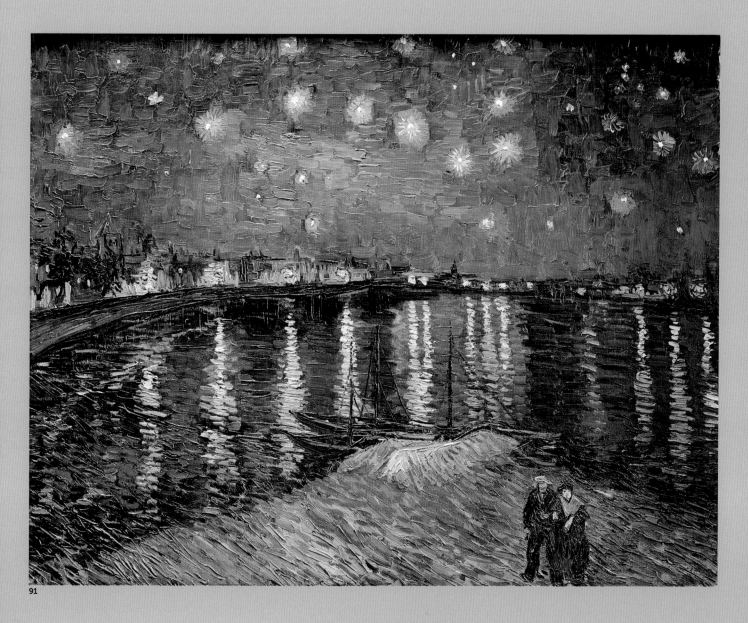

91

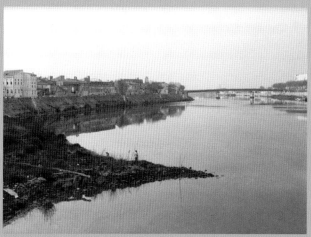

The riverbank in Arles, in
1990, before renovations.
Maps today mark the spot
where Vincent painted his
famous night sky sometime
between September 20 and
30, 1888, with the words
Nuit étoilée (Starry night).

91
Starry Night Over the Rhône
(Arles, September 20–30,
1888, around 10:30 p.m.)
Oil on canvas, 72.5x92cm.
Paris, Musée d'Orsay. F474/
JH1592.

Exhibited for the first time
in 1889 at the Salon de
la Société des Artistes
Indépendants in Paris, at
the Société d'Horticulture.

The Stars, the Moon, and a Nebula: Vincent's "Vision"

Recently, one of Whistler's stunning nocturnal scenes of London (*Grey and Gold, Westminster Bridge*, Glasgow Museums, c. 1872) was compared to Van Gogh's iconic *Starry Night over the Rhône* (Jacobi 2019, pp. 58–61). *Starry Night over the Rhône* is one of Van Gogh's best-known masterpieces. Although the painting displays a similar scenic setting to Whistler's vision of London by night, it still hides many mysteries, particularly regarding its starry sky, not the only one painted by Vincent in Provence. The first scholar to study many of the starry skies depicted by Van Gogh was the art historian Albert Boime (Boime 1984). After him, the most meticulous investigations that help us understand the genesis of these works come from astrophysicists: Charles A. Whitney, of the Harvard–Smithsonian Center for Astrophysics (Whitney 1986), and a group of researchers led by Donald Olson of Southwest Texas State University in San Marcos (Olson 2014 and 2018). Our astrophysicist consultant confirms their conclusions. In short, all of them agree that all of Vincent's night scenes painted at that time in Arles and Saint-Rémy depicting the moon, sun, or starry sky, and at least one painted in Auvers-sur-Oise, *White House at Night* (fig. 97–98, p. 201), show that he carefully studied the sky before painting the Big Dipper, planetary alignments, the crescent moon, or other celestial events. Thanks to the scientists, we can deduce, for example, that *Starry Night over the Rhône* was painted in Arles at about 10:30 p.m., between September 20 and 30, 1888. But even though the Big Dipper is clearly visible in that work, it wasn't actually in that part of the sky. It was behind the painter. Vincent surely knew this, but he needed to paint it above the old city anyway, to provide a contrast to the glittering lampposts along the river. Though he took poetic license, he likely relied on what he learned from publications such as those of Guillemin or Camille Flammarion, the most popular books at the time. It might be a coincidence, but that immense sea of gold dust and diamonds from Guillemin's most successful book, *Le Ciel* (published in 1864, reprinted multiple times, and translated into many languages), looks a lot like the spellbinding scene of glittering gems that Van Gogh saw on the beach at Saintes-Maries-de-la-Mer on the night of June 3, 1888. "In the blue depth the stars were sparkling, greenish, yellow, white, pink, more brilliant, more emeralds, lapis lazuli, rubies, sapphires." (Saintes-Maries-de-la-Mer, June 3 or 4, 1888. To Theo.) Maybe Vincent was thinking about the night sky over Paris, with its typical skyline of

92

92
Café Terrace at Night
(Arles, Place du Forum,
c. September 16, 1888).
Oil on canvas, 80.7x65.3cm.
Otterlo, Kröller-Müller
Museum. F467/JH1580.

93

93
Road with Cypress and Star
(Saint-Rémy-de-Provence,
May 12–15, 1890). Oil on
canvas, 90.6x72cm. Otterlo,
Kröller-Müller Museum.
F683/JH1982.

94

Landscape with Wheat Sheaves and Rising Moon (Saint-Rémy-de-Provence, July 13, 1889, 9:08 p.m.). Oil on canvas, 72x92cm. Otterlo, Kröller-Müller Museum. F735/JH1761.

94

The Stars, the Moon, and a Nebula: Vincent's "Vision"

bell towers and rooftops. Guillemin's book included eleven illustrations of Paris with recognizable constellations. Vincent may also have been thinking of Millet's and Whistler's skies.

What we do know—from letters to his sister, Theo, and friends—is that Vincent's interest in celestial events intensified in Arles. "I absolutely want to paint a starry sky. It often seems to me that night is still more richly colored than the day; having hues of the most intense violets, blues and greens." (Arles, between September 9 and 14, 1888. To Wil.)

The M51 Whirlpool Galaxy in the "hunting dogs" (Canes Venatici) constellation, as Lord Rosse saw it in 1845. From Amédée Guillemin, *Le Ciel. Notions d'Astronomie à l'usage des gens du monde et de la jeunesse* (Hachette, Paris, 1864, first edition), fig. 171, p. 480.

Astronomy for all. Given Vincent's interest in the sky, it's very likely that he read Guillemin's books, which were geared toward young people and anyone who wanted to know more about scientific discoveries. Images of the sidereal world—of the moon, the sun, comets, and nebulae (which today we call galaxies)—were becoming clearer and assumed the most surprising shapes. They appeared in *Le Ciel*, but Guillemin—who died three years after Van Gogh—also published brief monographs (sold for two and a half francs) of the sun, stars, and nebulae in *L'Illustration*, a magazine Vincent read and cited often. We're pretty sure he read these publications, or at least skimmed them, given the astrophysical precision of some of his paintings. They were well publicized and clearly displayed in every Parisian bookshop. He probably also read another highly accessible magazine, *L'Astronomie*, established in 1887 to promote the Société astronomique de France, founded by astronomer Camille Flammarion. The magazines from 1888 to 1890 (the years in which Van Gogh painted his most famous starry skies) contain all the information he might have used to depict the placement of the stars with almost scientific accuracy.

95
The Starry Night
(Saint-Rémy-de-Provence,
June 1889). Oil on canvas,
74x92cm. New York,
Museum of Modern Art.
F612/JH1731.

95

The Stars, the Moon, and a Nebula:
Vincent's "Vision"

The Whirlpool Galaxy and the Canes Venatici. The theories discussed here are borne out by Van Gogh's most famous canvas: *The Starry Night*, painted in mid-June 1889 at Saint-Rémy, from the window of his room at the psychiatric hospital of Saint-Paul de Mausole. A number of American astrophysicists have confirmed our conviction that this remarkable vortex, which many art historians regard as the product of a hallucination, was actually a specific reference or at least a subliminal memory of one of the most fascinating nebulae ever discovered: the Whirlpool Galaxy in the Canes Venatici (hunting dogs) constellation. This beautiful celestial object was discovered by Charles Messier in 1773 (catalog number 51); it's also known as M51 (*M* for *Messier*). The news traveled far and wide after the Irish Lord Rosse (William Parsons) captured its peculiar spiral shape with a highly advanced telescope in 1845. Ernest Guillemin's drawings of the galaxy didn't look all that different from images that can be obtained today. The Paris Observatory studied the Whirlpool Galaxy in 1862, and it became even more popular through magazines such as *L'Illustration* and books like *Les Étoiles et les Curiosités du Ciel*, by Camille Flammarion (1882). If Vincent was impressed by such images, as we posit, then his painted spiral was neither coincidence nor hallucination. Our conviction is reinforced by Octave Mirbeau's unfinished novel of 1892, *Dans Le Ciel*, in which Lucien (Van Gogh's alter ego) is bent on painting "a rising spiral. . . . Well, I don't know . . . maybe a cloud that hangs lower than the others and looks like a dog, the snout of a dog! Try to understand . . . I want to render—just with light, just with soaring, floating forms—a sense of the infinite, unlimited space, the celestial abyss, as if to return that primordial shudder—everything that moans, everything that suffers on earth . . . from the invisible to the intangible. . . ." (Mirbeau 1892–1893, ed. 2004, p. 126). The snout of the dog, naturally, refers to the Canes Venatici trying to bite the leg of the Ursa Major.

Photograph of the M51 Whirlpool Galaxy, 31 million light-years from Earth. Taken on the night between April 24 and 25, 2020, using a 203 mm–diameter telescope and a CMOS astrophotography camera.

96
The Starry Night (Saint-Rémy-de-Provence, June 1889), detail. Oil on canvas, 74x92cm. (Full painting fig. 95, p. 195.) New York, Museum of Modern Art. F612/JH1731.

SUBJECT — AUVERS-SUR-OISE

TECHNICAL DATA — 9-10 - Luoghi biamei - Auvers (prosaico perduto di v.g.)

Eighty Paintings in Sixty-Eight Days

May 20–July 29, 1890

Vertigo in Auvers-sur-Oise
"A mood of almost too much calm"

By late spring of 1890, Vincent's mental state seemed hopeless. His time in Provence had done nothing to lessen his suffering. Rather, his depression had become chronic. An examination of his illness is beyond the scope of this book, but the facts remain: Van Gogh was now thirty-seven years old. He'd moved thirty-seven times and lived in some twenty different cities and villages in four different countries—the Netherlands, Belgium, England, and France—in a wide range of social and natural settings. His mood was steadily deteriorating: his initial enthusiasm after a move would soon wane, usually following the first disappointment or misunderstanding. He painted hundreds of pieces; he painted practically every day. And almost every day he wrote to his family—to Theo and, less often, to his sister Wil and artist friends such as Bernard, Gauguin, and Van Rappard. There are hundreds of letters. In the letters, he always showed remarkable clarity of thought about painting—on contrasts, chromatic harmonies, and compositional approach. He had wanted to create more portraits and fewer landscapes and still lifes. In the portraits he did paint (quite a few) he used quick brushstrokes to capture the physical and psychological characteristics of his subjects in a completely original way, illustrating their "mood," as he called it in

Paris, Cité Pigalle, IX arrondissement Vincent spent his last three nights in Paris with Theo and his wife, Jo. He'd arrived on May 17, 1890, and left on the night of May 20 for Auvers-sur-Oise: the last destination on his tortured journey.

97

98

97–98
White House at Night,
(Auvers-sur-Oise,
June 16, 1890), full
painting and detail.
Oil on canvas, 59.5x73cm.
Saint Petersburg,
Hermitage. F766/JH2031.

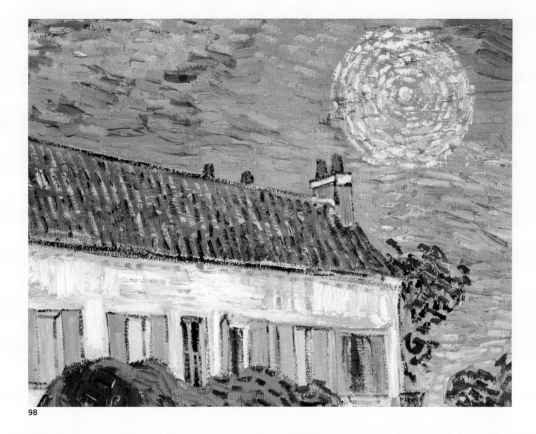

**Auvers-sur-Oise
(Val d'Oise, Île-de-France)**
"A white house in the
verdure with a star
in the night sky and an
orange-colored light in the
window." (Auvers-sur-Oise,
June 17, 1890. To Theo.) On
the night of June 16, 1890,
Vincent found himself in
front of this white house
at 8:00 p.m. Venus, the
brightest star in the sky,
was in the same location
as shown in the painting.
Rediscovered in Russia in
1995, the work is now on
exhibit at the Hermitage.

English. There was a darkness in him—maybe it didn't run as deep as many believe, but it was serious nonetheless.

Vincent and Gauguin managed to stay on friendly terms even after the incident in Arles and Gauguin's hasty departure from Provence. They continued to write to each other. Vincent even wanted to join his friend in Brittany at one point, in Le Pouldu, a village in Finistère, but Gauguin refused tactfully. Vincent was aware of his own altered mental state—he wasn't doing anything to hide it, and recovery seemed hopeless. His last letters were rife with observations on nature and painting and with literary quotes from Shakespeare, Voltaire, Ivan Turgenev, Lucien Daudet, and others. Gauguin called it an obsession, remembering how Vincent talked only about authors, books, and novels. Vincent's last days were dominated by melancholy, or "spleen," as he called it in English: he thought he'd shaken the feeling in Provence, but now, as he prepared for yet another move, he realized it was part of him no matter where he went.

Vertigo in Auvers-sur-Oise

"A mood of almost too much calm"

Vincent even started to doubt the value of painting. He left Provence driven by the possibility of "seeing Paris as beautiful." He wanted to paint a bookstore with a yellow window, pink in the evening, with passersby in black. He thought a modern subject such as this would look great "between an olive grove and a wheatfield," a sort of cross-pollination between books and paintings. He wanted to paint something "like a light in the darkness." Would this turn out to be the dark blue, stormy sky over wheat fields in Auvers? Meanwhile, a few of his paintings were making the rounds in Paris and Brussels. Parisian artists—including Monet, Toulouse-Lautrec, and others less well known—recognized his uncommon talent. Even critics, notably the young George-Albert Aurier, noticed him and wrote about him (Aurier 1890). Vincent thanked them and left Provence on May 17, 1890, at 10 a.m.

Theo went to pick him up at the station after Vincent sent a telegram from Tarascon. Vincent's sister-in-law greeted him from the window of the family apartment in Cité Pigalle. She thought he seemed healthy and lively, and the reunion with his family was emotional. However, according to unconfirmed sources it seems that Toulouse-Lautrec was surprised to see his friend, whom he had not visited for some time, looking so unwell.

Vincent found his newborn nephew—also named Vincent—completely charming. After he was born, Vincent had sent him a painting of a blooming almond tree from Provence. On this short visit, he experienced his last few moments of relative happiness.

Auvers-sur-Oise (Val d'Oise, Île-de-France)
Near the village before a rain.

99

99
Wheatfield under Thunder-clouds (Auvers-sur-Oise, July 1890). Oil on canvas, 50.4x101.3cm. Amsterdam, Van Gogh Museum (Vincent van Gogh Foundation). F778/JH2097.

But he didn't want to stay. Theo had asked Pissarro to host Vincent in Pontoise. The elderly artist declined but recommended a nearby village, Auvers-sur-Oise, not far from Paris. Cézanne, too, loved this place, where there was "a doctor and does painting in his spare moments. He tells me the gentleman in question has been in contact with all the Impressionists." (Paris, October 4, 1889. From Theo.) Vincent took the train to Auvers on May 20. He stayed briefly at the Saint-Aubin Hotel, but it was too expensive, so he moved to an inn run by the Ravoux family, in the main square. By June 3, he was engrossed in his work. The open country was beautiful, the village picturesque. He painted the houses with thatched roofs, the gardens, the fields, the church. His last brushstrokes seem to explode on the canvas. We don't know which painting was his last—there's no proof that it was *Wheatfield with Crows* (p. 13), as is often thought. We like to think that it was, rather, *Wheatfield under Thunderclouds* (fig. 99), a stormy sky of deep blue and intense green. He died of a gunshot wound—though exactly how it happened is still unknown. His last words, written on a piece of paper found in his pocket, were "Well, I risk my life for my own work, and my reason has half dissolved in it."

A Town of Artists and Patrons

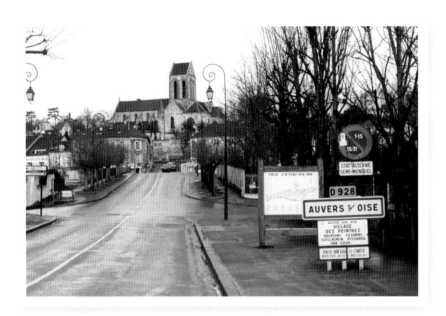

Auvers-sur-Oise (Val d'Oise, Île-de-France) Driving into Auvers-sur-Oise.

Auvers-sur-Oise is a picturesque village about twenty miles from Paris. It treasures the memory of Van Gogh, but its vibrant artistic tradition predates Vincent's stay there. In 1857, Charles-François Daubigny set up a studio there. In 1872, Camille Pissarro (who lived in Pontoise, less than four miles away) convinced Dr. Paul-Ferdinand Gachet, an amateur artist and friend to many painters, to buy a house in the village. The doctor set up an engraving workshop, where Pissarro and Cézanne practiced prior to the first impressionist exhibition in 1874. Six years later, the Parisian pastry chef Eugène Murer—also a novelist, patron, collector, and painter—moved to Auvers to live in an unusual building that still stands today.

Auvers-sur-Oise Home of Parisian pastry chef Eugène Murer. Artists including Victor Alfred P. Vignon, Renoir, Jean-Baptiste Armand Guillaumin, and Pissarro used to meet there.

100

Houses at Auvers (Auvers-sur-Oise,
May 1890). Oil on canvas, 61x73cm. Toledo,
Toledo Museum of Art. F759/JH1988.

100

Chaponval: The Station Bar

Chaponval, Rue Pontoise (Auvers-sur-Oise, Val-d'Oise, Île-de-France, France) The Café à la Halte opened in 1888 behind the Chaponval train station. This photo from 1990 shows what it used to look like. The typical posters advertising beer and orange soda have since been replaced by a pizzeria sign. Other than that, little has changed.

Vincent waited for Theo here—along the road from Chaponval to Auvers—on Sunday, June 8, 1890. Theo was due to arrive by train at 11:26 a.m. with his wife and their son, Vincent Willem. Our Vincent had brought Gachet, and they all had lunch together at the doctor's house—Gachet had invited the Van Goghs after meeting Theo in Paris. It would be Vincent and Theo's last happy day together. Theo's next visit, on July 28, was to Vincent's deathbed, as his brother lay wounded in a room at the Auberge Ravoux.

My dear Vincent, I cannot tell you how happy we are because you could write us that you continue in good health, and that your stay at Auvers has had rather a good influence on your condition. Dr. Gachet came to see me yesterday, but unfortunately there were customers, which prevented me from talking with him very much, but at any rate he told me that he thought you entirely recovered [. . .]. He invited us to visit him next Sunday, when you will also be there. We should be damned glad to do it, but it is not possible all the same for Jo to make a definite promise. On Whitsunday we went to St. Cloud, where we had that terrible cloudburst [. . .]. Without actually catching cold the little one has been quite upset ever since [. . .]. Will you be so kind as to go to Dr. Gachet and tell him that, if the weather is fine, we shall accept his invitation with great pleasure, but that we cannot absolutely promise it, and that if we should come, we should like to be home again in the evening. There is a train at 5:58 which we might take. In the morning we could go by the 10:25 train, which arrives at Chaponval at 11:26. The doctor told us to get off the train there, and that he wanted to come get us.
(Paris, June 5, 1890. Theo to Vincent.)

A Doctor as a Friend

101
Portrait of Dr. Gachet (Auvers-sur-Oise, early June, 1890). Lithograph, 18x15cm. F1664/JH2028.

Auvers-sur-Oise (Val d'Oise, Île-de-France) The sign that marks the road named after Dr. Gachet. Van Gogh, and earlier Cézanne and Pissarro, went there often. Dr. Gachet's children, Paul and Marguerite, lived there until the 1960s, when it passed to their children's governess and her husband. The house became a museum after that couple's death. They'd preserved the house well but neglected the garden, and prevented anyone from entering it (Cabanne, 1992). The garden has since been restored to its former glory.

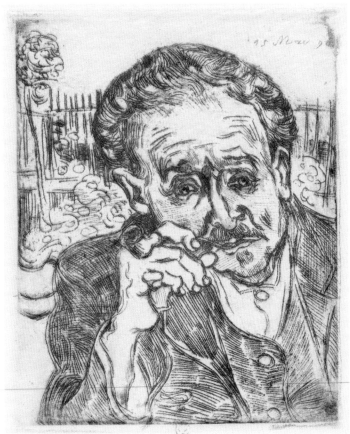

I have found a true friend in Dr. Gachet, something like another brother, so much do we resemble each other physically and also mentally. He is a very nervous man himself and very queer in his behaviour; he has extended much friendliness to the artists of the new school, and he has helped them as much as was in his power. I painted his portrait the other day, and I am also going to paint a portrait of his daughter, who is nineteen years old. He lost his wife some years ago, which greatly contributed to his becoming a broken man. I believe I may say we have been friends from the very first, and every week I shall go stay at his house one or two days in order to work in his garden, where I have already painted two studies, one with southern plants, aloes, cypresses, marigolds; the other with white roses, some vines and a figure, and a cluster of ranunculuses besides.

(**AUVERS-SUR-OISE, JUNE 5, 1890. TO WIL.**)

101

102

Marguerite Gachet in Her Garden
(Auvers-sur-Oise, early June 1890).
Oil on canvas, 46x55cm. Paris,
Musée d'Orsay. F756/JH2005.

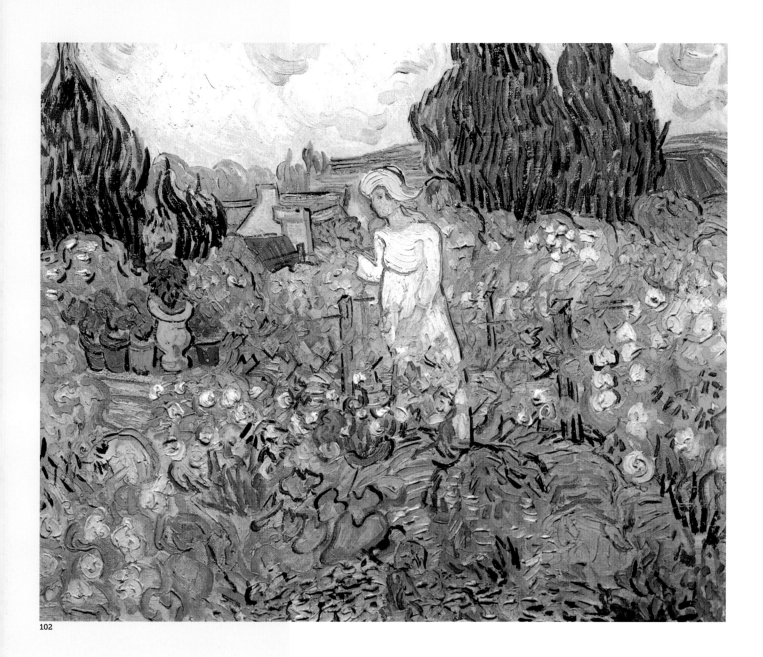

102

Doctor Gachet's Foxglove

I should like to paint portraits which would appear after a century to people living then as apparitions. By which I mean that I do not endeavor to achieve this by a photographic resemblance, but by means of our impassioned expressions—that is to say, using our knowledge of and our modern taste for color as a means of arriving at the expression and the intensification of the character. So the portrait of Dr. Gachet shows you a face the color of an overheated brick, and scorched by the sun, with reddish hair and a white cap, surrounded by a rustic scenery with a background of blue hills; his clothes are ultramarine—this brings out the face and makes it paler, notwithstanding the fact that it is brick-colored. His hands, the hands of an obstetrician, are paler than the face. Before him, lying on a red garden table, are yellow novels and a foxglove flower of a somber purple hue.

(Auvers-sur-Oise, June 5, 1890. To Wil.)

The adventures of Doctor Gachet on canvas. In a few letters to Wil and Theo, Vincent describes a portrait of Dr. Gachet he painted in early June 1890. Those descriptions (as in the letter to Wil above) correspond to the canvas illustrated on the opposite page, which has been missing for years: maybe it's in a bank vault somewhere or in someone's private—very private—home. No one has laid eyes on it since the end of the last century. It arrived at the Städel Museum in Frankfurt, Germany, in 1911. Hermann Göring confiscated it in 1939, calling it "degenerate art," and sold it to Frank Koenigs, a dealer who managed to bring it to Paris. Siegfried Kramarsky, a Jewish banker, bought it and took it with him when he escaped to the United States. The portrait was loaned to the Metropolitan Museum of Art and put on display in 1984. On May 15, 1990, one hundred years after its creation and the death of Van Gogh, the portrait was sold by Gachet's heirs at a Christie's auction in New York for $85.2 million—then a record sum for a painting. The buyer, Japanese paper magnate Ryoei Saito, promised to have the canvas burned with his body upon his death. Maybe he was joking, but he never showed it to anyone—not until his finances took a nosedive around 1996, when he sold the portrait to Austrian financier Wolfgang Flöttl. Flöttl in turn sold it to a mystery buyer, and it has not been seen in public since. For years, scholars have been struggling to analyze this masterpiece of the Auvers days. They see it as a crucial step in understanding Vincent's mental state.

In another version (in the Musée d'Orsay), there are no books, and the purple foxglove—a key element—is on the table instead of in the glass. As Van Gogh himself pointed out, both works exude melancholy. In a June 13, 1890,

103
Portrait of Dr. Gachet (Auvers-sur-Oise, early June 1890). Oil on canvas, 66x57cm. Location unknown. F753/JH200.

104

104
Still Life with Plaster Statuette, a Rose and Two Novels (Paris, December 1887), detail. Oil on canvas, 55x46.5cm. (Full painting fig. 33, p. 99.) Otterlo, Kröller-Müller Museum. F360/1349.

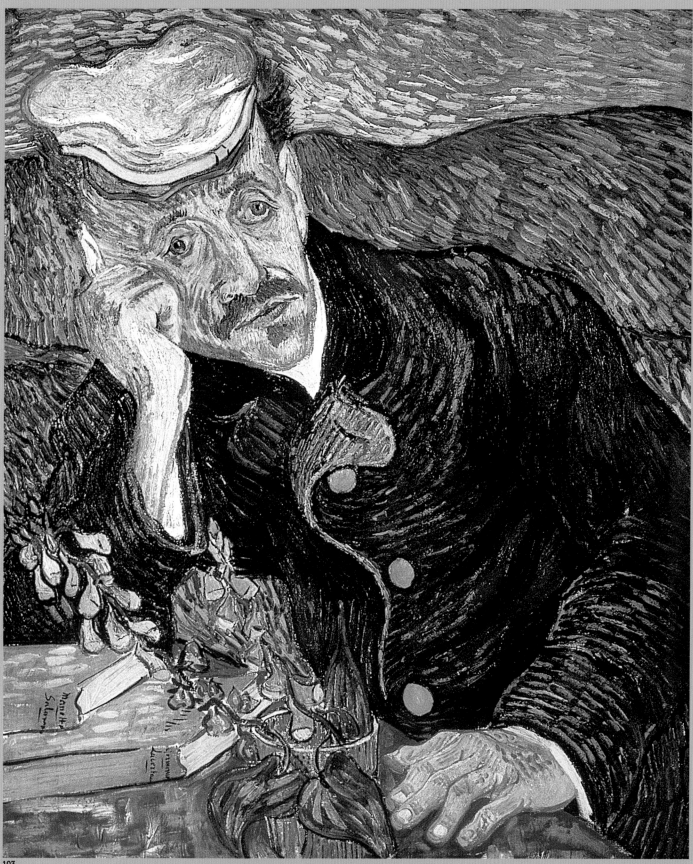

Doctor Gachet's Foxglove

letter to Wil, he said, "I painted a portrait of Mr. Gachet with an expression of melancholy, which would seem to look like a grimace to many who saw the canvas." This echoed a letter he'd written to Theo ten days earlier: "He certainly seems to me as ill and dazed as you or me, [. . .] but he is very much the doctor, and his profession and faith still sustain him [. . .]. I am working on his portrait [. . .]. It is in the same sentiment as the self-portrait I did when I left for this place. M. Gachet is absolutely *fanatical* about this portrait."

Paul-Ferdinand Gachet, almost a doppelgänger. Van Gogh reveals himself to be the alter ego of his model. But who was Gachet, really? At the time, Gachet was sixty-two years old. He was a scholar of mental pathologies, a homeopath, and a lover of fortune-telling. He had a dark and melancholic personality with a strong tendency toward depression, so much so that he published an essay on the subject Gachet, P.F., *Etude sur la mélancolie*. Typographic de Boehm, Montpellier 1858), where he said: "A melancholic person withdraws, contracts, tries to occupy as little space as possible [. . .]. His fingers are shrunken, his head droops to the left or to the right, the muscles in his body are half clenched. The facial muscles are withered, tormented, and lend a certain harshness to the expression. The eyebrows are always tense and seem to hide the eye, making the socket appear deeper." Suffice to say, this sounds like the description of his portrait.

Both Gachet's and Vincent's melancholy were an "essential" melancholy, as the literary critic Jean Starobinski explained (2012). Gachet must have found what Starobinski called "descriptive characteristcs" in his portrait, traits that he himself had seen in the melancholic personality type. This helps explain the prominence, in the original version, of two yellow books with clearly marked titles: *Manette Salomon*, which related the aspirations and disappointments of artists, and *Germinie Lacerteux*, set in a fictional Paris of opulence but poverty as well—naturalist novels by the Goncourt brothers. It also explains the flowering foxglove, a symbolic flower rarely seen in the history of art. Gachet prescribed purple foxglove as a cardiotonic medication, but it is highly toxic, even deadly if taken in high doses. To quote Vincent, the portrait was meant to "look like an apparition." Eight years later, the Italian poet and scholar Giovanni Pascoli dedicated a long poem to the purple foxglove, in which he wrote, "The flower has a sort of honey / that inebriates the air; a haze of its own that wets / the soul with a sweet, cruel oblivion."

Purple foxglove (*Digitalis purpurea*, Linnaeus 1753).

105
Portrait of Dr. Gachet (Auvers-sur-Oise, early June 1890), second version. Oil on canvas, 68x57cm. Paris, Musée d'Orsay. F754/JH2014.

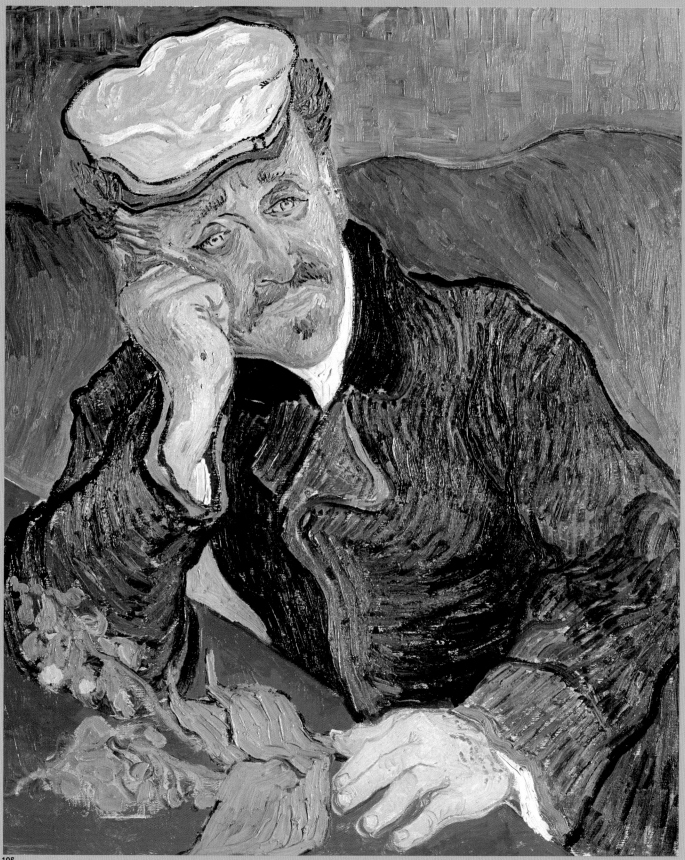

From Cobalt Blue to Ultramarine

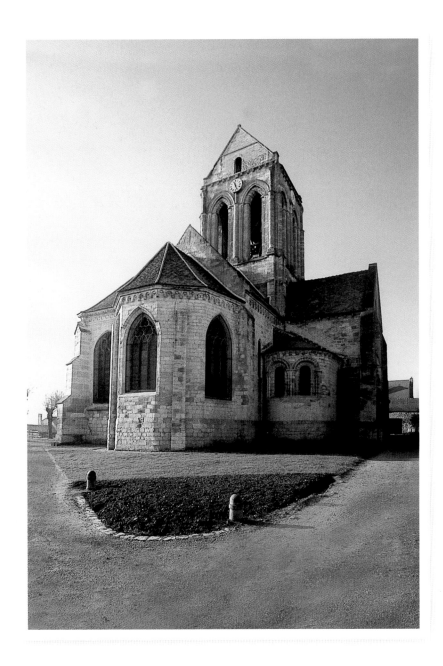

Auvers-sur-Oise (Val d'Oise, Île-de-France) The church of Notre-Dame-de-l'Assomption.

In describing his painting of the church in Auvers, just outside town, Vincent said to his sister Wil, "And once again it is nearly the same thing as the studies I did in Nuenen of the old tower and the cemetery."

He was clearly in the same mood, but his somber work from Neunen, with its dark and brown tones, was nothing like this striking new painting. Anyone looking at the church in Auvers from behind the apse, and at an image of the painting, can see the difference: the outlines seem tentative, trembling, and the colors scarcely mirror reality—but the image is so vibrant, it creates the sensation that the church is moving, even vibrating, as if it were made of gelatin. Vincent had scrapped the linear perspectives from his painting of the beach at Scheveningen, where he'd used the perspective frame in the style of Leonardo and Dürer. Nor had he repeated his tactic of dividing Japanese prints into squares, as he did in Paris. This represents a different principle of reality: that of feelings and emotions.

106

The Church at Auvers (Auvers-sur-Oise, June 4, 1890). Oil on canvas, 94x74cm. Paris, Musée d'Orsay. F789/JH2006.

I have a larger picture of the village church—an effect in which the building appears to be violet-hued against a sky of simple deep blue color, pure cobalt; the stained-glass windows appear as ultramarine blotches, the roof is violet and partly orange. In the foreground some green plants in bloom, and sand with the pink flow of sunshine in it.

(AUVERS-SUR-OISE, JUNE 5, 1890. TO WIL.)

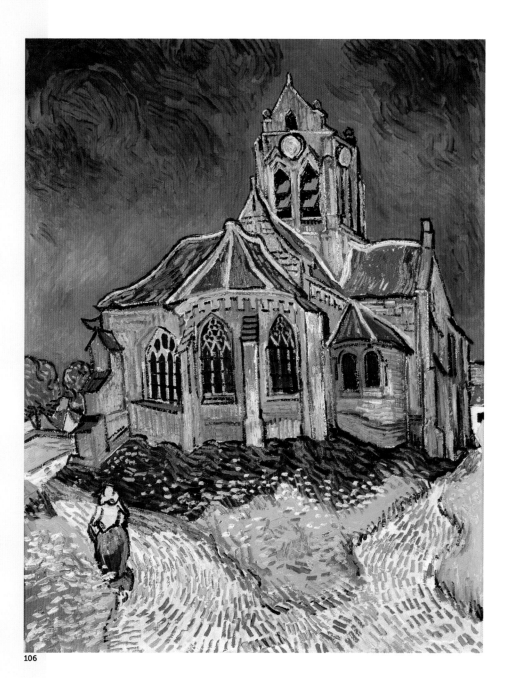

106

A Garden with a Passing Cat

On June 17, 1890, Vincent told Theo about a painting of a white house in Auvers and a star in the sky—it was the famous painting now in Saint Petersburg (see fig. 97–98, p. 201). "I have an idea for doing a more important canvas of Daubigny's house and garden, of which I already have a small study," he added, with nonchalance. (Auvers-sur-Oise, June 17, 1890. To Theo.) He'd sketched the study on a tea towel, since he was still waiting for blank canvases from Paris. He later made at least three versions of the painting—two horizontal, with the house in the background and the garden in the foreground, and one square, with the flowerbed at the very front and only a glimpse of the building and garden in the background. In another letter, he described one of the longer canvases: "Foreground of green and pink grass [. . .]. In the middle a bed of roses. To the right a hurdle, a wall, and [. . .] a row of rounded yellow lime trees. The house itself in the background, pink with a roof of bluish tiles."

107
Daubigny's Garden
(Auvers-sur-Oise, June 1890).
Oil on canvas, 51x51cm.
Amsterdam, Van Gogh
Museum (Vincent van Gogh
Foundation). F765/JH2029.

107

A passing cat. At least one of the two horizontal versions was painted around July 10, as suggested by his mentioning, on that date, that "the third canvas is Daubigny's garden, a painting I'd been thinking about ever since I've been here." The garden in question belonged to Marie-Sophie, widow of Charles-François Daubigny, a leading member of the Barbizon school. Van Gogh had always admired him. Daubigny had bought the large plot of land in the northwest corner of the village in 1860 and built a beautiful villa on it, with a studio annex and a large, well-tended garden.

Some have questioned the authenticity of these paintings, but that controversy has been put to rest. Let us focus instead on the passing cat, which Vincent drew in a rudimentary way, like a child's design. (Picasso would do something similar many years later, placing seemingly random cats or dogs in the foreground of some of his works.) Vincent located the widow at the edge of the garden, near the tree-lined path leading to the house. In real life, the buildings

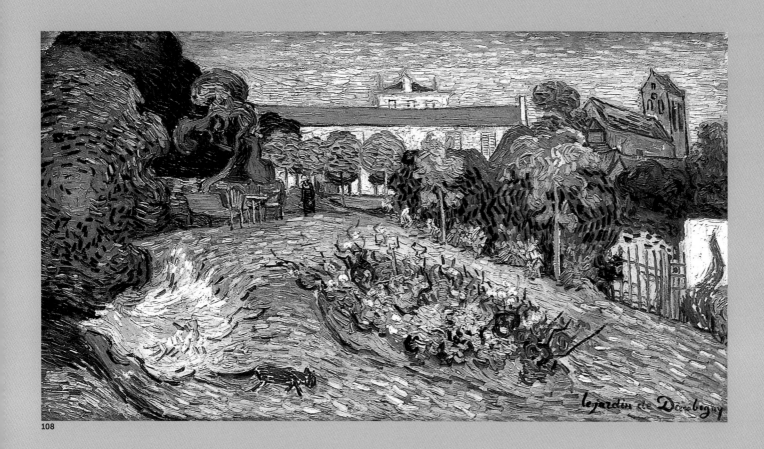

108

108
Daubigny's Garden (The Entire Garden with a Cat) (Auvers-sur-Oise, July 1890). Oil on canvas, 56x101.5cm. Basel, Kunstmuseum Basel. F777/JH2105.

beyond the villa, such as the Auvers church without its transept, can't be seen so clearly from that viewpoint. The focal point of the composition is the large, irregular flowerbed in the middle of the lawn, which suggests the vastness of the greenery around the villa. The Daubigny widow died soon after Vincent did, on December 22, 1890, before she could take possession of the painting intended for her. It ended up hopping from owner to owner. A version without the cat (the cat seems to have been covered up later) is now at the Hiroshima Museum of Art in Japan. Daubigny's garden was restored to its original splendor in 1990. Today, it is home to the Maison-Atelier de Daubigny, a foundation and museum.

Bastille Day in Auvers

109
The Town Hall at Auvers,
(Auvers-sur-Oise, July 14, 1890),
detail. Oil on canvas, 72x93cm.
Private collection. F790/JH2108.

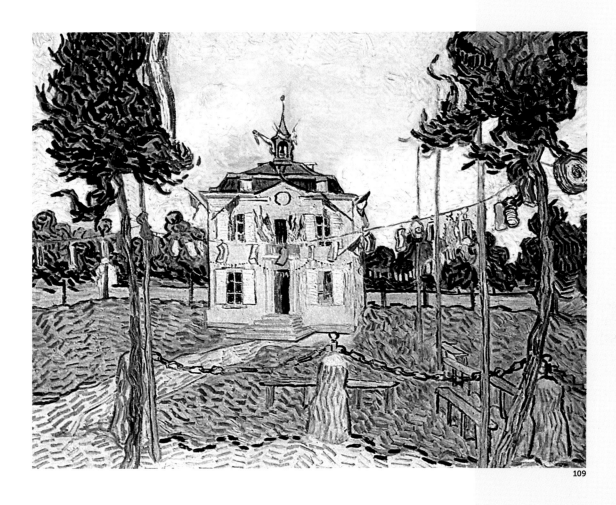

109

Auvers-sur-Oise (Val d'Oise, Île-de-France) The front of the town hall.

There is no direct information on this painting, which is currently in a private collection. We do know that it's of the Auvers town hall, in the square facing the Auberge Ravoux, where Vincent lived, and that it was one of the last paintings he made before he died. It is perfectly easy to date: the building is adorned with cockades and tricolor flags for the fourteenth of July, when the French celebrate the taking of the Bastille (July 14, 1789). Van Gogh slightly decentered the facade and framed it between two trees in the foreground, in the style of a Japanese print. The colors are rather delicate, an adjective he repeated obsessively in a letter sent around that date to his mother and sister Wil. In the message, Vincent didn't mention this painting, which he probably made soon after. Instead, he talked about being "quite absorbed in that immense plain with wheat fields up as far as the hills, boundless as the ocean, delicate yellow, delicate soft green, the delicate purple of a tilled and weeded piece of ground, with the regular speckle of the green of flowering potato plants, everything under a sky of delicate tones of blue, white, pink and violet." He added, ominously, that he was "in a mood of almost too much calm, just the mood needed for painting this." (Auvers-sur-Oise, July 10–14, 1890. To Anna and Wil van Gogh.)

Forever United in Ivy

Vincent died on July 29, 1890, after sustaining injuries from one or maybe two gunshots. Most scholars agree that he probably shot himself two days earlier. He'd taken a battered revolver from two reckless Parisians who used to go fishing in Auvers and play all sorts of tricks on him—Gaston and René Secrétan. Until the end of the last century, many thought they had accidentally fired the weapon at Vincent, but this hypothesis has since been scrapped. Vincent had certainly considered suicide before. He returned to his inn, injured and in pain, and told Madame Ravoux, wife of the innkeeper: "*C'est à refaire*" ("It must be done again"), as if to say, "I've failed."

The shot hadn't gone straight to his heart. It had hit him between the stomach and groin. He climbed the stairs and hid in his bedroom. Dr. Gachet stopped by to help now and then, and Theo quickly traveled to his brother's bedside and stayed there. Two days later, Vincent drew his last breath, with his pipe in his mouth.

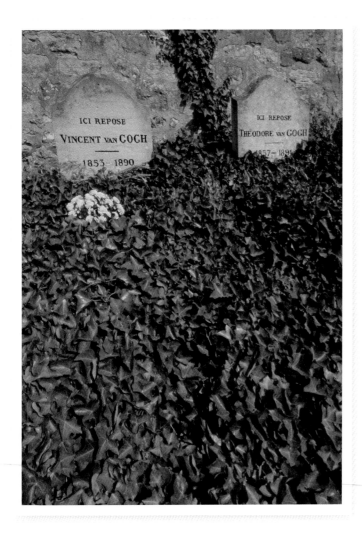

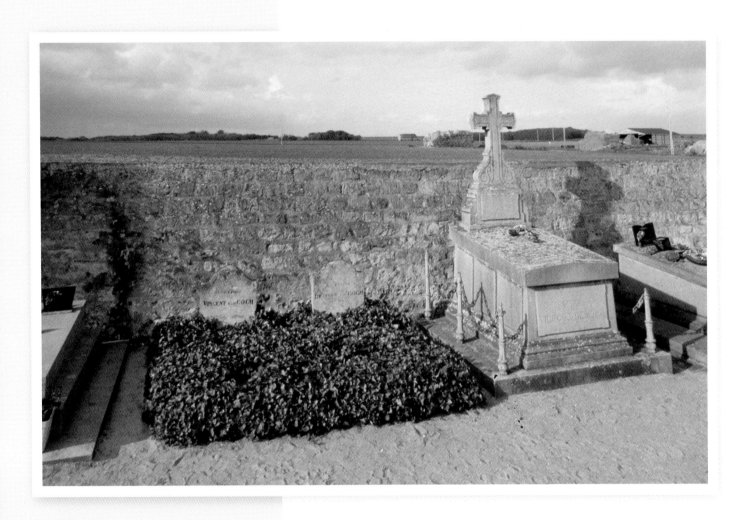

Auvers-sur-Oise (Val d'Oise, Île-de-France) The cemetery, Vincent and Theo van Gogh's graves, and the Auberge Ravoux, where Vincent died on July 29, 1890.

Vincent was buried on July 30 in the Auvers cemetery. His friend Toulouse-Lautrec couldn't attend the ceremony, writing to Theo that he was saddened to have learned the news too late. Theo, four years younger than Vincent and struggling with an illness of his own, couldn't stand the heartache. He had a severe syphilis attack in September, and on October 9 he suffered a mental and physical breakdown. Three days later, he was admitted to the hospital in Utrecht, where he died on January 25, 1891. In 1914, the Van Gogh brothers' remains were exhumed and buried next to each other in the same Auvers cemetery. Legend has it that whoever dug up Vincent's body found a wormwood plant sprouting from his chest. But it's just a legend. At least we think so.

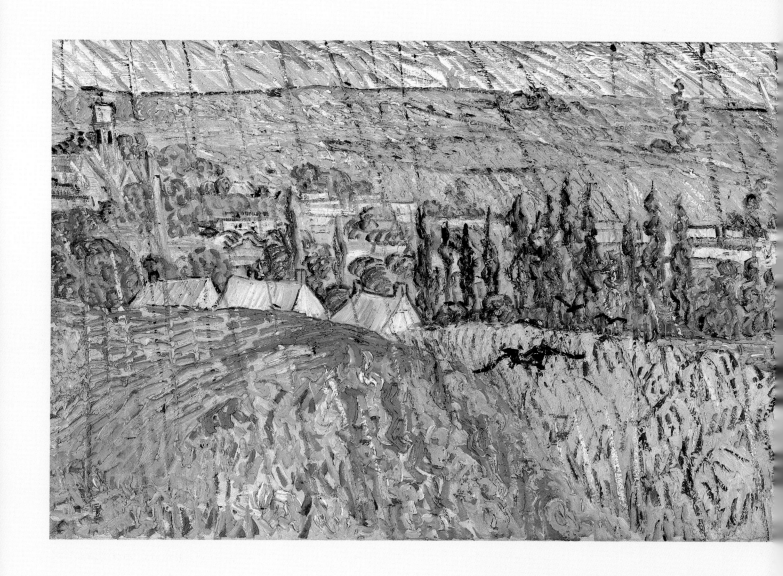

110

Landscape at Auvers in the Rain
(Auvers-sur-Oise, 1890). Oil on canvas,
50x100cm. Cardiff, Amgueddfa Cymru
National Museum Wales, Davies Sisters
Collection. F811/JH2096.

111–112

Bridge in the Rain (after Hiroshige, Paris, 1887),
full painting and detail. Oil on canvas,
73.3x53cm. Amsterdam, Van Gogh Museum
(Vincent van Gogh Foundation). F372/JH1297.

110

112

Afterword: Stars to Rain

Between July 10 and 14, 1890, about two weeks before Vincent died, the sky above Auvers was cloudy and rainy. No matter where he was, Vincent spoke about rain more than about any other weather phenomenon. This dated back to his time in England. In Ramsgate, in 1876, he drew a view of the English seaside town in the rain—one of his first sketches in pencil and ink. His drawings were faithful to reality, almost more so than De Marco's and Dondero's photographic depictions of a rainy dawn in 1990, taken from the same viewpoint (pp. 40–41). One can almost feel the humidity, the gray and cloudy sky, and hear the sound of light rain and the cries of seagulls.

Van Gogh had started to draw the rain while in England, in the early days of his artistic career. His literary descriptions of it were beautiful. For example, he told Theo of a long walk from Isleworth to London. He'd left at four in the morning, "the wet [. . .], and a gray rainy sky [. . .]; in the distance there was a thunderstorm." (Isleworth, October 3, 1876. To Theo.) He arrived in London after the sun had already risen. In the same letter, he advised his brother to read some verses of one of his favorite poets, Henry Wadsworth Longfellow:

[. . .] I see the lights of the village
　　Gleam through the rain and the mist,
And a feeling of sadness comes o'er me
　　That my soul cannot resist:

—Henry Wadsworth Longfellow, "The Day Is Done" (1844)

The imagery in this verse brings to mind one of Vincent's last masterpieces, *Landscape at Auvers in the Rain*. It is one of his lesser-known works, painted on a horizontal canvas, in the same format and likely around the same time as the beautiful and more famous *Wheatfield under Thunderclouds* (fig. 99, p. 203). This painting is widely considered to be a portent of Vincent's last act. But this is no place for psychoanalysis. Let's just say that rain is among the most difficult weather phenomena to express in painting, along with starry skies. Rain and sky—Vincent's last challenges. We know that Japanese artists greatly influenced his portrayal of rain. He believed that they alone could faithfully represent all aspects of nature, to the point of identifying directly with it, "as if they themselves were flowers." Hiroshige in particular could render the pounding rain of a sudden storm with the simplicity of a few transverse strokes. In 1887, while in Paris, Vincent had done a fairly accurate reinterpretation of the Japanese painting (fig. 111–112, opposite). But his depiction of Auvers under a hard rain made a clear

Auvers-sur-Oise (Val d'Oise, Île-de-France) The gate to the cemetery where Vincent and Theo van Gogh rest in peace (1990).

break from Japonisme: there is no human subject, the flight of a crow is barely perceptible, and the village is pierced by rain that almost seems to scratch the canvas. Despite the presence of a few scattered houses, this may have been the most abstract painting he ever created.

It was about a twenty-minute walk from Auvers to where Vincent probably set up his easel, in Méry-sur-Oise. A row of poplars along the river cuts through the middle of the composition. A cluster of houses and the unique profile of the Auvers church rise on the left, as they would have from that point of view.

My first visit to Auvers was in 1990, at the end of our journey to retrace Vincent's steps. We stopped at the church and the cemetery where Vincent and Theo lie at rest. Today, this is one of the most visited places for anyone looking for some Van Gogh history: it's estimated that tens of thousands of people per year visit the grave. Back then, before the hundredth anniversary of Vincent's death, no one was there. The gate was ajar (it's always open to allow visitors to pay tribute to Vincent and Theo), and a sign gave directions to the graves. I wondered whether De Marco and Dondero's black-and-white shot of the sign was a subliminal reference to the opening to Orson Welles's *Citizen Kane* (1941). In the film, a fading vertical shot shows the entrance to the home of Charles Foster Kane on the day of his death. The plaque reads: no trespassing. But in Auvers, everyone is welcome, so maybe this was just a personal notion and Orson Welles has nothing to do with it. But had I not asked Danilo, I never would have known that his photograph of youths playing billiards at the tavern in Nuenen (pp. 18–19), for example, had been carefully arranged in a sort of nocturne—an allusion to *The Potato Eaters*, Vincent's most famous painting from Nuenen (fig. 16, p. 71). I would simply have thought that Danilo was trying to recall the billiard table in Gauguin's *Night Café, Arles*.

In art as in photography, personal feelings drive us to explore every possible avenue. That is what we tried to do: two photographers thirty years ago and an art historian to this day. The mental and physical journey continues. I hope readers join our quest, at their own pace.

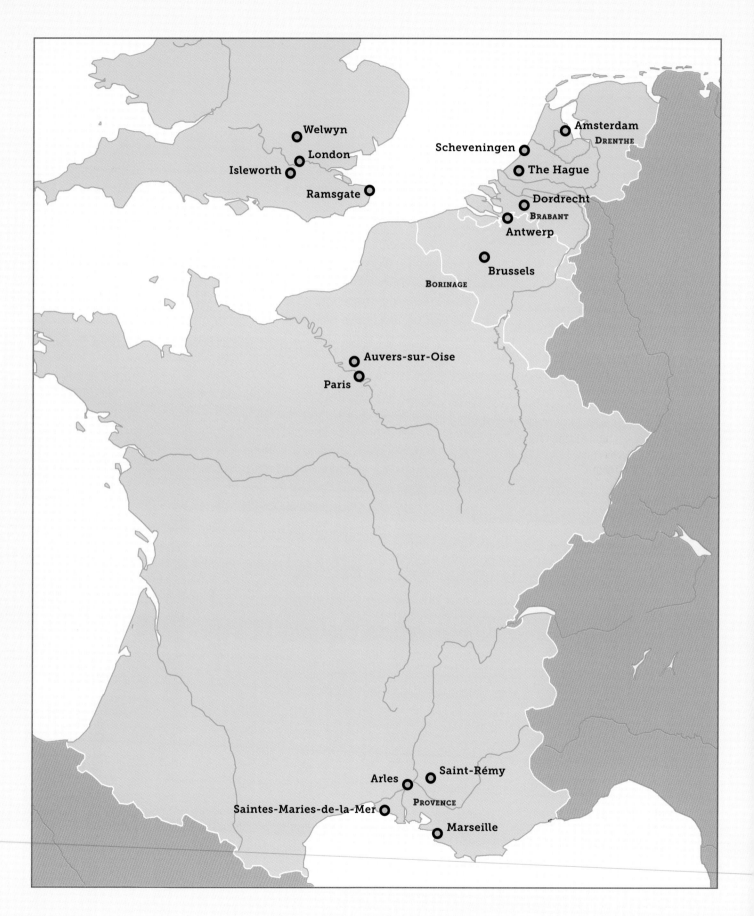

Welwyn

London

Isleworth

Ramsgate

Scheveningen

Amsterdam

DRENTHE

The Hague

Dordrecht

BRABANT

Antwerp

Brussels

BORINAGE

Auvers-sur-Oise

Paris

Saint-Rémy

Arles

PROVENCE

Saintes-Maries-de-la-Mer

Marseille

The Times and Places of Vincent van Gogh

1853

MARCH 30, ZUNDERT (NORTH BRABANT, THE NETHERLANDS): Vincent Willem van Gogh was born in the town parsonage (Markt 26–27), exactly one year after his stillborn brother Vincent. Vincent was the eldest living son of Theodorus van Gogh (1822–1885) and Anna Cornelia van Gogh-Carbentus (1819–1907). His siblings were born soon after: Anna Cornelia, married to van Houten (1855–1930); Theo (1857–1891); Elizabeth (Lies) Huberta, married to Du-Quesne (1859–1936); Wilhelmina (Willemien, Wil) Jacoba (1862–1941); Cornelius Vincent (Cor) (1867–1900).

1861

JANUARY, ZUNDERT: Attended public school for a few months. The following year he took lessons from governess Anna Birnie.

1864

OCTOBER 1–AUGUST 31, 1866, ZEVENBERGEN (NORTH BRABANT, THE NETHERLANDS): Boarded at the Jan Provily secondary school (Zandweg A40, now Stationstraat 16).

1866

SEPTEMBER 15–MARCH 19, 1869, TILBURG (NORTH BRABANT, THE NETHERLANDS): Went to the Hogere Burgerschool technical institute (Willemsplein, now at Stadhuisplein 130). Stayed at the Hannik boarding house (Korval 57, now Sint Annaplein 18–19).

1869

JULY 30: With help from his uncle Cent, moved to The Hague (southern Holland, the Netherlands) to work as an apprentice for Goupil & Cie (Plaats 14). Cent had ceded it to H. G. Tersteeg. Stayed at the Roos boarding house (Langee Beestenmarkt 32). He drew, visited museums, and collected photographs and prints.

1871

JANUARY 29: The Van Gogh family moved to Helvoirt (North Brabant, the Netherlands), at Torestraat 47.

1872

AUGUST–SEPTEMBER, THE HAGUE: Theo went to visit Vincent. They visited museums and took walks along the beach in Scheveningen.
SEPTEMBER 29: The two brothers began to write letters to each other.

1873

JANUARY 6, BRUSSELS: Theo worked at the Belgian branch of Goupil & Cie (58 Rue Montagne de la Cour).
JANUARY 26–27, AMSTERDAM: Went to see his uncle Cor.
APRIL 13, HELVOIRT (NORTH BRABANT, THE NETHERLANDS): Went to see his family.
MAY 12: Went to Paris for a few days.
ABOUT MAY 19: Moved to London to work for Goupil & Cie (17 Southampton Street). Visited the British Museum, National Gallery, Wallace Collection, South Kensington Museum (now the Victoria & Albert), and the Dulwich Picture Gallery.
AUGUST: Attended the Royal Academy Summer Exhibition.
END OF AUGUST: Moved to Brixton, to the home of Mrs. Loyer (87 Hackford Road).

1874

JUNE 27–JULY 14, HELVOIRT: Visited his family, then stayed with Theo in The Hague for a few days. Theo had been working at Goupil & Cie (Plaats 14) since November 1873. Their sister Anna moved to London to look for work and stayed with Vincent on Hackford Road.

ABOUT AUGUST 10, SOUTH LONDON: With Anna, moved to John Parker's house (395 Kennington Road). Vincent had fallen in love with Mrs. Loyer's daughter, but it was unrequited.
AUGUST 24, HERTFORDSHIRE, ENGLAND: Anna began to teach French. She moved to the Rose Cottage on Church Street.
OCTOBER 26, PARIS: Temporarily transferred to the Paris branch of Goupil & Cie (9 Rue Chaptal).
LATE DECEMBER, HELVOIRT: Vincent and Theo went to visit their parents.

1875

JANUARY, LONDON: Started working at the Holloway & Sons Gallery (25 Bedford Street), after it was taken over by Goupil & Cie. He was living in a small apartment (the address is not known).
OCTOBER 22: The Van Gogh family moved to Etten (near Breda, North Brabant, the Netherlands).
LATE DECEMBER, ETTEN: Spent the holidays with his parents.

1876

JANUARY 4, PARIS: Fired from the Goupil Gallery.
MARCH 31–APRIL 14: Stayed in Etten with his parents. Theo joined him.
APRIL 17, RAMSGATE (KENT, ENGLAND): Moved there to teach at the W. P. Stokes school; lived at 11 Spencer Square.
JUNE 12–17: Walked to London, then visited Anna in Welwyn.
LAST WEEK OF JUNE: Moved to Isleworth (Middlesex, England) after Stokes moved the school there. Was soon out of a job and hired as a lay minister by the Reverend Thomas Slade-Jones (158 Holme Court). Began to preach.

OCTOBER 29, RICHMOND-UPON-THAMES (LONDON): Delivered his first sermon at the Wesleyan Methodist Church.

DECEMBER 20: In Etten with his parents and Anna for Christmas vacation.

1877

JANUARY 14, DORDRECHT (SOUTH HOLLAND, THE NETHERLANDS): Worked as a salesperson at the Blussé & Van Braam bookstore, run by Mr. Braat. Stayed with wheat merchant Peter Rijken (Tolbrugstraat A312).

APRIL 1: In Etten with Theo.

MAY 2–14: In The Hague with Theo.

MAY 14, AMSTERDAM: Moved there to begin studies in theology, living with his uncle Hein (3 Grote Kattenburgerstraat).

LATE DECEMBER: In Etten with his parents.

1878

JANUARY: Returned to Amsterdam.

AUGUST 26, LAEKEN (BRUSSELS): Was studying to become a clergyman.

NOVEMBER 25: Failed his clerical exam.

DECEMBER 26: Arrived in Pâturages (Borinage, Belgium).

1879

JANUARY: In Wasmes (now Colfontaine), staying with Jean-Baptiste Denis, a baker.

FEBRUARY 1, BORINAGE (BELGIUM): Worked as a missionary for a trial period.

AUGUST: In Cuesmes, living with miner and parson Joseph Edouard Francq (6 Rue du Pavillon). Took up drawing. Theo visited him.

AUGUST 15–17: Brief stay in Etten.

NOVEMBER: Theo moved to Paris to work for Maison Goupil.

1880

MARCH: Walked to Courrières (France) looking for Jules Breton, but was disappointed by the look of his studio, so never went in.

JULY: Went to live with miner Charles Louis Decrucq in Cuesmes (3 Rue du Pavillon).

OCTOBER: Left for Brussels (Belgium), where he stayed in a small inn (72 Boulevard du Midi).

FIRST WEEK OF NOVEMBER: Admitted to the drawing program at Brussels's Royal Academy of Fine Arts. Came in last in a competition with his peers.

1881

APRIL 1: Returned to Etten. Now and then went to The Hague to visit Anton Mauve, his cousin by marriage on his mother's side. Mauve,

a painter, advised and encouraged Vincent. Fought with his father and in December decided to settle down in The Hague.

1882

JANUARY, THE HAGUE: Stayed with Anton Mauve for three weeks (on Schenkweg), then rented a small studio ten minutes away. Mauve helped him financially.

END OF JANUARY: Met Clasina Hoornik (Sien), a prostitute, and moved in with her.

MAY 7: Wrote to Theo that he'd had a fight with Mauve, with whom he broke off contact.

JUNE 7: Admitted to the municipal hospital for gonorrhea. After recovering, he started painting at the beach in Scheveningen.

AUGUST 4: Parents moved to Nuenen (North Brabant, the Netherlands).

1883

SEPTEMBER 11: Left The Hague and Sien behind and headed to the Drenthe (the Netherlands). Van Rappard had often described it to him. First lodged in Hoogeveen, at an inn run by Albertus Hartsuiker (Pesserstraat). Stayed there for about fifteen days, exploring the surroundings, which were full of peat bogs. Walked through the moors and along the canals, and painted farmhouses, men and women at work, the fields, and the moors.

LATE SEPTEMBER: Moved to Nieuw-Amsterdam, traveling there by barge via the canal (leaving at one in the afternoon and arriving around ten in the evening). The barge docked by a drawbridge near the inn run by Endrick Scholte, where Vincent stayed in a large room with a balcony looking out onto the moors, huts, and the drawbridge.

NOVEMBER 22, ZWEELOO: At three in the morning, took an open carriage to the village where Anton Mauve and Anthon van Rappard often painted. Was unable to meet German artist Max Liebermann, a frequent visitor.

DECEMBER: Left Drenthe for Nuenen and stayed with his parents at the vicarage. Set up a small studio near the laundry room, then moved it to the garden near the pigsty.

1884

Studied music with an organist in Eindhoven (North Brabant, the Netherlands) and taught painting to some friends, including tobacco merchant A. Kerssmakers and goldsmith A. P. Hermans of Eindhoven. Painted six decorative panels for Hermanses' dining room.

1885

MARCH 26: Father died suddenly.

OCTOBER: Stayed in Amsterdam for three days. Visited the Rijksmuseum and was struck by the work of Rembrandt and Frans Hals.

NOVEMBER 28: Moved to Antwerp (Belgium); stayed at Lange Beeldekensstraat 194 (now 224), above Willem and Anna Brandel's paint shop.

1886

JANUARY, ANTWERP: Admitted to the Royal Academy of Fine Arts (on January 18) for courses in illustration and tracing. Visited the Royal Museum of Fine Arts and saw works by Rubens, as well as others in the city's churches.

LATE FEBRUARY: Left Antwerp to join Theo in Paris.

FEBRUARY 28: Went to live in Montmartre, in Theo's apartment at 25 Rue Laval.

EARLY MARCH TO EARLY JUNE: Worked at Fernand Cormon's studio at 104 Boulevard de Clichy, where he met John Peter Russell, Émile Bernard, and Henri de Toulouse-Lautrec. He remained friends with these artists until the end.

MAY 1–JUNE 30: Visited the Salon des Indépendants, organized by the Société des Artistes Indépendants.

MAY 15–JUNE 15: Attended the last impressionist exhibition.

EARLY JUNE: Moved with Theo to 54 Rue Lepic, in Montmartre.

AUGUST 20–SEPTEMBER 21: Seems to have visited the second exhibition organized by the Société des Artistes Indépendants.

SEPTEMBER–OCTOBER: Displayed his paintings in Père Tanguy's shop and in the galleries of Pierre Firmin Martin, Georges Thomas, and possibly Alphonse Portier. Sold at least one painting to Tanguy.

FALL–WINTER: Participated in weekly meetings of young, avant-garde artists held in Toulouse-Lautrec's studio. The two were great friends.

1887

FEBRUARY: Made friends with art dealer Alexander Reid.

FEBRUARY–MARCH: Organized an exhibition of his personal collection of Japanese prints, held at Le Tambourin, a restaurant run by his lover Agostina Segatori.

LATE MARCH: Mother moved from Nuenen to Breda, bringing along the artwork Vincent had left with her in addition to her own collection of magazine illustrations.

The Netherlands

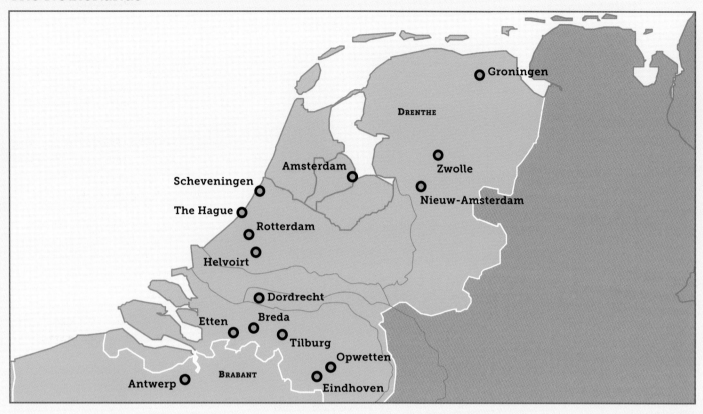

Auvers-sur-Oise at the time of Van Gogh

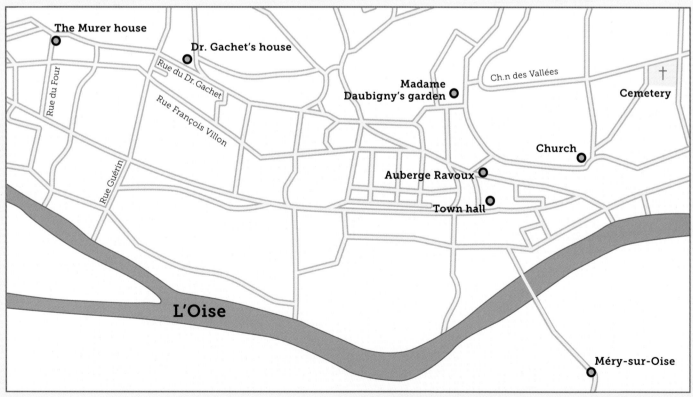

MARCH 26–MAY 3: Probably attended the third exhibit of the Société des Artistes Indépendants.

MAY: Spent time with Paul Signac in Asnières.

MAY–JUNE: Attended the sixth Exposition Internationale de Peinture et Sculpture at the Georges Petit gallery with Theo. Attended the Millet retrospective at the National School of Fine Arts.

MAY–JULY: Got in touch with Camille Pissarro and his son Lucien.

JULY: Displayed one of his most recent paintings in the window of Tanguy's shop.

1888

JANUARY: Probably attended the exhibition of Degas's pastels and Gauguin's paintings that Theo held at Boussod, Valadon & Cie.

FEBRUARY 19: Visited, with Theo, Seurat's studio to see his most recent work. A few hours later, Vincent took the train to Arles.

FEBRUARY 20: Arrived in Arles, initially staying at the Hotel Restaurant Carrel (30 Rue de la Cavalerie).

EARLY MAY: Rented the right wing of the Yellow House (2 Place Lamartine), with the idea of setting up a studio for a community of artists. He lived above the Café de la Gare, run by the Ginoux family.

JUNE: Spent a few days at Saintes-Maries-de-la-Mer. Also made a few trips to the Montmajour Abbey, which he sketched. Painted views of the the Crau plain, with the Alpilles in the background.

OCTOBER 23: Paul Gauguin arrived from Brittany and came to live in the Yellow House.

DECEMBER 23: Vincent chased Gauguin down the street with a razor. Spooked, Gauguin went to stay at a hotel. In a fit of self-harm, Vincent cut off part of his ear, which he delivered to a young woman (not a prostitute) at a brothel. Was admitted to the hospital in Arles for the first of many times. Gauguin left Arles.

1889

JANUARY 7: Left the hospital in Arles.

FEBRUARY 9: Admitted again for a few days.

MARCH: Due to popular outcry, and at the request of the mayor of Arles, he was committed again.

EARLY APRIL: Was allowed to return to the Yellow House for a few hours, where he showed Paul Signac some of his masterpieces, including a canvas that depicted the Alyscamps in Arles.

MAY 8, SAINT-RÉMY-DE-PROVENCE: Committed to the psychiatric ward at Saint-Paul de Mausole. He was allowed to paint and take walks in the surrounding countryside, which he painted dozens of times.

1890

JANUARY, BRUSSELS: His paintings appeared in the eighth exhibition of the Belgian group Les XX.

JANUARY 31: For the birth of Theo's son, who was also named Vincent, he painted a tribute with a flowering almond tree.

MARCH 20–APRIL 27: Exhibited some of his paintings at the Salon des Indépendants in Paris (Pavillon de la ville de Paris).

MAY 16: Left Provence to visit Theo in Paris.

MAY 20, AUVERS-SUR-OISE (VAL D'OISE, ÎLE-DE-FRANCE): Arrived by train from Paris. Stayed for a few days in an inn that was too expensive for him, so he moved to the Auberge Ravoux. Befriended Dr. Gachet and the pastry chef Eugène Murer, whose house was often visited by famous artists from Paris.

MAY 25: Drew a portrait of Gachet with his pipe and made an etching of it.

LATE MAY–EARLY JUNE: Painted Dr. Gachet twice.

EARLY JUNE: Painted Marguerite Gachet in Her garden and at the piano.

ABOUT JUNE 4: Drew the village church.

JUNE 8: Theo visited with his wife and child. They had lunch with Dr. Gachet.

ABOUT JUNE 10: Painted various versions of the Daubigny garden.

JUNE 16: Painted the White House in Auvers at night.

JULY 14: Painted the Auvers town hall as seen from the Auberge Ravoux.

JULY 27: Shot himself twice, apparently with a pistol he had taken from the Secrétan brothers, who had borrowed it from Mr. Ravoux to go fishing.

JULY 29: Died in his top-floor room at the Auberge Ravoux. Theo was by his side.

JULY 30: Buried in the Auvers cemetery. In addition to Theo and Dr. Gachet, Julien Tanguy (Père Tanguy), Émile Bernard, and Lucien Pissarro attended the funeral.

Index of Names and Places

This index contains the names of places, historical figures, inventions, and the geographical locations used in the text by the author and in the opening contributions by the photographers. Page numbers in italics refer to the letters of Van Gogh.

Index of
Van Gogh's Works

Amsterdam, Van Gogh Museum (Vincent van Gogh Foundation). F117/JH946.

29 (p. 94): *The Parsonage Garden at Nuenen* (Nuenen, January–February 1884). Oil on paper on panel, 25x57cm. Groningen, Groninger Museum. Stolen on March 29, 2020.

30 (p. 95): *The Vicarage at Nuenen* (Nuenen, September–October 1885). Oil on canvas, 33x43cm. Amsterdam, Van Gogh Museum (Vincent van Gogh Foundation). F182/JH948.

31 (p. 96): *Water Mill at Opwetten* (Nuenen, November 1884). Oil on canvas on panel, 44.9x58.5cm. Last purchased at a Sotheby's auction (London, June 20, 2013, lot 336). F48/JH527.

32 (p. 97): *Farmhouse in Nuenen* (Nuenen, May 1885). Oil on panel, 64x78cm. Amsterdam, Van Gogh Museum (Vincent van Gogh Foundation). F83/JH777.

33 (p. 99): *Still Life with Plaster Statuette, a Rose and Two Novels* (Paris, December 1887). Oil on canvas, 55x46.5cm. Otterlo, Kröller-Müller Museum. F360/1349.

34 (p. 102): *Backyards of Old Houses in Antwerp in the Snow* (Antwerp, December 1885–February 1886). Oil on canvas, 43.7x33.7cm. Amsterdam, Van Gogh Museum (Vincent van Gogh Foundation). F260/JH970.

35 (p. 103): *View of Het Steen* (Antwerp, December 1885). Pencil, pen, ink, chalk on paper, 13.1x21.1cm. Amsterdam, Van Gogh Museum (Vincent van Gogh Foundation). F1351/JH977.

36 (p. 107): *Plaster Cast of a Woman's Torso* (Paris, February–March 1887). Oil on canvas, 40.8x27.1cm. Amsterdam, Van Gogh Museum (Vincent van Gogh Foundation). F216g/JH1055.

37 (p. 109): *Montmartre the Quarry and Windmills* (Paris, June–July 1886). Oil on canvas, 32x41cm. Amsterdam, Van Gogh Museum (Vincent van Gogh Foundation). F230/JH1177.

38 (p. 110): *Self-Portrait with Pipe* (Paris, September–November 1886). Oil on canvas, 46x38cm. Amsterdam, Van Gogh Museum (Vincent van Gogh Foundation). F180/JH1194.

39 (p. 113): *View of Paris from Montmartre* (late summer 1886). Oil on canvas, 38.5x61.5cm. Basel, Kunstmuseum Basel. F262/JH1102.

40 (p. 114): *Interior of a Restaurant* (Paris, June–July 1887). Oil on canvas, 56x45.5cm. Otterlo, Kröller-Müller Museum. F342/JH1256.

41 (p. 115): *View of Paris from Vincent's Room in the Rue Lepic* (Paris, March–April 1887). Oil on canvas, 46x38cm. Amsterdam, Van Gogh Museum (Vincent van Gogh Foundation). F341/JH1242.

42 (p. 116): *Courtesan: After Eisen,* inspired by *Courtesan,* by Kesai Eisen (1790–1848) (Paris, October–November 1887). Oil on cotton, 100.7x60.7cm. Amsterdam, Van Gogh Museum (Vincent van Gogh Foundation). F373/JH1298.

43 (p. 119): *Portrait of Père Tanguy* (Paris, fall–winter 1887). Oil on canvas, 65x51cm. Stavros Niarchos Collection, formerly belonging to Edward G. Robinson. F364/JH1352.

44 (p. 121): *Portrait of Père Tanguy* (Paris, fall–winter 1887). Oil on canvas, 92x73cm. Paris, Musée Rodin. F363/JH1351.

45 (p. 125): *Terrace of a Café on Montmartre (La Guinguette)* (Paris, October 1886). Oil on canvas, 49x64cm. Paris, Musée d'Orsay. F238/JH1178.

46 (p. 126): *The Moulin Le Radet seen from rue Girardon* (Paris, October 1886). Otterlo, Kröller-Müller Museum. F227/JH1170.

47 (p. 129): *Le Moulin de Blute-Fin* (Paris, fall 1886). Oil on canvas, 55.2x38cm. Zwolle, Museum de Fundatie.

48 (p. 130): *Le Moulin de la Galette* or *The Blute-Fin Windmill* (Paris, fall 1886). Oil on paper, 61x50cm. Buenos Aires, Museo Nacional de Bellas Artes. F348/JH1182.

49 (p. 131): *Windmills on Montmartre* (Paris, 1886). Oil on canvas, 46.5x38cm. Tokyo, Artizon Museum (formerly in New York, J. S. Lasdon Collection). F273/JH1116.

50 (p. 132): *Pont du Carrousel* (Paris, June 1886). Oil on canvas, 31x44cm. Copenhagen, NY Carslberg Glyptotek. F221/JH1109.

51 (p. 134): *Bridges Across the Seine at Asnières* (Paris, summer 1887). Oil on canvas, 53.5x67cm. Zurich, Foundation E. G. Bührle. F301/JH1327.

52 (p. 137): *The Laundry Boat on the Seine at Asnières* (Paris, summer 1887). Oil on canvas, 19x27cm. Richmond, Virginia Museum of Fine Arts. F311/JH1325.

53 (p. 139): *Self-Portrait* (Paris, fall 1887). Oil on canvas, 47x35cm. Paris, Musée d'Orsay. F320/JH1334.

54 (p. 140): *Self-Portrait with Straw Hat* (Paris, August–September 1887). Oil on cardboard, 40.5x32.5cm. Amsterdam, Van Gogh Museum (Vincent van Gogh Foundation). F469/JH1310.

55 (p. 140): *Self-Portrait as a Painter* (Paris, December 1887–February 1888). Oil on canvas, 65x50.5cm. Amsterdam, Van Gogh Museum (Vincent van Gogh Foundation). F522/JH1356.

56 (p. 140): *Self-Portrait with Palette* (Saint-Rémy-de-Provence, late August 1889). Oil on cardboard, 57.79x44.5cm. Washington, DC, National Gallery of Art. F626/JH1770.

57 (p. 141): *Self-Portrait* (Saint-Rémy-de-Provence, September 1889). Oil on canvas, 65x54.2cm. Paris, Musée d'Orsay. F627/JH1772.

58, 60 (pp. 144, 146): *Field with Irises Near Arles* (Arles, May 1888), detail and full painting. Oil on paper on canvas, 54x65cm (full painting). Amsterdam, Van Gogh Museum (Vincent van Gogh Foundation). F409/JH1416.

59 (p. 146): Letter to Émile Bernard with a sketch of the Langlois Bridge. (Arles, March 18, 1888. To É. Bernard, 587F.) New York, Morgan Library & Museum, Thaw Collection.

61 (p. 149): *The Trinquetaille Bridge* (Arles, October 1888). Oil on canvas, 72.5x91.5cm. Sold at auction by Christie's (New York, June 19, 1987, lot 78). F481/JH1604.

62 (p. 149): *Le Pont de Trinquetaille* (Arles, June 1888). Oil on canvas, 65x81cm. Sold at auction by Christie's (New York, November 3, 2004, lot 41). F426/JH1468.

63 (p. 150): *Seascapes at Saintes-Marie-de-la-Mer* (Saintes-Maries-de-la-Mer, June 1888). Oil on canvas, 51x64cm. Amsterdam, Van Gogh Museum (Vincent van Gogh Foundation). F413/JH1452.

64 (p. 151): *Fishing Boats on the Beach at Saintes-Maries-de-la-Mer* (Saintes-Maries-de-la-Mer, June 1888). Oil on canvas, 64.5x81cm. Amsterdam, Van Gogh Museum (Vincent van Gogh Foundation). F415/JH1460.

65 (p. 153): *The Langlois Bridge at Arles with Women Washing* (Arles, March 1888). Oil on canvas, 54x65cm. Otterlo, Kröller-Müller Museum. F397/JH1368.

66 (p. 154): *Two Lovers (Fragment)* (Arles, March 1888). Oil on canvas, 32.5x23cm. F544/JH1369.

67 (p. 155): *The Langlois Bridge at Arles* (Arles, May 1888). Oil on canvas, 49.5x64.5cm. Cologne, Wallraf-Richartz Museum. F570/JH1421.

68 (p. 156): *The Harvest* (Saint-Rémy-de-Provence, June 1888). Oil on canvas, 73x92cm. Amsterdam, Van Gogh Museum (Vincent van Gogh Foundation). F412/JH1440.

69 (p. 159): *The Hill with the Ruins of Montmajour* (Arles, July 1888). Pen on paper, 47.5x59cm. Amsterdam, Van Gogh Museum (Vincent van Gogh Foundation). F1446/JH1504.

70 (p. 160): *La Maison de la Crau (The Old Mill)* (Arles, September 10, 1888). Oil on canvas, 64.77x53.97cm. Buffalo, Albright-Knox Art Gallery. F550/JH1577.

71 (p. 162): *Still Life with Two Sunflowers* (Paris, August–September 1887). Oil on canvas,

43.2x61cm. New York, Metropolitan Museum of Art. F375/JH1329.

72 (p. 163): *Vase with Twelve Sunflowers* (Arles, August 1888). Oil on canvas, 92.1x73cm. London, National Gallery. F454/JH1562.

73 (p. 164): *Self-Portrait (Dedicated to Paul Gauguin)* (Arles, September 1888). Oil on canvas, 61.5x50.3cm. Cambridge, Harvard Art Museums/Fogg Museum. F476/JH1634.

74 (p. 166): *The Yellow House* (alt. *The Street*) (Arles, September 1888). Oil on canvas, 76x94cm. Amsterdam, Van Gogh Museum (Vincent van Gogh Foundation). F464/JH1589.

75 (p.169): *Bedroom in Arles* (Arles, October 1888). Oil on canvas, 72.4x91.3cm. Amsterdam, Van Gogh Museum (Vincent van Gogh Foundation). F482/JH1608.

76–78 (pp. 170, 171): *Bedroom in Arles* (Saint-Rémy-de-Provence, September–October 1889), details. Oil on canvas, 57.3x74cm (full painting). Paris, Musée d'Orsay. F483/JH1793.

79 (p. 172): *Les Alyscamps: Falling Autumn Leaves* (Arles, November 1, 1888). Oil on canvas, 72.8x91.9cm. Otterlo, Kröller-Müller Museum. F486/JH1620.

80 (p. 172): *Les Alyscamps* (Arles, November 1888). Oil on canvas, 91.7x73.5cm. Sold at auction by Christie's (New York, November 4, 2003, lot 25). F569/JH1623.

81, 82 (p. 175): *The Arlésienne* (Arles, the Yellow House, November 1888), full painting and detail. Oil on canvas, 91.4x73.7cm. Paris, Musée d'Orsay. F498/JH1624.

83 (p. 174): *The Arlésienne* (Arles, the Yellow House, November 1888). Oil on canvas, 92.5x73.5cm. New York, Metropolitan Museum of Art. F498/JH1624.

84 (p. 176): *The Arlésienne with a Pink Background* (Saint-Rémy-de-Provence, February 1890). Oil on canvas, 65x54cm. São Paulo, Museu de Arte de São Paulo Assis Chateaubriand. F542/JH1894.

85 (p.180): *Self-Portrait with Bandaged Ear* (Arles, January 1889). Oil on canvas, 60x49cm. London, Courtauld Gallery. F527/JH1657.

86 (p.182): *Garden of the Hospital in Arles* (Arles, April 1889). Oil on canvas, 73x92cm. Winterthur, Oskar Reinhart collection am Römerholz. F519/1687.

87 (p.184): *Saint-Paul Asylum, Saint-Rémy* (Saint-Rémy-de-Provence, October 1889). Oil on canvas,

92.2x73.4cm. Los Angeles, Hammer Museum, Armand Hammer Collection. F643/JH1799.

88 (p. 186): *Corridor in the Asylum* (Saint-Rémy-de-Provence, October 1889). Oil color and essence over black chalk on pink Ingres paper, 65.1x49.1cm. New York, Metropolitan Museum of Art. F1529/JH1808.

89 (p. 188): *The Gorge (Les Peiroulets)* (Saint-Rémy-de-Provence, October 1889). Oil on canvas, 73x91.7cm. Boston, Museum of Fine Arts. F662/JH1804.

90 (p. 189): *Olive Grove* (Saint-Rémy-de-Provence, summer 1889). Oil on canvas, 72x92cm. Otterlo, Kröller-Müller Museum. F585/JHJ1758.

91 (p. 191): *Starry Night Over the Rhône* (Arles, September 20–30, 1888). Oil on canvas, 72.5x92cm. (Detail on pp. 4–5.) Paris, Musée d'Orsay. F474/JH1592.

92 (p. 192): *Café Terrace at Night* (Arles, Place du Forum, c. September 16, 1888). Oil on canvas, 80.7x65.3cm. Otterlo, Kröller-Müller Museum. F467/JH1580.

93 (p. 192): *Road with Cypress and Star* (Saint-Rémy-de-Provence, May 12–15, 1890). Oil on canvas, 90.6x72cm. Otterlo, Kröller-Müller Museum. F683/JH1982.

94 (p. 193): *Landscape with Wheat Sheaves and Rising Moon* (Saint-Rémy-de-Provence, July 13, 1889, 9:08p.m.). Oil on canvas, 72x92cm. Otterlo, Kröller-Müller Museum. F735/JH1761.

95, 96 (pp. 195, 197): *The Starry Night* (Saint-Rémy-de-Provence, June 1889), full painting and detail. Oil on canvas, 74x92cm. New York, Museum of Modern Art. F612/JH1731.

97–98 (p. 201): *White House at Night* (Auvers-sur-Oise, June 16, 1890), full painting and detail. Oil on canvas, 59.5x73cm. Saint Petersburg, Hermitage. F766/JH2031.

99 (p. 203): *Wheatfield under Thunderclouds* (Auvers-sur-Oise, July 1890). Oil on canvas, 50.4x101.3cm. Amsterdam, Van Gogh Museum (Vincent van Gogh Foundation). F778/JH2097.

100 (p. 205): *Houses at Auvers* (Auvers-sur-Oise, May 1890). Oil on canvas, 61x73cm. Toledo, Toledo Museum of Art. F759/JH1988.

101 (p. 208): *Portrait of Dr. Gachet* (Auvers-sur-Oise, early June, 1890). Lithograph, 18x15cm. F1664/JH2028.

102 (p. 209): *Marguerite Gachet in Her Garden* (Auvers-sur-Oise, early June, 1890). Oil on canvas, 46x55cm. Paris, Musée d'Orsay. F756/JH2005.

103 (p. 211): *Portrait of Dr. Gachet* (Auvers-sur-Oise, early June, 1890). Oil on canvas, 66x57cm. Location unknown. F753/JH2007.

104 (p. 210): *Still Life with Plaster Statuette, a Rose and Two Novels* (Paris, December 1887), detail. Oil on canvas, 55x46.5cm. (Full painting fig. 33, p. 99.) Otterlo, Kröller-Müller Museum. F360/1349.

105 (p. 213): *Portrait of Dr. Gachet* (Auvers-sur-Oise, early June 1890), second version. Oil on canvas, 68x57cm. Paris, Musée d'Orsay. F754/JH2014.

106 (p. 215): *The Church at Auvers* (Auvers-sur-Oise, June 4, 1890). Oil on canvas, 94x74cm. (Detail on p. 6.) Paris, Musée d'Orsay. F789/JH2006.

107 (p. 216): *Daubigny's Garden* (Auvers-sur-Oise, June 1890). Oil on canvas, 51x51cm. Amsterdam, Van Gogh Museum (Vincent van Gogh Foundation). F765/JH2029.

108 (p. 217): *Daubigny's Garden (The Entire Garden with a Cat)* (Auvers-sur-Oise, July 1890). Oil on canvas, 56x101.5cm. Basel, Kunstmuseum Basel. F777/JH2105.

109 (p. 218): *The Town Hall at Auvers* (Auvers-sur-Oise, July 14, 1890). Oil on canvas, 72x93cm. Private collection. F790/JH2108.

110 (pp. 222–223): *Landscape at Auvers in the Rain* (Auvers-sur-Oise, 1890). Full painting: Oil on canvas, 50x100cm. Cardiff, Amgueddfa Cymru National Museum Wales, Davies Sisters Collection. F811/JH2096.

111–112 (p. 222–223): *Bridge in the Rain* (after Hiroshige, Paris, 1887), full painting and detail. Oil on canvas, 73.3x53cm. Amsterdam, Van Gogh Museum (Vincent van Gogh Foundation). F372/JH1297.

pp. 4–5 *Starry Night Over the Rhône* (Arles, September 20–30, 1888), detail. Oil on canvas, 72.5x92cm. (Full painting fig. 91, p. 191.) Paris, Musée d'Orsay. F474/JH1592.

p. 6 *The Church at Auvers* (Auvers-sur-Oise, June 4, 1890), detail. Oil on canvas, 94x74cm. (Full painting fig. 106, p. 215.) Paris, Musée d'Orsay. F789/JH 2006.

p. 8: The port at Scheveningen (1990).

p. 10: Mural with a self-portrait by Van Gogh, covering the facade of the Auberge Ravoux in Auvers-sur-Oise during renovations in 1990.

pp. 18–19: Pool players in Nuenen.

Bibliographical Notes

Van Gogh biographies abound, even recent ones, so here we've only included the main works we consulted, which can be useful for further study. In this volume, all citations from foreign authors, even if already available in an Italian edition, were retranslated by the author directly from the original texts.

ARTAUD 1947: Antonin Artaud, *Van Gogh. Le suicidé de la société*, K éditeur, Paris, 1947. (Italian edition, *Van Gogh. Il suicidato della società*, Adelphi, Milano, 1988.)

AURIER 1890: George-Albert Aurier, "Les Isolées: Vincent van Gogh," in *Mercure de France*, January 1, 1890, pp. 24–29.

AURIER 1889–1892: George-Albert Aurier, *Scritti d'arte 1882–1892*, Elisa Baldini, Gianluca Tusini, Giuseppe Virelli, Mimesis, eds. Milan/Udine, 2019.

BAILEY 1990: Martin Bailey, *Young Vincent: The Story of Van Gogh's Years in England*, Allison & Busby, London, 1990.

BAILEY 2019: Ibid., *Living with Van Gogh*, White Lion, London, 2019.

BEECH 1988: Martin Beech, "Millet's Shooting Stars," in *Journal of the Royal Astronomical Society of Canada*, vol. 82, no. 6, December 1988, pp. 349–358.

BLONDEL 2019: François Blondel, *Van Gogh–Années parisiennes: catalogue raisonné des tableaux peints à Paris* (1886–1888), VisiMuZ, Paris, 2019.

BOIME 1984: Albert Boime, "Van Gogh's Starry Night: A History of Matter and a Matter of History," in *Arts Magazine*, vol. 59, no. 4, December 1984, pp. 92–95.

CABANNE 1992: Pierre Cabanne, *Qui à tué Vincent van Gogh?*, Quai Voltaire, Paris, 1992. (Italian edition, *Chi ha ucciso Vincent van Gogh?*, translated by Eileen Romano, Skira, Milan, 2013.)

DE BRUYN-HEEREN 1996: C. de Bruyn-Heeren, *Cornelis Schuitemaker (1813–1884), model for Vincent van Gogh*, in *Brabantse biografieën. Levensbeschrijvingen van bekende en onbekende Noordbrabanders*, vol. 4, J. van Oudheusden, Amsterdam/Meppel, 1996, pp. 109–112.

DE LA FAILLE 1928/1970: Jacob Baart de la Faille, *L'Oeuvre de Vincent van Gogh*, Catalogue Raisonnée, Paris–Brussels, 1928. (English edition, *The Works of Vincent van Gogh: His Paintings and Drawings,* Reynal & Company/Meulenhoff International, New York/Amsterdam, 1970.)

DU-QUESNE VAN GOGH 1910: Elizabeth Du-Quesne Van Gogh, *Personal Recollections of Vincent van Gogh*, Dover, New York, 2017. (Dutch edition, *Vincent van Gogh. Persoonlijke herinneringer aangaande een kunstenaar*, Baarn, 1910; Italian edition, *Vincent, mio fratello*, Skira, Milan, 2010).

FLAMMARION 1880: Camille Flammarion, "Les comètes les étoiles et les planètes," in *L'Astronomie Populaire*, Eugène Ardant Editeurs, Limoges, 1880.

FLAMMARION 1882: Ibid., *Les étoiles et les curiosités du ciel. Description complète du ciel visible à l'oeil nu et de tous les objects célestes faciles à observer, supplément de L'Astronomie Populaire*, Paris, 1882.

FLAMMARION 1886: Ibid., *L'Astronomie* 1886, tomo V, vol. 15, Gauthier-Villars et Fils, imprimeurs–libraires de l'Observatoire de Paris, Paris, 1886.

FLAMMARION 1887: Ibid., *Revue d'Astronomie populaire* 1887, tomo VI, Gauthier-Villars et Fils, imprimeurs–libraires de l'Observatoire de Paris, Paris, January 1, 1888.

FLAMMARION 1888: Ibid., *L'Astronomie 1888*, revue mensuelle d'Astronomie populaire, tomo VIII, Gauthier-Villars et Fils, imprimeurs–libraires de l'Observatoire de Paris, Paris, January 1, 1889.

FOSSI, DE MARCO, DONDERO 1990: Gloria Fossi, *Sulle tracce di Van Gogh. Alla ricerca dei luoghi, dei segni, del mito*, fotografie di Danilo De Marco e Mario Dondero, Giunti, Florence, 1990.

FOSSI 1993: Gloria Fossi, "Biondo Rubens. Théophile Gautier sulle tracce del maestro fiammingo," in *Art e Dossier*, no. 79, May 1993, pp. 24–29.

FOSSI 1996: Ibid., *Il Ritratto. Gli artisti, i modelli, la memoria*, Giunti, Florence, 1996.

FOSSI 2017: Ibid., "I libri rossi, gialli e blu di Van Gogh," in *Art e Dossier*, October 2017, no. 347, pp. 82–83.

FOSSI 2020: Ibid., "La digitale del dottor Gachet," in *Art e Dossier*, September 2020, no. 379, pp. 60–63.

GACHET 1858: P. F. Gachet, *Etude sur la mélancolie*, Typographic de Boehm, Montpellier, 1858.

GAUTIER 1839: Théophile Gautier, "La Toison d'or 1839," in *La Presse*, August 6–12, 1839. (Italian edition, *Il vello d'oro e altri racconti*, Lanfranco Binnie, ed., Giunti, Florence, 1993).

GAYFORD 2006: Martin Gayford, *The Yellow House: Van Gogh, Gauguin, and Nine Turbulent Weeks in Arles*, Fig Tree, London, 2006. (Italian edition, *La casa Gialla*, Excelsior 1881, Milan, 2007.)

GONCOURT 1865: Edmond et Jules de Goncourt, *Germinie Lacerteux*, Charpentier, Paris, 1865.

GUILLEMIN 1864: Amédée Guillemin, *Le Ciel, Notions d'Astronomie à l'usage des gens du monde et de la jeunesse*, Hachette, Paris, 1864.

GUZZONI 2014: Mirella Guzzoni, *Van Gogh. L'infinito specchio. Il problema dell'autoritratto e della firma in Vincent*, foreword by Massimo Recalcati, Mimesis, Milan/Udine, 2014.

GUZZONI 2020: Ibid., *Vincent's Books: Van Gogh and the Writers Who Inspired Him*, Thames & Hudson, London, 2020. (Italian edition, *I libri di Vincent*, Johann & Levi, Milan, 2020.)

HENDRIKS, VAN TILBORGH 2011: Ella Hendriks, Louis van Tilborgh, *Vincent van Gogh. Paintings 2: Antwerp & Paris 1885–1888*, Lund Humphries Publishers Ltd, Amsterdam, 2011.

HULSKER 1977: Jan Hulsker, *The Complete Van Gogh: Paintings, Drawings, Sketches*, Abrams, New York, 1977.

JACOBI 2019: Carol Jacobi, *Van Gogh and Britain*, Rizzoli Electa, New York, 2019, pp. 58–61.

JANSEN, LUIJTEN, BAKKER 2009: Leo Jansen, Hans Luijten, Nienke Bakker, *Vincent van Gogh– The Letters: The Complete Illustrated and Annotated Edition*, 6 vols., London/Amsterdam, 2009; www. vangoghletters.org.

JANSEN, LUIJTEN, BAKKER 2013: *Vincent van Gogh, Scrivere la vita*, selection of letters edited by Leo Jansen, Hans Luijten and Nienke Bakker, Donzelli, Rome, 2013.

JASPERS 1951: Karl Jaspers, *Strindberg und Van Gogh*, Piper Verlag, Berlin, 1951. (Italian edition, *Genio e follia. Strindberg e Van Gogh*, Raffaello Cortina, Milan, 2001.)

KNAPP, VAN DER VEEN 2009: Peter Knapp, Wouter van der Veen, *Vincent van Gogh à Auvers*, Editions du Chêne, Paris, 2009. (Italian edition, *Vincent van Gogh. Sotto il cielo di Auvers*, Contrasto, Rome, 2010.)

LETTERS 2006: Vincent van Gogh, *Lettere a un amico pittore*, edited by Maria Mimita Lamberti, translated by Sergio Caredda, Rizzoli, Milan, 2006 (6th ed., Milan, 2020).

LETTERS 2013: Vincent van Gogh, *Lettere (selezione parziale)*, edited by Cynthia Saltzman, translated by Margherita Botto, Laura Pignatti, Chiara Stangalino, Einaudi, Turin, 2013.

MAUPASSANT 1885: Guy de Maupassant, *Bel-Ami*, Italian edition in episodes, in *Gil Blas*, April 6–May 30, 1885.

MAKING VAN GOGH 2019–2020: *Making Van Gogh: A German Love Story*, exhibition catalog edited by Alexander Eiling, Felix Krämer, with Elena Schroll (Frankfurt, Staedel Museum, October 23, 2019–16 February 2020), Hirmer, Frankfurt 2019.

METZGER, WALTHER 2008: Rainer Metzger, Inigo Walther, *Vincent van Gogh 1853–1890*, Taschen, Colonia, 2008. (Updated Italian edition, *Vincent van Gogh, Tutti i dipinti*, 2015.)

MIRBEAU 1892–1893: Octave Mirbeau, "Dans le ciel," in *L'Écho de Paris*, September 20, 1892– May 3, 1893 (full edition, in volume: Éditions de l'Échoppe, Caen, 1989). (Italian edition, *Nel cielo*, translated by Albino Crovetto, Skira, Milan, 2015.)

OTTERLO 2003: Jos ten Berge, Teio Meedendorp, Aukje Vergeest, Robert Verhoogt, *The Paintings of Vincent van Gogh in the Collection of the Kröller-Müller Museum*, Kröller-Müller Museum, Otterlo, 2003.

MURPHY 2016: Bernadette Murphy, *Van Gogh's Ear: The True Story*, Vintage, London, 2016.

OLSON 2014: Donald W. Olson, *Celestial Sleuth: Using Astronomy to Solve Mysteries in Art, History and Literature*, Springer Praxis Books, New York, 2014.

OLSON 2018: Ibid., *Further Adventures of the Celestial Sleuth: Using Astronomy to Solve More Mysteries in Art, History and Literature*, Springer Praxis Books, New York, 2018.

POLLOCK 1978: Griselda Pollock, *Vincent van Gogh: Artist of His Time*, Phaidon, Oxford, 1978.

SALTZMANN 1998: Cynthia Saltzmann, *Portrait of Dr. Gachet: The Story of a Van Gogh Masterpiece*, Penguin, London, 1999. (Italian edition, *Ritratto del dottor Gachet*, translated by Clelia Bettini, Einaudi, Turin, 2009.)

SHAEBERLE 1903: Shaeberle, J. M., "The ring nebula in Lyra and the dumb-bell nebula in Vulpecula, as great spirals," in *Astronomical Journal*, no. 547,1903, pp. 181–182.

STAROBINSKI 2012: Jean Starobinski, *L'éncre de la Mélancolie*, Éditions du Seuil, Paris, 2012. (Italian edition, *L'inchiostro della malinconia*, translated by Mario Marchetti, Einaudi, Turin, 2014.)

THOMSON 2008: Richard Thomson, *The Starry Night*, Museum of Modern Art, New York, 2008 (2nd ed., 2017).

TOBIN, HOLBERG 2008: W. Tobin, J. B. Holberg, "A newly discovered accurate early drawing of M51, the Whirlpool Nebula," in *Journal of Astronomical History and Heritage*, vol. 11, no. 2, 2008, pp. 107–115.

TRALBAULT 1969: Marc Edo Tralbault, *Van Gogh, le mal aimé*, Lazarus, Lausanne, 1969.

UN AMI DE CÉZANNE 1999: *Un ami de Cézanne et Van Gogh. Le Docteur Gachet*, exhibition catalog edited by Anne Distel, Susan Alyson Stein, Andreas Blühm (Paris, Grand Palais, January 28–April 26, 1999 /New York, Metropolitan Museum of Art, May 17–August 15, 1999), RMN, Paris, 1999.

VAN GOGH 1990: *Vincent van Gogh*, 2 vols., exhibition catalog (Amsterdam, Van Gogh Museum [paintings]/Otterlo, Kröller-Müller Museum [drawings], March 30–July 29, 1990), De Luca/Mondadori, Rome/Milan, 1990.

VAN GOGH ET GAUGUIN 2002: *Van Gogh et Gauguin. L'atelier du Midi*, exhibition catalog edited by Douglas W. Druick, Peter Kort Zegers (Chicago, Art Institute/Amsterdam, Van Gogh Museum 2002), Gallimard, Paris, 2002.

VAN GOGH AND BRITAIN 2019: *Van Gogh and Britain*, exhibition catalog, with an introduction by Carol Jacobi and Ben Okri (London, Tate Britain, March 27–August 11, 2019), London, 2019.

VAN GOGH AND THE COLORS 2008: *Van Gogh and the Colors of the Night*, exhibition catalog edited by Sjraar van Heugten, Joachim Pissarro, Chris Stolwijk (New York, Museum of Modern Art/Amsterdam, Van Gogh Museum, September 2008–June 2009), Van Gogh Museum/ The Museum of Modern Art, Mercatorfonds, Brussels, 2008.

VAN GOGH 2015: *Van Gogh in the Borinage. The Birth of an Artist*, exhibition catalog edited by Sjraar van Heugten et al. (Mons, Musée des Beaux Arts, 2015), Mercatorfonds, Brussels, 2015.

VAN GOGH THE MAN AND THE LAND 2015: *Van Gogh. L'uomo e la terra*, exhibition catalog edited by Kathleen Adler (Milan, Palazzo Reale, October 18, 2014–March 8, 2015), Motta/ ilSole24ore cultura, Milan, 2014.

VAN GOGH-BONGER 1914: Johanna Van Gogh-Bonger, *Vincent van Gogh* (1914, preface to the first full edition of the letters, first Italian edition, 1954). (Italian edition, *Vincent van Gogh*, translated by Guido Coppi, with commentary from Elio Grazioli, Abscondita, Milan, 2007.)

VAN GOGH'S INNER CIRCLE 2019: *Van Gogh's Inner Circle: Friends, Family, Models*, exhibition catalog edited by Sjraar van Heugten and Helewise Berger, with a contribution from Laura Prins ('s-Hertogenbosch, September 21, 2019–January 12, 2020), ACC ART Books, 's-Hertogenbosch, 2019.

VAN TILBORGH, VELLEKOP 1999: Louis van Tilborgh, Marije Vellekop, *Vincent van Gogh, Paintings I. Dutch Period 1881–1885*, Van Gogh Museum & V+K publishing/Inmerc, Amsterdam, 1999.

VAN TILBORGH 2006: Louis van Tilborgh, *Van Gogh and Japan*, Van Gogh Museum, Amsterdam, 2006.

VELLEKOP, VAN HEUGTEN 2001: Marije Vellekop, Sjraar van Heugten, *Vincent van Gogh, Paintings I. Dutch Period 1885–1888*, Amsterdam, 2001.

WHITNEY 1986: Charles A. Whitney, "The Skies of Vincent van Gogh," in *Art History*, vol. IX, no. 3, September 1986, pp. 355–362.

ZOLA 1878: Émile Zola, *Une page d'amour*, Charpentier, Paris, 1878.

Photographic References

The original photographs are by Danilo De Marco and Mario Dondero, unless otherwise indicated. Also noted:

Alamy Stock Photo / IPA: © Art Collection, 28 a; © "Art Collection 3", 97 a; © FineArt, 28, 164, 193; © GL Archive, 31; © Heritage Image Partnership Ltd, 222; © Historic Images, 95 a; © PAINTING, 218; © Peter Barritt, 188 a; © Pictures Now, 84; © The Picture Art Collection: 34 a, 83 b

© Bridgeman Images: 71 a, 182

Contrasto: © Album, 54 b; © Everett Collection / CBS Films, 177

Getty Images: © Archive Photos / Pictorial Parade, 118 r; © DeAgostini, 125, 189 b; © Heritage Images / Fine Art Images, 90, 134, 149 b, 169, 172, 181; © ullstein bild / ullstein bild, 152; © Universal Images Group / Picturenow, 126, 137; © Universal Images Group/ Sepia Times, 159; © VCG / Corbis / Francis G. Mayer, 149 a

© Gloria Fossi: 6, 44, 72, 99, 170, 171 a, 171 b, 190, 194, 210

© Sandro Fossi: 196

Mondadori Portfolio: © AKG-Images, 117; © Album, 103 a; © COLLECTION CHRISTOPHEL Warner Bros., 13 b

© Roget Viollet / Alinari: 130 b

Scala, Firenze: © Digital image, The Museum of Modern Art, New York, 195, 197; © Heritage Images / Foto Fine Art Images, 116, 156, 203

© Shutterstock: 25, 37, 39 b, 43 b, 124 b, 145, 151 b, 212, 220

© The Metropolitan Museum of Art, New York: 162, 175, 186

© The National Gallery of Art, Washington, DC: 61 a, 61 b, 140 b,

Wikimedia Commons: 4–5, 12, 24, 29, 32, 35, 36, 41, 45, 56 a, 70 b, 71 b, 74 a, 77, 78 b, 81, 82 a, 93, 94 a, 96 a, 102 r, 107 l, 107 r, 109, 110, 111, 113, 114, 115, 119, 121, 127 al, 127 bl, 129, 130 a, 131, 132, 139, 140 ar, 140 al, 141, 144, 146, 147, 150, 151 a, 153, 154, 155 a, 160, 163, 165 a, 165 b, 166, 172 b, 174 a, 174 b, 176 a, 176 b, 184, 191 a, 192 a, 192 b, 201 l, 201 r, 205, 209, 211, 213, 215, 216, 217, 223

The publisher agrees to disburse any monies owed for images whose sources were not identifiable.

ADDITIONAL CREDITS

Vincent van Gogh, *Starry Night over the Rhône* (Arles, September 20–30, 1888), detail. Paris, Musée d'Orsay. (p. 4–5)

Vincent van Gogh, *The Church at Auvers* (Auvers-sur-Oise, June 4, 1890), detail. Paris, Musée d'Orsay. (p. 6)

The port at Scheveningen (1990). (p. 8)

Mural with a self-portrait by van Gogh, covering the facade of the Auberge Ravoux in Auvers-sur-Oise during renovations in 1990. (p. 10)

Pool players in Nuenen. (p. 18–19)

ABOUT THE AUTHORS

GLORIA FOSSI is an art historian, writer, and journalist, who studied in Florence, Rome, France, and the United Kingdom. Her specialties include comparative disciplines and the relationship between literature and visual art. Her books have been translated into eleven languages; they include *Galleria degli Uffizi. Arte. Storia, collezioni*; *Il Nudo. Arte Eros Artificio*; *Il Ritratto. Gli artisti, i modelli, la memoria*; and *Mari del Sud. Artisti ai tropici da Gauguin a Matisse*. She has edited many great works working with famous photographers and art historians from around the world. For many years she has followed in the footsteps of great artists such as Van Gogh, Matisse, Gauguin, Picasso, and Hugo Pratt, and of travel writers such as R. L. Stevenson, Joseph Conrad, Jack London, and Somerset Maugham, following her subjects across Europe, Polynesia, sub-Saharan Africa, the Indian Ocean, the Antilles, and the South Seas. She has also translated *The Narrative of Arthur Gordon Pym of Nantucket*, by Edgar Allan Poe, and edited *The Strange Case of Dr. Jekyll and Mr. Hyde*, by Robert Louis Stevenson, and *Heart of Darkness*, by Joseph Conrad.

DANILO DE MARCO has been working as a freelance photographer for almost forty years, appearing on mastheads across half of Europe and beyond (although no one has ever sent him on location; he has always sent himself!). He hails from the Italian region of Friuli Venezia Giulia but lives in Paris. He likes to say about himself, "I am not a photographer. I take photos." His beautiful black-and-white photos buck the trend of photography as a commodity aimed at a specific market. They stand against the obsessive self-promotion that has taken over the internet. His many publications and exhibitions include *Pasolini una melodia infinita*; *Il sale della Terra*; *Argonauta* (for the seventieth anniversary of Claudio Magris); *Partigiani di un'altra Europa* (more than a thousand faces of partisans, photographed over fourteen years across Europe); *Noi che siamo così poveri nel dire* (where he writes about his travels and encounters in Italy and worldwide); and *Dentro i tuoi occhi per vedermi* (including more than two hundred images). As the anthropologist Gianpaolo Gri wrote, "Danilo can't resist the smell of heresy."

MARIO DONDERO (1928– 2015) was among the most sensitive, committed, and intelligent photojournalists of the post–World War II period. His black-and-white photos made history: snapshots of Orson Welles on the set of Pier Paolo Pasolini's *Curd Cheese*, Alberto Giacometti in Paris, and large-scale images of space and conflict. As a young partisan, he participated in the liberation of Milan. He later became a reporter and photojournalist, and was a leading figure in the group of intellectuals and photographers who frequented the Bar Giamaica in Milan. He moved to France in 1955, where he lived for forty years, working with *Le Nouvel Observateur, Le Monde, Jeune Afrique,* and *Régard*. He covered the war in Algeria and the conflict in Afghanistan. One of his most famous images, from 1959, shows the writers of the Nouveau Roman movement— including Samuel Beckett, Alain Robbe-Grillet, and Nathalie Sarraute—standing in front of the Éditions de Minuit building in Paris.

ACKNOWLEDGMENTS

THE AUTHOR WISHES TO THANK: Lee Ann Bortolussi, Franco Cardini, Erri De Luca, Davide Mazzanti, Marilou Rella and Mirella Guzzoni for their helpful contributions, and Marco Driussi, Eleonora Gracci, Matteo, Niccolò, Tommaso Fossi, the Galatioto family, Giovanna Torrini, and Martina Vendali for their friendship and support. And many thanks to Soyolmaa Lkhagvadorj and the HarperCollins team for their enthusiam and professionalism.

Art Director Giunti Editore: Claudio Pescio

Translation of Van Gogh Letters into Italian: Gloria Fossi

Original Photographs: Danilo De Marco, Mario Dondero

Astrophysics Consulting: Sandro Fossi

Graphics and Layout: Sansai Zappini

Imagery Research: Claudia Hendel

Image Postproduction: Nicola Dini

IN SEARCH OF VAN GOGH

HarperCollins books may be purchased for educational, business, or sales promotional use. For information, please email the Special Markets Department at SPsales@harpercollins.com.

First published in the U.S. in 2021 by
Harper Design
An Imprint of HarperCollins*Publishers*
195 Broadway
New York, NY 10007
Tel: (212) 207-7000
Fax: (855) 746-6023
harperdesign@harpercollins.com
www.hc.com

Distributed throughout the world by
HarperCollins*Publishers*
195 Broadway
New York, NY 10007

FRONT COVER: *Field with Irises near Arles* (Arles, May 1888). Amsterdam, Van Gogh Museum (Vincent van Gogh Foundation)
BACK COVER, TOP: photograph © Danilo De Marco and Mario Dondero
BACK COVER, BOTTOM: *The Church at Auvers* (Auvers-sur-Oise, June 4, 1890). Paris, Musée d'Orsay. Wikimedia Commons.

ISBN 978-0-06-308517-6

Library of Congress Control Number 2021016246

Printed in Korea

First Printing, 2021